John Boardman
was born in 1927, and educated at
Chigwell School and Magdalene College, Cambridge. He
spent several years in Greece, three of them as Assistant
Director of the British School of Archaeology at Athens, and
he excavated in Smyrna, Crete, Chios and Libya. For four
years he was an Assistant Keeper in the Ashmolean Museum,
Oxford, and he subsequently became Reader in Classical
Archaeology and Fellow of Merton College, Oxford. He is
now Lincoln Professor of Classical Archaeology and Art in
Oxford, and a Fellow of the British Academy. Professor
Boardman has written widely on the art and archaeology of
Ancient Greece, and his other books include *Athenian Black
Figure Vases*, *Athenian Red Figure Vases: The Archaic Period*
and *Greek Sculpture: The Archaic Period*

WORLD OF ART

This famous series
provides the widest available
range of illustrated books on art in all its aspects.
If you would like to receive a complete list
of titles in print please write to:
THAMES AND HUDSON
30 Bloomsbury Street, London WC1B 3QP
In the United States please write to:
THAMES AND HUDSON INC.
500 Fifth Avenue, New York, New York 10110

GREEK ART

New revised edition

JOHN BOARDMAN

250 illustrations, 30 in color

THAMES AND HUDSON

© *1964, 1973 and 1985 Thames and Hudson Ltd, London*

This edition first published in the USA in 1985 by Thames and Hudson Inc., 500 Fifth Avenue, New York, New York 10110 Reprinted 1987

Library of Congress Catalog Card Number 83-50636

Printed and bound in Singapore by GnP

Contents

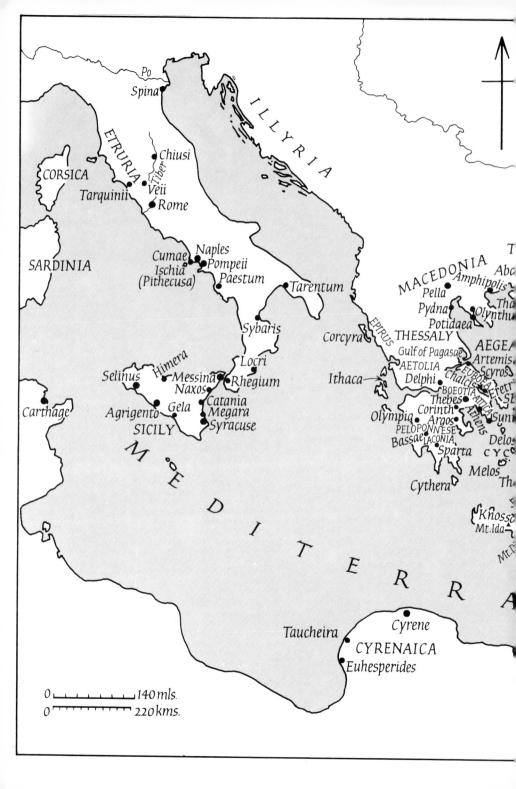

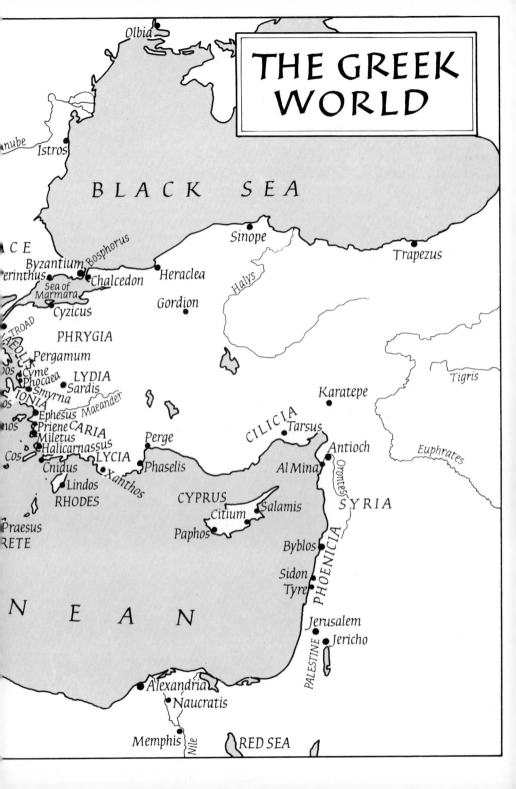

THE GREEK WORLD

Olbia

BLACK SEA

Istros

ACE

Sinope

Trapezus

Bosphorus

Byzantium
erinthus Chalcedon Heraclea
Sea of Halys
Marmara
Cyzicus Gordion

TROAD

PHRYGIA

AEOLIS
os Pergamum Tigris
Cyme
Phocaea LYDIA
os Smyrna Sardis
IONIA Maeander Karatepe
nos Ephesus CILICIA
Priene CARIA Tarsus
Miletus Perge Antioch Euphrates
Cos Halicarnassus LYCIA Al Mina Orontes
Cnidus Xanthos Phaselis CYPRUS SYRIA
Lindos Citium Salamis
RHODES Paphos
Praesus Byblos
RETE Sidon PHOENICIA
 Tyre
N E A N
 Jerusalem
 Jericho
 PALESTINE

Alexandria
Naucratis

Memphis Nile RED SEA

Introduction

'Some girls affect what is called the Grecian bend' commented the
Daily Telegraph in 1869, and the Irish ballad applauds the 'sort of
creature, boys, that nature did intend, to walk right through the
world' without that affectation. It is a measure of the popular view of
Greek art and of ancient Greeks in general that 'Grecian bend' was
coined for the affected gait, leaning forward from the hips, seen in
nineteenth-century England. It is hard to see just what Classical poses
inspired the term, but it became current soon after the arrival in
England of the Elgin Marbles. They had recently been rescued from
the Acropolis in Athens and offered English artists and scholars their
first opportunity to appreciate a large complex of original Greek
statuary of the finest period. It need hardly be said that there were
many dissenters who preferred still the slick prettiness of Classical
artists like Canova (who himself appreciated the Elgin Marbles:
'Oh! that I had but to begin again') and derived their notion of
Greek art from them. The notion dies hard too, together with other
misconceptions about ancient Greece. The 'Greek profiles' of actors
of the silent film were admired, and even Schliemann expressed naïve
surprise when he excavated the skeletons of the Greeks who died at
the Battle of Chaeronea and saw that they had not got 'Classical' noses.
Isadora Duncan dancing on the steps of the Parthenon would have
looked far odder to the ancient Athenian than the chorus of *Cats*. The
grammar of Greek architecture is now readily understood, however
transmuted, for we see it dimly still in all sorts of construction – from
the façades of banks to the dentils incongruously crowning a pillar-
box. There are even straight copies, and the Erechtheion in Athens has
contributed its Caryatid porch to the Church of St Pancras in London
and its north porch columns to many another church façade.
 This popular view of Greek art is so commonplace and the truth so
subtly different, that it is worth while considering for a moment how
we have come to know the art of the ancient Greeks. We have also to
distinguish it from that of Roman copyists and the Renaissance, for
these are the intermediaries who cherished the Classical tradition in
Western art.

Some monuments of Greek antiquity remained visible in Italy and Sicily in the Greek colonial sites, but Italian scholars and artists were naturally first attracted to Roman remains, the clay relief bowls (Arretine) and coins being collected already in the thirteenth and fourteenth centuries. In the fifteenth century some of the big Italian collections of sculpture were being formed, and not only from finds in Italy, for scholars were visiting Greek lands and both Venetian and Genoese families were trading freely in the Aegean. The young Michelangelo was proud that his work could be mistaken for antique, and artists like Piranesi ran studios in which incomplete statues, like the pieces from Hadrian's Villa at Tivoli, were repaired and completed.

Even earlier some Greek work had reached Italy. The great gilt-bronze horses which today stand over the entrance to St Mark's, Venice, had been taken to the Hippodrome of Constantinople from Chios in the fifth century A D, according to one account, and thence to Venice, as part of the Crusader booty, in 1204. Others say they started their career in Rome. In Venice they were threatened with being melted down in the Arsenal, but the poet Petrarch and others recog-

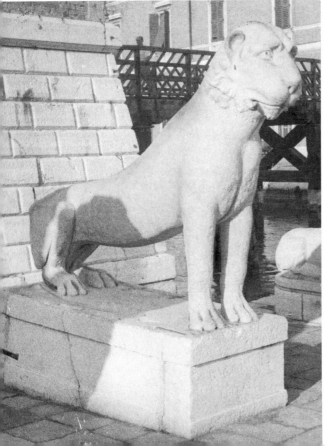

1 Marble lion before the Arsenal at Venice. The body is from Delos, of the early sixth century B C; the head is an eighteenth-century A D addition

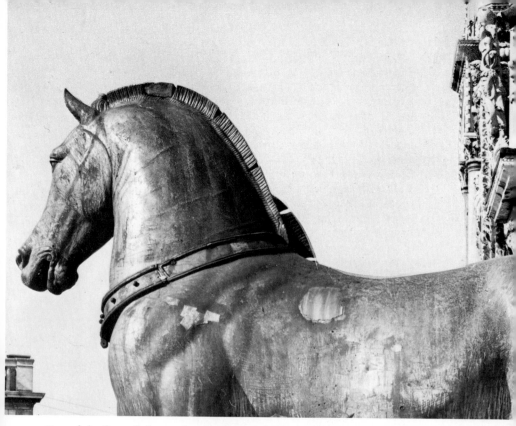

2 One of the four gilt-bronze horses, above the entrance to St Mark's, Venice. Possibly original Greek works from the island of Chios, but their gilding and other features might indicate Roman copies of a Hellenistic group

nized their value and beauty: 'Works of Lysippus himself', they said, and they were possibly made not much after the lifetime of that sculptor. To Venetians they showed the brilliant casting techniques of the ancients, forgotten again until Donatello. The prizes have not stood undisturbed on St Mark's. Napoleon took them to Paris in 1798 and mounted them on the Arc du Carrousel in the Tuileries. They were returned in 1815, despite the popular outcry for their retention. And in the First World War they came down again under the threat of Austrian bombardment. The two lions before Venice Arsenal also came from Greece: one from Piraeus, port of Athens, the other a fine Archaic creature from Delos, which was brought in the early eighteenth century and had to be provided with a new head in the con- 1 temporary manner.

The big Italian collections remain an important source for the study of Greek statuary – in Roman copies – although the cult of the fig leaf persists here and there, and the copy of Praxiteles' Aphrodite in the Vatican only lost the lead drapery swathed decently round her hips in 1932. Similar collections grew in France, where Louis XIV's sculptor, Girardon, was called upon to perform an early instance of plastic surgery on the Venus of Arles (another Praxitelean copy) to reduce her pose, dress and the contour of her breasts to something nearer the contemporary fashion. In England the Earl of Arundel, much of whose collection is in Oxford, had travelled in Greece and was able to acquire several important Greek originals in the early seventeenth century. One piece from his collection, now recognized as from the Great Altar of Zeus at Pergamum, wandered as far as Worksop, where it was built into the front of a Georgian red-brick house and refused by a firm of masons for breaking into chips before it was rescued and recognized in 1961.

But it was the really big finds of the late eighteenth and early nineteenth century that opened the eyes of western Europe to original

3 The Temporary Elgin Room in the British Museum in 1819. A painting by A. Archer. Canvas, 1·32 × 0·94 m.

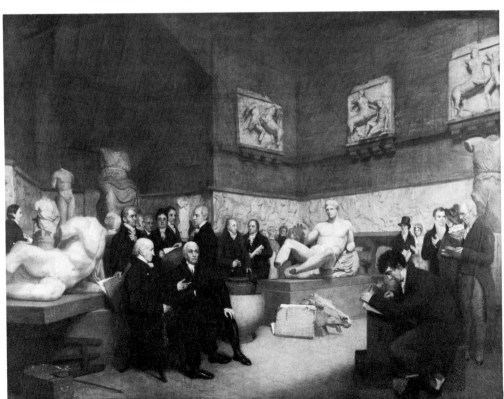

4 The staircase in the Ashmolean Museum, Oxford, with a restored and partly coloured cast of the frieze from the fifth-century BC Temple of Apollo at Bassae (*see Ills. 127–9*). Designed by C. R. Cockerell, 1845

Greek art. The sculptures of the Temple of Aphaea at Aegina went to Munich. The Elgin Marbles from Athens were acquired for the British Museum in 1816, and despite the condition of exhibition and *3* some strong expression of prejudice, came to be valued at their true worth, and had a profound influence on artists, and on the more popular and scholarly ideas about Greece. C. R. Cockerell explored and drew the Temple of Apollo at Bassae, and its relief sculptures too *127–9* came to London. When he built the University Galleries at Oxford (now the Ashmolean Museum) in 1845 he recalled the unusual column types of Bassae in the exterior, and at the top of the staircase set a cast *4* of the sculpture frieze from the inner room of the temple, where, with its painted background and in an architectural setting, it can give some idea of the part such architectural sculpture can play in decoration. Even the Great Exhibition of 1851 had its tribute to antiquity, although when the historian of Greece, George Finlay, visited it with 'Athenian' Penrose, who had studied and elucidated the architectural refinements of the Parthenon itself, he wrote afterwards in his diary, 'Crystal Palace with Penrose. The frieze of the Parthenon is fearful coloured and the Egyptian figures not only men but lions and sphinxes look as if they were drunk.'

Greek vases were being found in quantity in the cemeteries of Etruria and south Italy from the eighteenth century on. At first called 'Etruscan', their Greek character was eventually recognized, although

the earlier vases of Greece, when they first appeared in Greek lands, were dismissed as Phoenician or Egyptian, so unlike were they to the Classical statues and vase-paintings. Greek and Roman gems had remained in use as decoration through the Middle Ages, and had been copied freely. The nineteenth-century excavations in Greece itself revealed new treasures, both of major statuary like the Olympia sculptures and the Archaic marbles of the Athenian Acropolis, and the host of other works on which scholars can now base a reasoned history of the whole development of Greek art, the summary of which is attempted in these chapters.

The problems which attend the understanding of the history of Greek art are no fewer now that so much more evidence is available, but they have reached the point at which discussion can concern matters of attribution to individual artists, and the sequence of styles can be taken as well established. There is still much to be gleaned from the accounts of ancient authors, in the identification of famous Greek works in copies of the Roman period, and, for example, in the identification of portraits. Some results come from a happy combination of excavation, observation and brilliant detective work. A good example is the demonstration that the originals of a well-known series of four
5 reliefs, known in several late copies, stood in the balustrade round the Altar of the Twelve Gods in the market-place of Classical Athens.

New excavations provide both new works of art and fresh evidence for the understanding and dating of works already known. Not all the finds are quite deliberate. Wrecked ships carrying statues, probably *en route* for Roman palaces or villas, have yielded some of the finest major bronzes of the Classical period. The Roman General Sulla sacked the port of Piraeus in 86 BC, and seems to have surprised a shipment of statuary which never got away but was burned in its warehouse. The statues were rediscovered in 1959 while a sewer was being dug in the streets of Piraeus. A dramatic find is of the two
7 bronze warriors from a wreck off Riace in south Italy, which have revolutionized our knowledge of the styles of the mid fifth century and taught us the inadequacy of judgments based wholly on surviving marbles. It might well be thought that the major sites likely to yield notable works have by now been all discovered and exhausted. This seems far from true. In the first place there are the many unexpected finds far from Greece which sometimes produce works unrivalled in Greece itself: I think of the tomb at Vix, little over one hundred miles south-east of Paris, which in 1953 yielded the
103 largest and finest of all Archaic bronze *craters* yet known. There are
6 new sites in Greece too, like the royal tombs of Vergina in Macedonia
165 where, it may be, we have the burial of Alexander's father, Philip II.

14

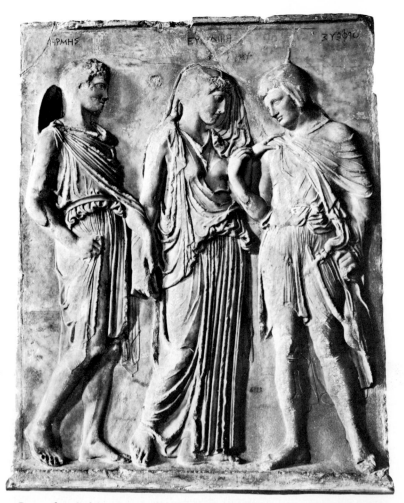

5 Copy of a relief showing Hermes, Orpheus and Eurydice; one of the four from the Altar of the Twelve Gods set up in the Athenian market-place in the later fifth century B C

Meanwhile, the old sites are far from exhausted and the lower levels of great sites like Delphi and the Heraion on Samos still surprise us with their treasures. At Olympia it was too late by nearly two millennia to rescue the gold and ivory statue of Zeus, made by Phidias, and one of the Seven Wonders of the Ancient World. But in 1954–58 Phidias' workshop, in which the statue was made, was excavated, with its tools, scraps of ivory, moulds for the glass inlays and matrices on which the sheet-gold was beaten out; and in the

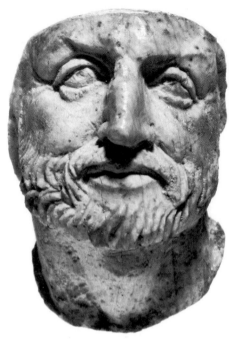

6 Ivory head, possibly of Philip II of Macedon. Found in a royal tomb (11) at Vergina which is, probably rightly, identified as Philip's own. *c.*340 BC. Height 3·2 cm

corner the great artist's own tea-mug with his name incised on the base, 'I belong to Phidias'. These finds may not take us much closer to the great statue, but they teach us a lot about how it was made, as well as offering a rather poignant relic of the greatest of all Classical artists.

One further problem of supply for the art historian is that of copies and forgeries. Ancient copies of earlier, famous works, are often our only evidence for the appearance of masterpieces, yet expertise with ancient descriptions and Roman copies, whatever its intrinsic merit, can bring us but little closer to the originals, and in a brief history such as this these studies can be largely ignored in favour of the many original works surviving. The Neo-Classical copyist or forger can seldom deceive us – but the modern can, and so hard does he press on the heels of the scientist that it is better now to ignore any work (especially a painted vase) which has no pedigree and exhibits any peculiarities of style, plausible or not. It is sometimes hard to decide who is working the faster – the forger or the illicit excavator. Neither deserve continuing success.

The perplexity with which scholars faced the evidence of those works of Greek art which are earlier than the Classical has already been remarked. Certainly, a Geometric vase is as different as it can be

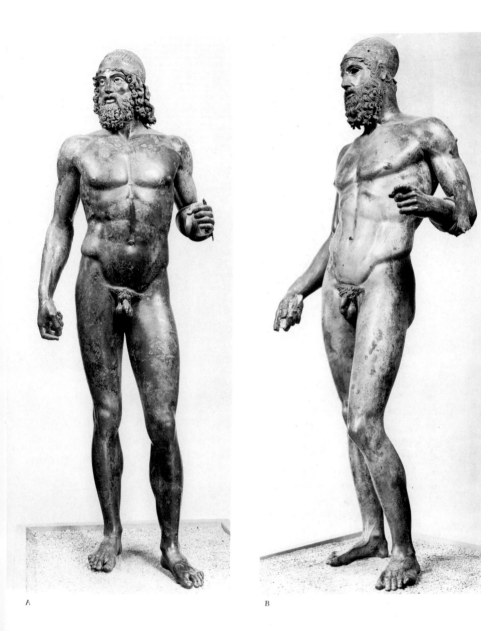

A B

7 Bronze warriors found in the sea off Riace, near Reggio. To be restored with shields, spear (A) and sword (B), and a helmet for B. Copper inlaid on lips and nipples, silver on the teeth of A. B's arms were restored in antiquity. Slightly over life-size

from a red-figure one, and there is little in seventh-century sculpture to suggest that within two centuries Greek artists were to carve statuary of the quality and type which appeared on the Parthenon. In a way this is the most remarkable lesson of any history of Greek art – its rapid development from strict geometry admitting hardly any figure decoration, to full realism of anatomy and expression. We shall see how the geometry broke before the influence of Near Eastern art, and how the Greek artists absorbed these foreign elements and welded them into an art form in which the best formal qualities of their native tradition remained dominant. And then, at about the time of the Persian Wars, a break with Archaic conventions and a steady progress, centred in the study of representation of the human body, towards the unrivalled competence of the following centuries.

When we have to contrast one style with another and we use words like 'the Archaic' and 'the Classical', 'the Geometric' and 'the Orientalizing', this is simply a matter of convenient terminology, for the development from one style to another is smooth, only accelerated by outside influence or the brilliance of particular schools. And, of course, it is easy to fall into errors of talking about the 'sixth-century style' – another sheer convenience – utterly meaningless, of course, to the ancients who did not know what century BC they were living in, although they could readily recognize what was primitive in their own art. We can talk with only a little more conviction about the different spirit of Quattrocento and Cinquecento Italy. The passage into a new century or decade in modern times is more readily felt to be significant in some way: 'the nineties', 'the twenties' are to a fair degree valid individual periods.

Finally, the pictures in this book. The finest vase-painting styles are essentially linear, black and white (or rather red). Greek sculpture was coloured, but the colour has seldom lasted even in slight traces. There were fine wall-paintings, but none have survived, except in late copies. So if in picture-books Greek art looks colourless beside, say, Egyptian, or the arts of more recent periods, we must make allowances for the problems of survival. In these chapters the theme is one of change and development with an emphasis on the less well-known arts which are too readily forgotten, and special emphasis on original works rather than copies. Histories of art tend to be written around the few stock masterpieces. It is well to realize how much more there is and the fulness of the evidence. In choosing the pictures no conscious effort has been made to include all the old favourites, any more than to seek out the unknown deliberately.

The Beginnings and Geometric Greece

There is no difficulty in tracing the development of the Classical tradition in Western art from Greece of the fifth century B C, through Rome, the Renaissance, to the modern world. Working backwards, to its origins, the story is no less clear, but it is extraordinarily varied and there are two views about what should be regarded as its starting-point. Once the Geometric art of Greece was recognized for what it was, the steps by which it was linked to the Classical period were quickly discovered. This was the work of scholars of the end of the nineteenth century, who were at last able to show that Classical art was not a sudden apparition, like Athena springing fully armed from the head of Zeus, nor a brilliant amalgam of the arts of Assyria and Egypt, but independently evolved by Greeks in Greece, and its course only superficially conditioned by the influence and instruction of other cultures.

But even while the importance of Geometric Greece was being recognized, excavators like Schliemann and Evans were probing deeper into Greece's past. The arts of Minoan Crete and of Mycenae had to be added to the sum of the achievements of peoples in Greek lands, and now that it has been proved that the Mycenaeans were themselves Greek-speakers the question naturally arises whether the origins of Classical Greek art are not to be sought yet further back, in the centuries which saw the supremacy of the Mycenaean Empire.

The trouble has been to find a link across the Dark Ages which followed the violent overthrow of the Mycenaean world in the twelfth century B C. It would be idle to pretend that there is none, but the fact remains that Mycenaean art, which is itself but a provincial version of the arts of the non-Greek Minoans, is utterly different, both at first sight and in many of its principles, to that of Geometric Greece. For this reason our story begins after the Dark Ages, with Greek artists working out afresh, and without the overwhelming incubus of the Minoan tradition to stifle them, art forms which satisfied their peculiar temperament, and out of which the Classical tradition was born.

For this reason our only picture of Bronze Age, Mycenaean Greece here is probably the most familiar one – the Lion Gate at the main

8 entrance to the castle at Mycenae. There is more, however, than its familiarity which suggests its inclusion. It was one of the few monuments of Mycenaean Greece which must have remained visible to Greeks in the Classical period, beside massive walls which they attributed to the work of giants. And it illustrates two features of Mycenaean art which were not learnt from the Minoans, and which the Minoans had never appreciated. Firstly, the monumental quality of the architecture, massive blocks and lintels piled fearlessly to make the stout castle walls which the life of Mycenaean royalty found necessary. Secondly, the monumental quality of the statuary, impressive here for its sheer size rather than anything else, since the art form derived directly from the Minoan tradition which was essentially miniaturist and decorative. More than five hundred years were to pass before Greek sculptors could command an idiom which would satisfy these aspirations in sculpture and architecture.

The revival, or rather the rebirth of Greek art after the fall of the. Mycenaean world introduces a city which seems to have become important only at the end of the Bronze Age, but which is to dominate the story from now on – Athens. To some degree the Acropolis citadel of Athens had survived the disasters attendant on the destruction of other Mycenaean centres, and her countryside was to serve as a refuge for other Greeks dispossessed by the invaders from the north. It is on painted clay vases that we can best observe the change that takes place, and since about one-quarter of the pictures illustrating this book will be of decorated pottery – nowadays a somewhat recherché art form – it will be as well to explain why this is. Virtually all that we know about the art of these early centuries has been won from the soil, and the rigours of survival have determined what our evidence shall be. No textiles, embroidery or woodwork, for one thing. Only by good fortune marble or bronze statuary, since the materials were only too readily appreciated by later generations as raw material for their lime-kilns or furnaces. But a fired-clay vase, with its painted decoration fired hard upon it, is almost indestructible. It can be broken, of course, but short of grinding the pieces to powder something will remain. In an age in which metal was expensive, and glass, cardboard and plastics unknown, clay vessels served more purposes than they do today, and in Greece at least the artist found on them a suitable field for the exercise of his draughtsmanship.

On the vases made in Athens in the tenth century B C, we see the simplest of the Mycenaean patterns, arcs and circles, which are themselves debased floral patterns, translated into a new decorative form by the use of compasses and multiple comb-like brushes which rendered with a sharp precision the loosely hand-drawn patterns of the older

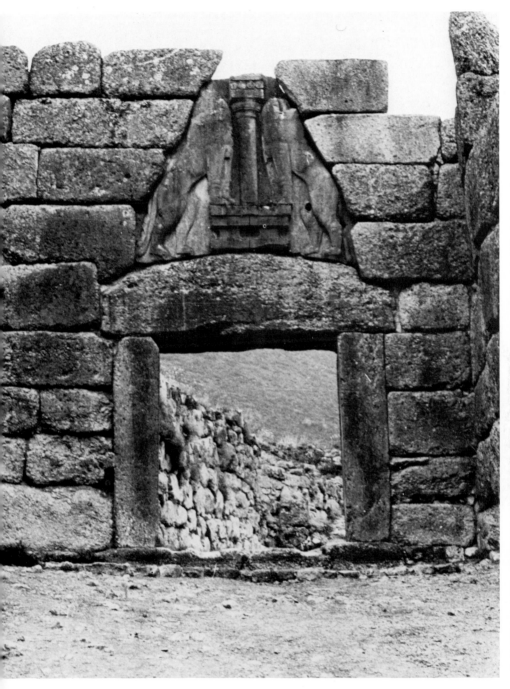

8 The Lion Gate at Mycenae. Two lions, their heads missing, stand heraldically at either side of an altar supporting a column. The triangular gap, filled by the slab, helps to relieve the weight of masonry on the great lintel. Thirteenth century B C

9 style. A few other simple Geometric patterns are admitted, but because we have yet to reach the full Geometric style of Greece, this period is called 'Protogeometric'. The vases themselves are better made, better proportioned, and the painted decoration on neck or belly is skilfully suited to the simple, effective shape. The painters had not forgotten how to produce the fine black gloss paint of the best Bronze Age vases, and as the Protogeometric style developed we see more of the surface of the vase covered by the black paint. Athens' pottery was soon accepted as the standard for vase decoration in other parts of Greece.

 The vases that we have come mostly from tombs and there is little enough to set beside them, except for simple bronze safety-pins (*fibulae*) and some primitive clay figures, especially from Crete where,

10 again, some of the Minoan forms and techniques seem to have survived. Of the domestic architecture and temples we know little, but the dramatic recent discovery of a building 45 metres long at Lefkandi in Euboea, covering royal tombs and dated securely to the tenth century, shows that rubble and mudbrick could sometimes aspire to the monumental.

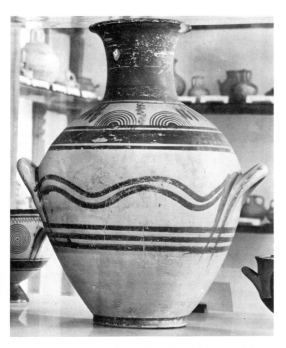

10 A janiform clay head from Crete, which may have fitted into a roughly carved wooden body and served as a cult idol. The two faces (one male – at the back, one female?) were painted. Tenth–ninth century B C. 28 × 19 cm

9 A Protogeometric *amphora* from Athens, with the characteristic concentric semicircles on the neck, and wavy lines at the belly. Vases of this shape, with belly handles, were used for women's graves. Early tenth century B C. Height 41 cm

11 An Athenian Geometric *crater* with meander, zigzags and early representations of horses. The knob of the lid is finished as a small jug. *c.* 800 B C. Height 57 cm; diam. between handles 26 cm

GEOMETRIC VASES

The full Geometric period belongs to the ninth and eighth centuries B C. It begins, or rather slowly develops from the relative obscurity of the Protogeometric, and ends with a new, prosperous Greece of strong city-states, whose merchants and families were already travelling far from the home waters of the Aegean to trade and settle and whose nobles were already looking for something of the luxury and the trappings of Court life as it was known in the older civilizations of the Near East and Egypt, and as it had been known in Greece's own Golden Age of Heroes, the Bronze Age.

On the Geometric vases we soon begin to see a new repertory of patterns as well as the decorative development of the old ones. The vases are girt by continuous bands of meanders, zigzags and triangles, to name only the most popular patterns. The circles and semicircles *11* are seen less often. These zones are divided from each other by neat triple lines, and the patterns themselves are drawn in outline and hatched. Much of this is strongly reminiscent of ordinary basketry

23

designs, and while it is clear that there was some influence from this craft, even in some vase shapes (*pyxides* like knitting-baskets) it still does not explain the whole phenomenon of Geometric decoration. Several new vase shapes are introduced, as well as refinements of the old, to suit the more varied needs of a more prosperous and sophisticated community.

While in the Protogeometric period the artist confined his decoration to clearly defined areas of the vase, the Geometric painter soon let zones of zigzags and meanders cover the whole vessel, filling in the blank spaces of the earlier vases with strips of simple pattern. The over-all effect is fussy, but precise, and the shape is still well enough expressed by setting the emphatic patterns at the neck, shoulder or between the handles. But it looks as though the artist soon became absorbed with the patterns themselves, and variants upon them, to the detriment of the general effect of the vase as an expression of the wedded crafts of potter and painter. The zones are broken into panels with individual motifs of circles, swastikas or diamonds, and the resultant chequered appearance has a depressingly rhythmic effect.

However, by the time these changes were being made, in the early eighth century, the artist had already begun to admit figure decoration to his vases, and this marks the introduction of the most fundamental element in the later tradition of Classical art – the representation of men, gods and animals. It also introduces problems about the character of Geometric Greek art, best considered after we have observed its expression on the pottery. At first there are isolated studies of animals, even a human mourner, rather lost in the Geometric patterning; but soon the animals are repeated with identical pose to fill a frieze where 13 before a meander or zigzag ran. And the effect is still of a Geometric frieze, with the grazing or reclining animals presenting a repetitive pattern of limbs and bodies, rather than individual studies. By the mid century human figures were admitted too in scenes of some complexity. The finest appear in the main panels on the big funeral vases which stood (some over five feet high) marking graves in an Athens 12 cemetery. Here we can best observe the way the artist treated his figure studies. It was an idiom which appears to have sprung from the discipline of the Geometric patterns, which were all he knew, and it owes nothing immediately to the influence or example of other cultures, although similar conventions have been adopted in different parts of the world at different times. The parts of the body are rendered in angular sticks and triangles, blobs for the heads, bulging sausage-like thighs and calves. The whole figure is thus reduced to a 14 Geometric pattern. All is rendered in plain silhouette and only later is an eye reserved within the head, and strands of hair are shown, as well

24

13 Athenian Geometric *amphora* with encircling bands of Geometric patterns interrupted by rows of grazing deer, recumbent goats and geese. *c.* 750 BC. Height 41 cm

12 This large *amphora* stood over a grave in Athens. The centre panel shows the dead laid out on a bier, with mourners at either side. On the neck two of the friezes are of repeated animal figures. *c.* 750 BC. Height 1·55 m

14 Detail from a grave *crater* with funeral scenes. The mourning women (breasts shown by strokes at either side of the triangle torsos) tear their hair. The charioteers' helmets are reduced to a crest only, but of their chariots we see both wheels and rails, and of their horses all legs, tails and necks. They carry *Dipylon* shields which cover their bodies. *c.* 750 BC.

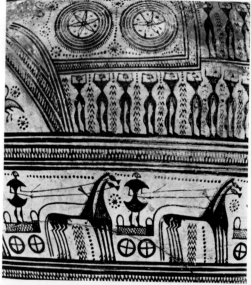

as chins, noses, fingers and breasts. The artist paints what he knows of the figures, not what he sees, and though he did not show both eyes in a profile head, still, in chariot groups, all legs, tails and necks of all horses would be shown, and the two wheels put side by side. On the funeral bier the chequered shroud, lifted over the corpse, is cut away to show clearly the body beneath. Action, like fighting, is shown easily enough with these stick figures and their spears, swords and bows; and emotion is translated into action – like the mourners tearing their hair. On the grave vases we see the body laid out for burial (*prothesis*), or the bier carried by carts to the cemetery (*ekphora*): the centrepiece flanked by rows of mourners so that the whole still forms a symmetrical, Geometric composition, although it is also telling a story. Sea fights are shown on some vases, vivid illustration of days in which Greek merchants and colonists were probing the shores of the Mediterranean, and Athens herself, though no colonizer, was sending her wares into distant waters.

On the smaller vases too these figure scenes become more and more common. Here we are offered the earliest and clearest expression of that interest in narrative art which is an essential part of the Classical tradition. In literature it is expressed first in the Homeric Poems, and it is no accident that it is just at this time that Homer must have been moulding the lays about the Age of Heroes into the epic poems from which artists – poets, dramatists, sculptors and painters – were to draw inspiration for centuries to come. Some of the protagonists on the vase

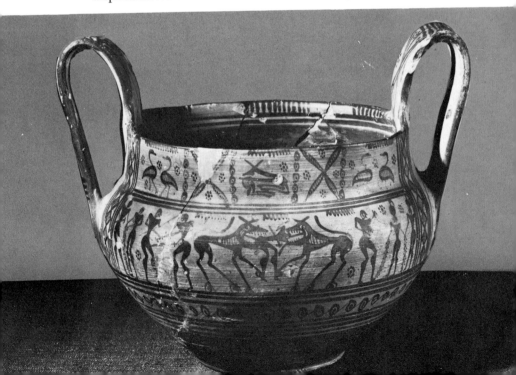

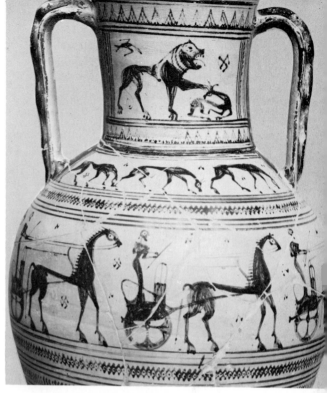

15 (*left*) Athenian Late Geometric drinking-cup (*kantharos*) showing, in the main frieze, a warrior leading away a woman, a duel, two lions tearing a warrior, and a lyre-player talking to two water-girls. Late eighth century B C. Height 17 cm

16 (*right*) An Athenian Late Geometric *amphora* from Attica. The Geometric ornament is now wholly subordinated to figure scenes: a lion pulling down a doe, grazing horses and chariots shown in a reasonable profile view. Reserved areas admit details of eyes and manes. *c.* 700 B C. Height 60 cm

scenes might be identified as heroes of popular Greek myths in characteristic exploits – like Heracles' encounter with the lion. Others might illustrate heroic episodes – duels at Troy, the shipwreck of Odysseus, but on this threshhold of full narrative art in Greece it is easy to be over-optimistic and over-anxious to identify myth in what may be scenes of every day, of cult or of foreign inspiration.

Already foreign goods and foreign craftsmen had reached Greek shores after centuries of virtual isolation. We may judge their effect more readily in arts other than vase-painting, never a favourite in the East, but the lions on Athenian vases are heralds of the new age, 15, 16 borrowed and translated from the arts of the Near East. It is likely enough that this whole phenomenon of a figure art was inspired by Eastern example. There are scenes and groups which echo the Easterner's reliefs, even the Egyptian's painting, but the translation to a wholly different idiom is total, and the idiom itself may not be completely explained as a simple application of geometry to the problems of the figure. The last of the Mycenaean Greeks practised a stylized figure art which is superficially similar, and it might be wise not to underestimate the debt of Geometric Greek art to a past which

27

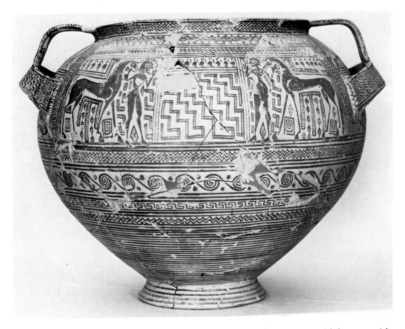

17 A *crater* (mixing-bowl) found in a grave at Argos. It shows men with horses, with devices beneath them recalling the yokes of carts or chariots. The central meander panel and row of birds seem to suggest a duck pond! Late eighth century B C. Height 47 cm

was increasingly occupying poets and priests, just as it is certainly unwise to underestimate its sophistication.

At the end of the Geometric period the rigid silhouette drawing is loosened, detail is admitted, the lavish and intricate patterns of frieze
16 and panel are subdued. In other parts of Greece local schools had followed Athens' lead, and some evolved styles of some independence and merit. Argos (in the Peloponnese) is prominent, with a range of
17 rustic figure scenes and pattern panels, often ill-composed on the architecture of the vase. Crete and the islands have distinctive styles in Geometric painting, and in some parts of Greece (as the eastern Aegean) such styles died hard. In the next chapter we shall see what replaced the Geometric decoration on pottery, but it is worth remembering that the patterns long remained popular, and that the basic, architectonic, principle of Geometric decoration was never forgotten; indeed it is one of the underlying factors in Greek art of all periods.

28

18 Impression of a Late Geometric stone seal showing a centaur (man-horse) attacked by a bowman, possibly Heracles. Compare the figures drawn on vases, as *Ill. 15*. Width 2·2 cm

OTHER ARTS

The figure style of the Geometric vases reappears on the many other objects, of other materials, which were being made in the eighth century BC. We know about these from the richer gifts which now accompany burials, and from their appearance as offerings in sanctuaries – both the national sanctuaries like Delphi and Olympia which attracted dedications from all over the Greek world and sometimes outside it, and the local shrines.

Figures like the more elaborate painted examples are found incised on the flat catch-plates or bows of safety-pins (*fibulae*) found in Athens and Euboea as early as the ninth century, and made in a more elaborate form in Boeotia towards the end of our period. There are simpler figures impressed on gold bands found on the bodies of the dead, but these succeed a more thoroughgoing Orientalizing type with animal friezes. Another early intimation of the influence of the Near East is the resumption of seal-engraving in Greece. There are ninth-century seals of ivory and in the eighth century stone ones made in the islands, simple square stamps with designs which are wholly Geometric and not Eastern in spirit.

19

18

19 Decorative Bronze safety-pin (*fibula*), its pin missing, of a type made in Boeotia about 700 BC. One side of the catch-plate shows a duel between bowmen above a ship; the other a hero fighting twin warriors. Length 21 cm

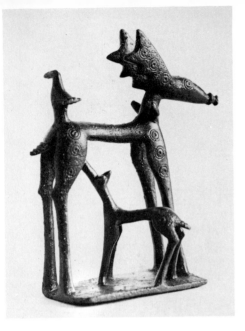

20 (*left*) Bronze group of a deer with a fawn, the bodies decorated with groups of circles. A bird is perched on the deer's rump. Late eighth century B C. Height 7 cm

21 (*right*) Bronze group showing a hunter and his dog attacking a lion, its prey in its mouth. The hunter wears a helmet and is perhaps a hero. The group is from Samos. Late eighth century B C. Height 9 cm

When we come to bronze figures in the round the picture is somewhat different. On the one hand we have some rather stylish figures of horses and stags, which, although they are cast in the round, strongly resemble the cut-out or flat hammered figurines from which they probably derive. Occasionally more elaborate groups are composed of such figures – mares or deer with their young, a centaur-like monster fighting a god. Other bronze figurines, cast solid from an individual mould, are rendered in a much freer, plastic style and reflect the easy modelling of the soft clay or wax from which their moulds were made. Still, their broad shoulders and elongated bodies closely match painted figures on vases. The bronzes are generally of naked men, perhaps intended to represent a god – Zeus at Olympia – and may be equipped with helmet, spear and shield. Rarely we find groups, like the lion-hunt, or action figures, like a helmet-maker squatting at his work, or a charioteer. In the lion-hunt from Samos the artist has given the monster (which he has never seen) elephantine legs, but appropriately massive jaws and shoulders. Many figurines of men and horses were intended as decorative attachments to the rims of bronze cauldrons. These magnificent vessels were valuable offerings standing on slender tripod legs which are at first cast, with simple decorative patterns; and later worked with figure scenes in relief, or hammered and impressed with Geometric patterns. There are comparatively few small bronze vases. The metal was still somewhat

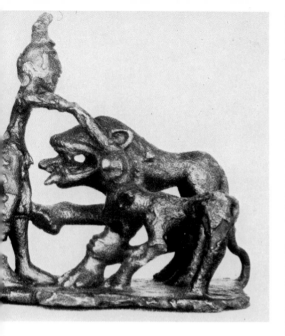

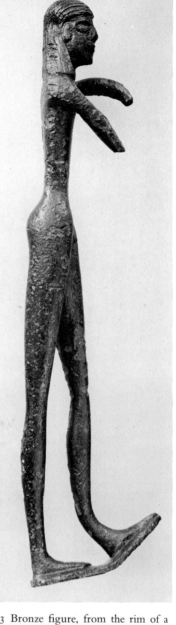

22 (*below*) Bronze warrior from Karditsa in north Greece. His spear is missing but he wears a light shield of *Dipylon* shape at his back; otherwise only a belt and cap-helmet. *c.* 700 B C. Height 28 cm

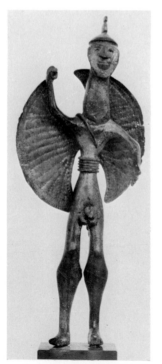

23 Bronze figure, from the rim of a bronze cauldron dedicated at Olympia soon after 700 B C. With a companion he would have supported an upright ring handle. Height 37 cm

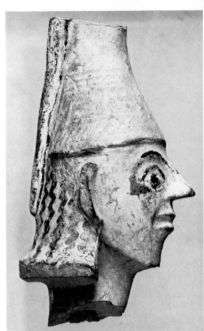

25 Clay head from a temple site, Amyclae, near Sparta. Presumably a warrior, wearing a conical helmet. c. 700 B C. Height 11 cm

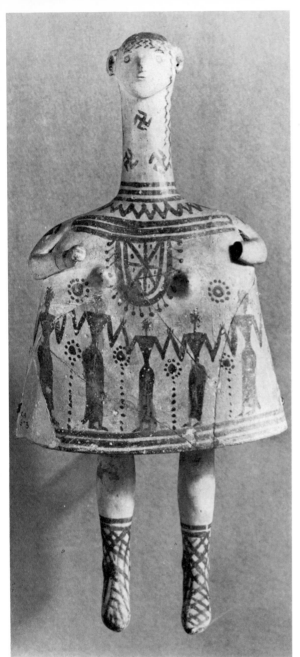

24 Clay figure of a woman. The legs were made separately and suspended inside. The painted decoration resembles that on vases and shows a line of women dancing. Made in Boeotia. c. 700 B C. Height 33 cm

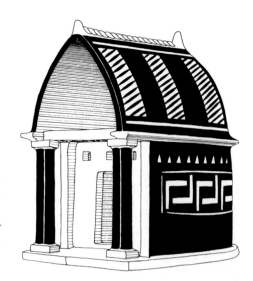

26 Restored clay model of a shrine or house found in a sanctuary at Perachora, and probably made in Corinth. It has an apse and a thatched roof was intended. The painted meander need not represent house decoration but is a motif borrowed from pottery for the model. Late eighth century BC. Height (as restored) 33 cm

scarce, and had to meet a growing demand for dedications and, later, the new types of all-bronze armour.

In clay, apart from the simplest figures which show little sophistication, there are oddities like the bell-shaped idols of Boeotia which were painted up, like vases, and some far more elaborate works in which the features are picked out in paint while the whole heads are careful geometricized studies, far more detailed than the most elaborate of the bronzes.

24

25

Already in the eighth century BC Greece offers an assemblage of arts and techniques which begins to recall the variety of Mycenaean art, even if not the riches of Mycenae itself. Only its architecture remains completely unpretentious, with, at the best, one-roomed houses of mud brick with columned porches, and rare examples of larger complexes which just recall the simplest plans of Mycenaean 'palaces' (as in eighth-century Andros). There are some clay models made in Corinth, Argos and Crete, which give an idea of the upper works of the one-roomed houses: apsidal or rectangular in plan with steep thatched roofs or, in Crete, like a cube with a flat roof, a central chimney and a bench or sleeping-platform at the back.

26

Several features of the Geometric Age are clearly more than a matter of natural, local evolution from Protogeometric. We have speculated already on the debt Geometric art itself owed to the East and remarked other tokens of new influences which invited the artist to exercise new crafts and new forms. His response and the resultant revolution in the physical appearance of the arts in Greece are the subjects for our next chapter.

33

Greece and the Arts of the East and Egypt

Greece is a poor country. Its mineral resources are slight and its farm-land neither extensive nor very fertile. In the eighth century BC the growing population had to look overseas for the materials to satisfy the new appetite, and eventually even for new homes for the families whose own lands had become too small or uncomfortable for them. Already in the ninth century merchant-adventurers from Euboea and the Greek islands had sailed to the eastern shores of the Mediterranean, along routes already well travelled by the Phoenicians. At the mouth of the River Orontes in north Syria (now part of Turkey) they found the natural outlet for the goods and raw materials from the richer valleys of Mesopotamia, one of the earliest seats of civilization. In a small village (the site is known as Al Mina) they established a trading post beside Cypriots, who were also trading there. As time passed the Cypriot and native elements were swamped by the Greek and the town flourished as a staging post for East–West trade for nearly five hundred years, while in near-by Cilicia, and farther down the coast, other Greeks came in smaller groups to live and trade.

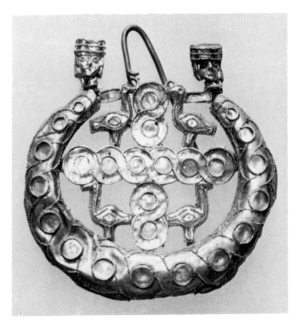

27 Gold crescent pendant from near Knossos, with human heads and four birds attached. The eyes of the cable pattern were once filled with amber paste. Late ninth century BC. Width 5 cm

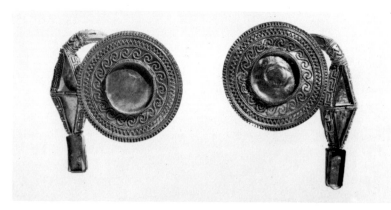

28 Ear-ring pendants of gold, with patterns in wire and granulation, and settings for inlays of glass or amber. Eighth century B C. Diameter 3 cm

At the same time as this enterprise which brought a trickle of Eastern bronzes and jewellery into the Greek world even before 800 B C, there were other arrivals of even greater potential. These were troubled times in the Near East and it seems that it was not only goods but craftsmen that were attracted westwards into Greek lands. In Cretan Knossos it appears that a group of Eastern artists had established a workshop for jewellery and the working of hard stones and decorative *27* bronzes, whose distinctive style can be recognized here and elsewhere in the island for over a century. But although Cretan vase-painters copied their patterns they did not learn their techniques, which died with them. A similar group reached Attica, shorter-lived, while in *28* another part of Crete Eastern bronzesmiths inaugurated an important school best known for the votive shields with animal-head bosses it fashioned for the Idaean Cave. But it is not the immigrants, or at least not those whom we can detect, that had the most profound effect.

BRONZE AND IVORY

The Greeks brought back with them from the East metals, and consumer goods, including works decorated in styles utterly foreign to the conventions of Greek Geometric art. We find especially bronze bowls decorated in low relief with animals and figure scenes, and ivory plaques carved in low relief as fittings to furniture or toilet articles. Several of these have survived on Greek sites, and there is no doubt much, like textiles or embroidery, which has not. All these things had their effect on both the style of Greek artists' work and the range

35

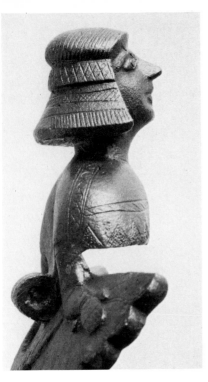

29 Cast-bronze siren attachment for the shoulder of a cauldron, the head facing into the bowl. These were usually fixed in pairs, with an iron ring through the loop at their backs. Early seventh century B C. Width 15 cm

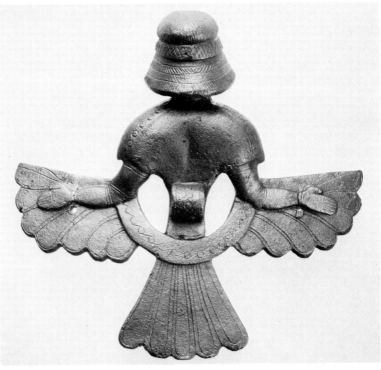

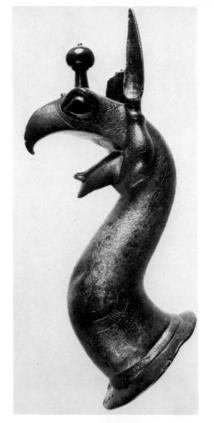

30 Three or six bronze griffin heads of this type were fastened below the rims of many Orientalizing bronze cauldrons. The eyes were inlaid, the scales and curls on the neck incised. Late seventh century B C. Height 36 cm

of their repertory of figures and animals. We can study this most easily in the changes which took place in decorated pottery, but there were other studios, not obviously initiated by immigrant craftsmen but dependent at first on Eastern forms and techniques, soon mastered and translated into what we can recognize as a purely Greek form. Hammered work in bronze is prominent, especially for the griffin heads which project like lugs or handles on the deeper cauldrons of Eastern type which are coming to replace the open tripod cauldrons of Geometric Greece. There are soon several Greek workshops producing these fine decorative attachments, the later examples being cast and not hammered. The motif is Eastern but the treatment is *30* Greek, and Greek artists soon elaborate the monster's high ears, forehead knob, gaping beak and sinuous neck into an entirely new decorative form. The same happened to the solid cast siren attachments for cauldrons, which are quickly naturalized Greek, translating the puffy Eastern features into angular Greek ones. In these, as in all other *29* instances of borrowing or inspiration from the East, the Greek artist

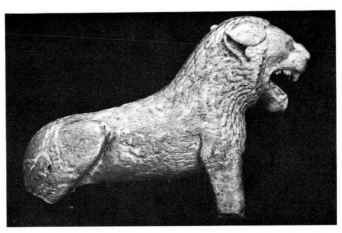

31 An ivory lion from Old Smyrna, of Assyrian type, with folded ear, pointed nose and heavy mane, but probably Greek work. Late seventh century B C. Length 5·5 cm

was discriminate in what he took, and he very soon adapted it according to his own sense of composition or pattern into forms which went far beyond the banal, repetitive designs on the Eastern bronzes or ivories which had prompted them. In this respect the East acted as little more than a catalyst on the development of Greek art, for all the physical changes that it wrought or inspired.

Ivory too was brought from the East. Already in a Geometric grave in Athens we find a group of ivory maidens, naked as the Eastern odalisques or goddesses who inspired them, but slimly built, sharp featured – the Geometric artist's interpretation of an Eastern form. There were various schools of Orientalizing ivory-workshops in Greece. Those in the eastern Greek islands and on the shore of Asia Minor (Ionia), which was an area which the Greeks had settled in the 31 Dark Ages, produced work closer to the Eastern prototypes. This is observed both in the subjects and in the treatment of the human figure – fuller and rounder – a persistent feature of east Greek art. From east Greece (on Samos) also we have a few examples of small wooden figures carved in a manner very like the ivories. Small carvings travelled far in the Greek world: a clear east Greek type of god and 32 lion was found at Delphi, and on Samos the kneeling youth may resemble more closely works of mainland Greece, but is the figure attachment to an instrument of a type which is certainly east Greek. 33 It is still difficult to locate the workshops for many of the ivories of this period. In mainland Greece too the Geometric stone seals were

38

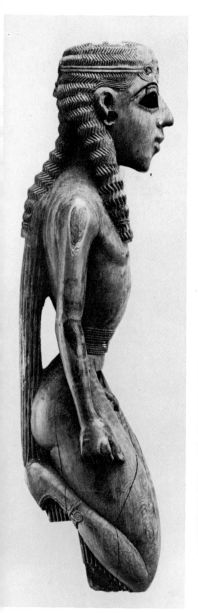

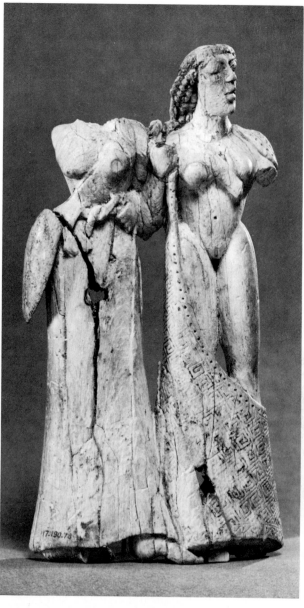

32 (*left*) The kneeling youth in ivory from Samos may be part of the fitting to a lyre. His eyes and pubic hair had been inlaid in other material. The artist has carefully exploited the grain of the ivory. Later seventh century B C. Height 14·5 cm

33 (*right*) The two girls with their clothes slipping from them may be the daughters of Proitos. They had been sent mad by Hera and ranged over the land of Argos attacking wayfarers. Later seventh century B C. The ivory group is 13·5 cm high

being replaced by ivory seals. Some of these took the form of recumbent animals, with the intaglio devices on the base – an Eastern form but a Greek usage. Others – the majority – are discs with simple animal patterns on one or both sides. The wealth of ivory-work in Greece in this century is not to be matched in any later period.

VASE-PAINTING

The most obvious effects of the Orientalizing wave are observed on painted pottery – a field largely ignored by the Easterner but which, as we have already seen, meant much to the Greeks. In Eastern figure drawing and carving the Greeks found an art which was as conventional as their own Geometric, but far more realistic. The strictly profile or frontal were the rule but the masses of the body were more accurately observed, and anatomical detail stylized into more realistic patterns. They also found a variety of floral devices such as Geometric art had shunned, both as the principal subject of a pattern and as subsidiary decoration. These new styles had their effect in different ways in the various pottery-producing centres of Greece.

34 A Protocorinthian perfume-flask (*aryballos*) showing the new technique of outline drawing and the new animal and floral repertory with a stylized Eastern Tree of Life. *c.* 720 B C. Height 6·8 cm

35 A Protocorinthian jug (*olpe*) with friezes of sphinxes and animals, including dogs chasing a hare, in the black-figure technique and the characteristic dot rosettes. Third quarter of the seventh century B C. Height 32 cm

In Corinth, a powerful State guarding the landward approach to the Peloponnese from the north, the Geometric styles of Athens had been copied, as by other Greek States, but the figure scenes were generally avoided and instead we see a fondness for most precise drawing of simple Geometric patterns. This meant that without a strong tradition in figure drawing, like Athens', Corinthian artists were more prepared to accept the new figure styles, and the intricate floral friezes. These they adapted in various ways. The silhouette style of Geometric figure painting was also inadequate when it came to the detailing of eyes, manes and muscles and to showing overlapping figures in vigorous action. The Corinthian painters invented a new technique in which the figures are drawn still in silhouette but details are incised, to show the pale clay beneath in thin clear lines. Red and white paint came to be used also to pick out odd features, like ribs or hair. This new technique we call 'black-figure' and it is practised first on vases called 'Protocorinthian' by archaeologists (to distinguish them from the later Archaic 'Corinthian' series). At its very best the

34

35

41

36 A Protocorinthian perfume-flask (the 'Macmillan *aryballos*') with its neck and mouth moulded as a lion's head. The painted friezes show florals, a fight, horsemen, a hare-hunt and rays – all on a vase barely 7 cm high. Mid seventh century B C.

36 style is miniaturist, and tiny figures barely one inch high are painted – etched, rather – on the small perfume-flasks (*aryballoi*) which seem to have been one of the most important products of Corinth's potters' quarter. Larger figures are rarely attempted. The decoration is set in friezes round the vase, as it had been in the preceding period. Animals are the main subjects (lions, goats, bulls and birds) – but there are some new monsters too, taken from the East – sphinxes, griffins and similar *35* creatures. These, and the lions, had already appeared on some Geometric vases but then their forms had been geometricized by the *15, 16* artists. Now the new conventions are observed; their bodies fill out, jaws gape, tongues loll, ribs and muscles bulge. The background is filled with small dot rosettes or abstract motifs just as on the Geometric vases where massed zigzags were used to fill the gaps which the painter dared not leave empty. The creatures generally pace aimlessly round

42

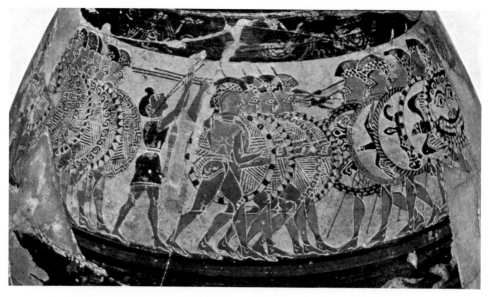

37 A detail from the Protocorinthian 'Chigi vase' in Rome, showing hoplite warriors closing in battle. On the left a piper plays to help the ranks to keep step. There is freer use of colour here (red, browns and white) and on this vase the ordinary animal friezes are suppressed. Mid seventh century BC, by the same painter as of *Ill. 36*. Height of frieze 5 cm

38 Part of a Protoattic clay plaque, dedicated to Athena at Sunium, showing marines on a ship, with a steersman. *c.* 700 BC. Length 16 cm

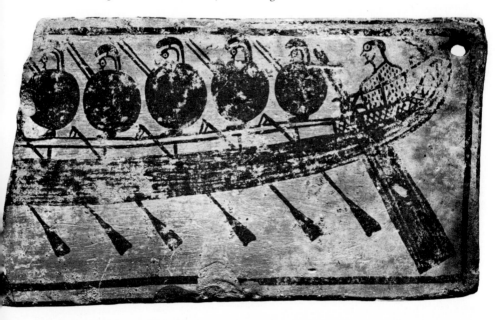

39 The one-eyed giant Polyphemus (Cyclops) is blinded by Odysseus and his com-
panions in his cave, having been reduced to a drunken stupor (notice the cup). From
the neck of a Protoattic grave vase, found at Eleusis. Odysseus is differentiated from
his companions by the colour of his body. There is some incision (as in black-figure)
for the hair, beards and fingers. Mid seventh century B C. Height of frieze c. 42 cm

the vase, but sometimes they are posed heraldically facing each other over a floral, itself a version of the Eastern Tree of Life. There are very few scenes with human figures but towards the middle of the seventh century we find more of the heroic episodes as well as a number of battle scenes showing the latest hoplite tactics with disciplined ranks of bronze-clad soldiers. Floral friezes – the Eastern lotus and bud or *37* palmette – appear on the shoulders of the vases, while below the main frieze there may often be a smaller one with a row of animals or a hare-hunt. At the base upward-pointing rays recall the spiky blossoms which decorate the rounded bases of many Eastern and Egyptian vases.

The Orientalizing vase-painting of Athens presents far less of a break and contrast with what went before than does that of Corinth. The new patterns and subjects are admitted, but more slowly. A black-figure technique is not adopted, and instead the details of figures are rendered by line drawing instead of silhouette for heads, and *38* eventually for whole figures. White paint is sometimes used for details (Corinth at this time preferred red) and even a spot of incision here and there. The figures themselves – even of the Eastern sphinxes and the Greek centaur – are still rendered very much in the Geometric *45* manner with angular features and bodies. The filling ornament is still largely Geometric and the floral patterns are translated into geometrical constructions rather than simply copied as was usual at Corinth.

At first sight these Athenian vases (called 'Protoattic') simply look more primitive and outdated beside the Protocorinthian, and they certainly did not travel so far in the Greek world or have the same influence. But they have significant and important redeeming features. Firstly, the monumental character of the Geometric grave-marking vases is not forgotten. On the new vases the figures sometimes stand over half a metre tall and they present problems of drawing which the miniaturist Protocorinthian painters never had to face. Secondly, the tradition of human figure drawing ensured the continued appearance of narrative or genre scenes as well as the inevitable incursions of *39* Orientalizing animals and monsters. Thirdly, the technique allowed a far more pictorial treatment and balance of the dark and light masses both in the general composition and the individual figures. This is enhanced by the mid seventh century by the use of white paint in the so-called 'black and white style'. It leads naturally to experiments with broad masses of other colours, or colour washes to cover flesh parts or drapery. This attempt at polychromy is something new on Greek vases. It is also short-lived since it presented technical difficulties. In the seventh and early sixth centuries it was exploited less by Athens than

40 by the Greek islands, where vases of a style and technique analogous to the Athenian were being made. In Crete and occasionally in the islands there was a vogue for vases modelled partly as animals or as
44 human heads. The griffin top to the jug from Aegina follows a type
30 more familiar to us in bronzes. The outline style was practised also in parts of the Peloponnese, despite the proximity of Corinth, as at
41 Argos. It may have been emigrant Argive artists who introduced the style to the Greek colonies in Sicily. On some island vases we can
42 follow the outline, polychrome style until well into the sixth century. The simpler outline drawn styles were affected by the east Greek cities, who were even slower to abandon Geometric patterns and figures. In Rhodes and Ionia a decorative animal frieze style (called the 'Wild Goat style' after its most popular beast) is adopted in about the middle of the century. It is unpretentious, but in general effect very different from the styles of mainland Greece and has been thought to owe some-
43 thing to Eastern tapestry patterns. It too survives into the sixth century.

40 A plate from Thasos, probably made in Naxos. Bellerophon, on the winged horse Pegasus, attacks the Chimaera, which has a lion's body, a goat's head in the small of the back and a serpent tail. Mid seventh century B C. Diameter 28 cm

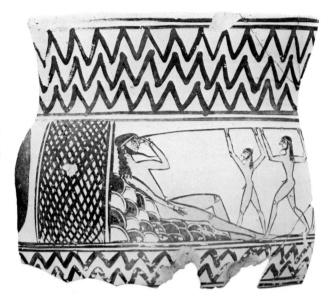

41 Polyphemus and Odysseus, as in *Ill. 39*, but treated in a rather different manner. The fragment is from Argos, from a vase of Argive shape. The drawing is like Attic work and the washes of paint on the human bodies recall island vases. Mid seventh century BC

42 (*below*) The upper part of an island 'Melian' vase. On the neck women watch a duel over armour. From the body we see part of a lyre-playing Apollo with two Muses in a chariot drawn by winged horses. A brown wash is used on the men's flesh. *c.* 630 BC. Height of neck 22 cm

43 A 'Wild Goat' vase, made in Rhodes. The lotus and bud frieze is typical of this class but there is more colour on the animals than usual and no goat frieze. *c.* 580 BC

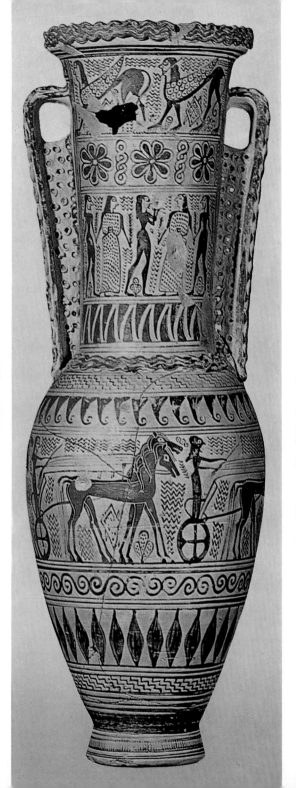

44 The griffin jug from Aegina was painted on one of the Cyclades islands. The lion with its prey is an Eastern motif but the grazing horses go back to the Geometric tradition. Notice the floral attachments to the Geometric triangles at the base. Earlier seventh century B C. Height 39 cm

45 A Protoattic vase with sphinxes (contrast *Ill. 35*), a pipes player with dancers, and chariots. For patterning the Athenian artist used stippling and scales, with outline drawing and a very little incision (the horses). By the Analatos Painter (as also *Ill. 38*). *c.* 690 B C. Height 80 cm

OTHER ARTS

The conventions of Greek Orientalizing art, which we best observe
on the painted vases, determine also the decoration of other objects
and other materials. Besides the painted vases there are large clay jars
with decoration in low relief. These are best known in Crete, Boeotia
and in the Greek islands, and the scenes on them, freely modelled or
impressed, introduce us to some new subjects in the artist's repertory,
including the Trojan Horse. Engaging small vases in the shape of
animals or heads were made as perfume-flasks, and we have already
seen the necks of vases moulded as griffins' or lions' heads. Clay and
bronze figurines reflect the styles of larger works in stone, and painted
clay revetments begin to appear, to protect the wooden parts of
buildings, or as decoration on temples and altars. Sheet-bronze is often

46

49

46 The neck of a clay relief vase found in Mykonos in 1961. The Trojan Horse,
on wheels. The Greeks within it are shown, as through windows out of which they
hold their weapons and armour. Others have 'dismounted' already. Later seventh
century B C

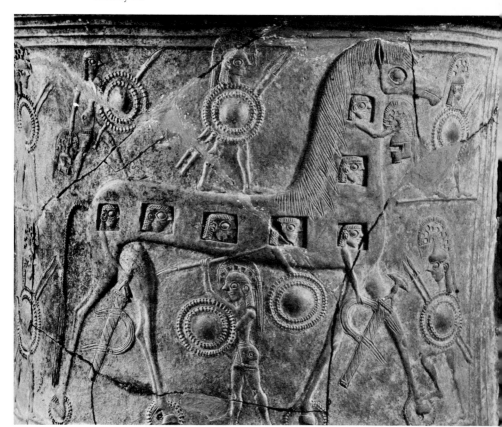

47 Cut-out bronze plaque, decorated in very low relief with incised details, from Crete, and of a type peculiar to Crete. It shows two huntsmen, one with a wild goat (ibex) on his shoulders. Third quarter of the seventh century B C. Height 18 cm

used for the sheathing of parts of furniture or weapons. On it we find
the early technique of hammering with beaten details, for floral or
figure scenes. A different technique involves incision of detail lines and
47 appears at its best on the decorative cut-out plaques made in Crete
and a number of shield blazons found at Olympia. One offers a
characteristic Greek treatment of an Eastern monster, tamed and
48 domesticated: a mother griffin suckling her young.

The stone seals which were being cut at the end of the Geometric
period were replaced in the Peloponnese by ivory. In the islands, how-
ever, an unexpected source inspired an important new school of
stone-seal engravers. Fine Mycenaean and Minoan seals found in
plundered tombs or in fields were studied by artists on Melos, who
copied the shapes of the stones and, as soon as they had mastered the
technique, some of the distinctive motifs. For the most part, however,
they used the Orientalizing animal and monster devices which we see

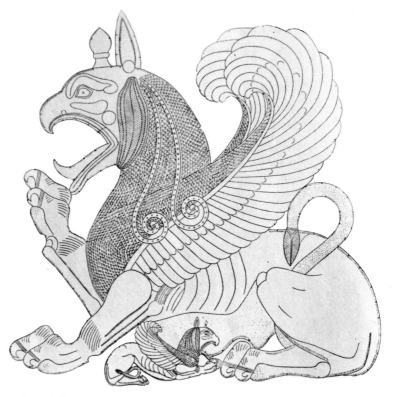

48 Cut-out bronze plaque from Olympia with incised details showing a mother
griffin with her young. This was probably the blazon of a wooden shield. Late
seventh century B C. Height 77 cm

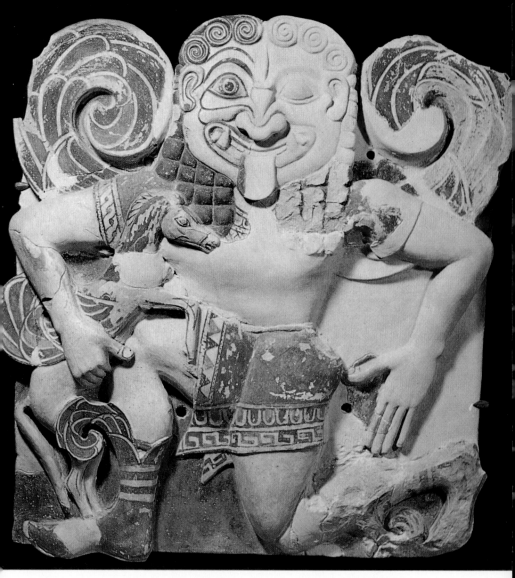

49 The monstrous Gorgon with her child, the winged horse Pegasus, is the subject of this clay relief which may have decorated the end or side of an altar at Syracuse. Her kneeling posture is the Archaic convention for running or flying. Later seventh century B C. Height 55 cm

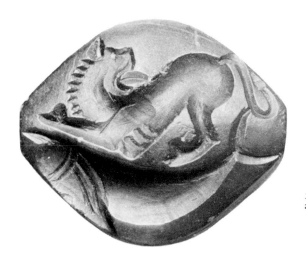

50 An Island Gem showing a lion and dolphin. *c.* 600 B C. Length 2·2 cm

50 on island vases. These 'Island Gems' – they were once mistaken for prehistoric stones – provide a continuous tradition of engraving until well into the sixth century, when a new source introduces new shapes and initiates a more fruitful tradition. In the islands again, and east Greece, goldsmiths exploit to the full their newly mastered techniques *51* in some of the finest decorative jewellery we have from antiquity.

SCULPTURE

Of larger works of art in this early period we know very little. Wall-paintings there may have been, but we can only guess about them from their hypothetical influence upon vase-painting (the influence more likely passed the other way). Wooden sculpture there must have been and there are literary references to early cult statues of wood (*xoana*), but they were probably very primitive in appearance, and nothing wooden has been preserved except for a few statuettes from the waterlogged temple site on Samos. The hammered bronze sheathing of wooden statuettes at Dreros, in Crete, shows forms akin to other early Orientalizing hammered work in bronze and gold, of eighth-century date.

Soft limestone can be carved almost as easily as wood, and there are stray examples of relief work in an early Orientalizing style, again from Crete. One of the new techniques introduced from the East had been the use of the mould for clay plaques and figures. This means of mass production helped to canonize and stereotype proportions for figures and, especially, the features of a facing head. The type is close

54

to that of the Eastern naked goddess (Astarte) plaques, some of which reached the Greek world and were copied there, although the whole figure of the goddess was soon given clothes and called Aphrodite. But the face is still thoroughly Greek, alert and angular unlike the podgy Easterner. The type – it is called 'Dedalic' – is most commonly met on the mould-made clay figures and plaques, but it is found also on other objects – bronzes, ivories, gold jewellery, stone lamps – and, *51, 54* more important, it is used for limestone statuettes. These are either independent figures, or they appear in the round, standing or seated, *52* as the sculptural embellishment of temple buildings (as later at Prinias, in Crete) which at about this time began to attract such decoration.

This is the fashion after the mid seventh century, but even the largest examples of figures carved in the Dedalic style are little more than decorative statuettes, until a new influence promotes a new scale. The monumental quality which we look for in Greek sculpture needed a more lively source of inspiration than anything the Near East could offer – and it was found in Egypt. Greek mercenaries had been allowed to settle in the Nile Delta after the mid seventh century and a trading town was soon established by the east Greeks and Aeginetans at Naucratis. This brought Greeks and Greek artists into close contact with Egypt for the first time since the Bronze Age. They

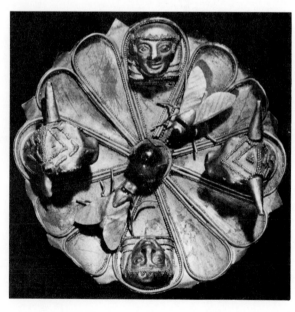

51 A gold roundel. On the petals are pairs of golden flies, human (Dedalic) heads and bulls' heads. Probably made in one of the Greek islands (?Melos) in the second half of the seventh century B C. Width 4 cm

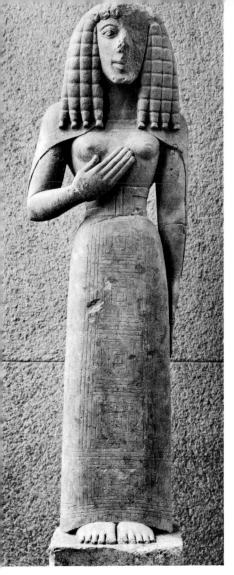

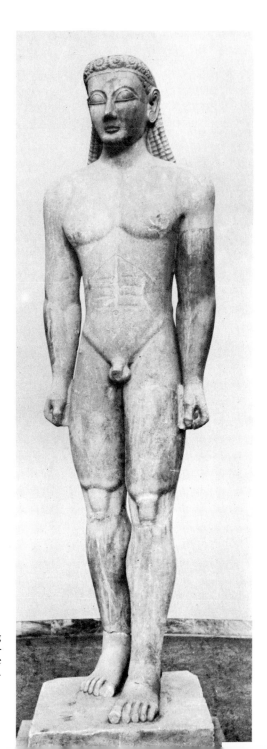

52 Limestone statuette (the 'Auxerre goddess') of typical Dedalic type, with the usual wig-like hair. The incised lines on the dress outlined the areas of different colours picking out the pattern. The shawl, covering both shoulders, is a Cretan garment. *c.* 630 BC. Height 62 cm

53 Marble *kouros* (part of the face, including the nose, the left arm and leg restored) dedicated to Poseidon at Sunium in Attica. The marble is from one of the Greek islands. *c.* 590–580 BC. Height *c.* 3 m

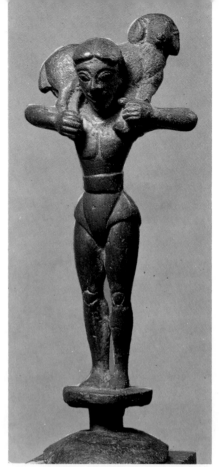

54 Bronze statuette of a man carrying a ram on his shoulders, from Crete. The head is Dedalic, the dress Cretan. Later seventh century B C. Height 18 cm

were impressed by what was least familiar to them – the massive stone statuary and architecture, and it was from this inspiration that the beginnings of Greek monumental sculpture and architecture stem. They had to face the challenge of both size and material, for the Egyptian figures were often of the hardest stones – porphyry and granite. The Greeks looked to the fine white marble which could be so easily quarried on their islands, and which could be worked with iron tools and the emery which these same islands (notably Naxos) could supply. The style of the new figures – of white marble and life-size or more – is still Dedalic, for these were the only conventions for statuary which the Greek artists could at that time employ in statues of women. We have early marble examples from Samos and Delos (the dedication of Nikandre), and some, including seated figures, in the softer stone but at the new scale. There is little more in the way of

statuary of women for at least a generation, but for some small marble goddesses with lions who support water-basins (*perirrhanteria*) and are probably Peloponnesian in origin and inspiration. The males too at first follow the Dedalic conventions for the head, but the body is shown naked (but for a belt), long-limbed, one foot set just before the other in a pose which lent stability, and had been used before in bronze statuettes. It owes nothing to the stiff Egyptian figures which appear rooted to the ground. The earliest of these statues of youths – *kouroi* – are from the islands and there is a distinguished group from Attica from about 600 B C. At this early date the anatomical detail is translated into pure pattern – ears, knee-caps, ribs – not related organically to the body, which is itself foursquare, perceptibly imprisoned still in the rectangular block on which its outlines had been drawn and from which it had been painstakingly chipped.

Monumental stone architecture in Greece owned the same source of inspiration as the sculpture – Egypt. The effect was felt at about the same time, but the development was slower and is best discussed in the next chapter. It must be mentioned here because these two phenomena mark an important stage in the progress of Greek art: the establishment of new crafts in which the Greek artist was to find his most fully satisfying media of expression.

The motley of seventh-century Greek art is as confusing as it is brilliant. Local schools flourish and propagate individual new styles. New techniques are learnt, and often improved upon. The Greek artist took note of the exotic and grandiose works of those older civilizations with which his world had now regained contact. He borrowed and adapted as he thought fit, imposing his native sense of pattern and standards of precision on the stereotyped forms of the foreigners' arts. Because of the paramount importance of Greek art in later centuries we tend sometimes to assume that it had always been so independent, and always the teacher rather than the taught. It is well to remember how little this is true of some of the most important formative years. It is equally important to remember the strength of the tradition which had its beginnings far earlier than the arrival of new ideas from overseas, and was able to translate these new ideas into forms in which we recognize the origins of Classical art.

Archaic Greek Art

The sixth century sees the consolidation of the prosperity of the States of mainland Greece with the rule of benevolent tyrants (or at least not 'tyrannical' in our sense of the word) giving place already in some cities to democratic constitutions. The city-states remain independent of each other, and often at war, but there was a growing sense of nationality, of the difference between the Greeks and the rest – the barbarians. The new prosperity went hand-in-hand with vigorous trading round the shores of the Mediterranean, and the rapid growth of the colonies – in Sicily, Italy and on the shores of the Black Sea – which had been founded in past generations to ease problems of land at home. One result of all this was that the Greeks made some enemies overseas as a nation (although there were always a few fellow travellers) and not simply as individual States. In the west there were the Carthaginians and the Etruscans, their rivals and customers in trade, and in the east the new Empire of Persia. In the early fifth century they had to face these enemies with force of arms. They survived the encounters and made sure that for a while at least their troubles would be with their fellows rather than with foreigners. In the century or more leading up to this the arts of the Greek world and its different schools also moved closer to a common style, usually under the influence of the dominant cities in each craft – Athens for pottery, the Peloponnesian cities for bronze-work. Regional differences are still readily perceptible, however, and one of the features of sixth-century art is the contribution made by east Greek artists working away from home, many no doubt as refugees from the Persians.

The new arts of monumental architecture and sculpture present the most striking monuments of this, as of succeeding centuries; indeed the sheer size of some building projects in the east Greek cities remained unrivalled until after the Classical period.

ARCHITECTURE

The architectural achievements of the Egyptians had made a rather different effect on the Greeks from that of their sculpture. Hitherto the Greeks had been used to fairly simple brick or stone structures

59

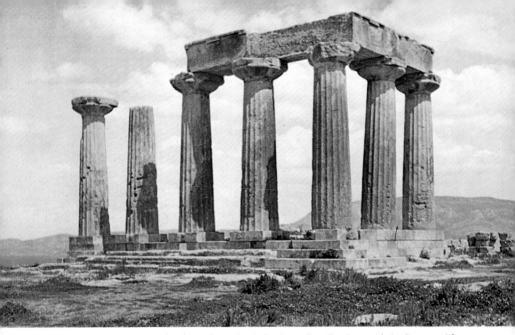

55 The Temple of Apollo at Corinth; the earliest Doric temple in Greece with some of its monolithic columns still standing. Mid sixth century B C

with no decorative elaboration beyond the occasional use of a sculptural frieze on walls, in the Eastern manner. In Egypt they saw massive stone architecture and stone columns with carved capitals and bases.

In Greece already at least one temple (on Samos) had been given an encircling colonnade in the seventh century and the Greeks were not slow to take the hint about the elaboration of this feature which was to prove such an integral element in their architecture. In origin it perhaps did no more than distinguish the building as a house of the god and to provide a covered ambulatory round the walls of the one-roomed *cella* which held the cult statue. The Eastern contribution was in the patterns of stone bases and furniture, copied by Ionian architects, and in the rare use of figures in the place of columns in temple porches.

The beginnings of the major stone orders of architecture in Greece can be traced back to the seventh century. In mainland Greece the Doric order was evolved, with simple columns, reminiscent of both Mycenaean and Egyptian types, having cushion capitals, fluted shafts 55 and no bases. The upper works were divided rhythmically into a frieze of triglyphs (the vertical bands) and metopes (often sculptured)

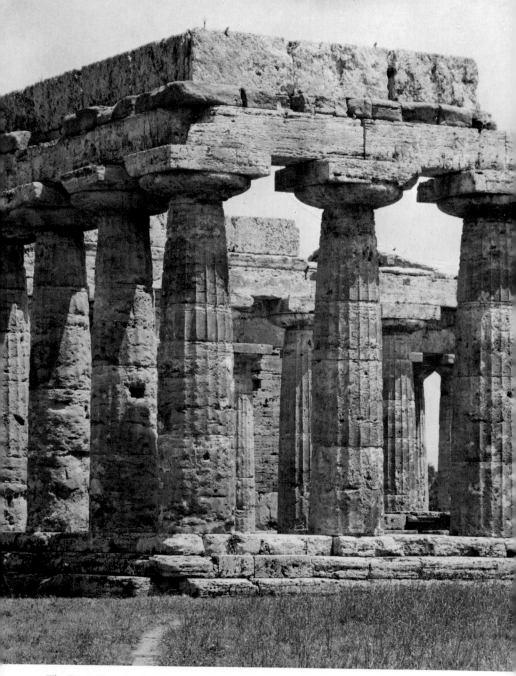

56 The Doric Temple of Hera (the so-called 'Basilica') at Paestum. A good example of the early cigar-shaped columns with bulging capitals. Mid sixth century B C

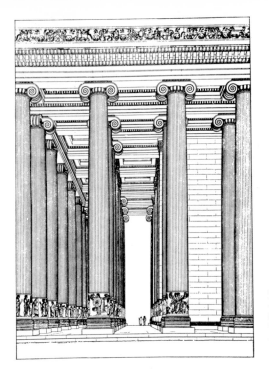

57 A restoration (by F. Krischen) of the side front of the Temple of Artemis at Ephesus. Designed in the 540s, completed a century later. It has been suggested that the reliefs should go to the tops of the columns

which were a free adaptation of the woodwork in these parts of earlier buildings. This was the style popular in the western Greek colonies also. In east Greece and the islands the other major order of stone architecture, the Ionic, borrowed its decorative forms from the repertory of Orientalizing art, with volutes and florals which in the Near East had never graced anything larger than wooden or bronze furniture, or – like the volute capitals of Phoenicia – had never formed an element of any true architectural order. The first capitals (known at Smyrna and Phocaea) are bell-shaped with floral patterns in relief upon them. They are followed by the 'Aeolic' capitals, with the volutes springing from the shafts, which give way to the broader Ionic, with the volutes eventually linked. The shafts have more flutes than the Doric, with, in time, flat ridges between them. There are bases too – swelling *tori* and discs, elaborately fluted like carefully turned wooden furniture. Some of the earliest Ionic columns served as bases for votive statues, like the sphinx dedications made by Naxians at Delphi and on Delos. On Ionic buildings the upper works over the colonnades are simpler than the Doric, but an important feature is the running frieze, which is sometimes carved with figures. Altogether there is much more variety in the Ionic order, with much more superficial ornament and decoration. It seems ornate and fussy

62

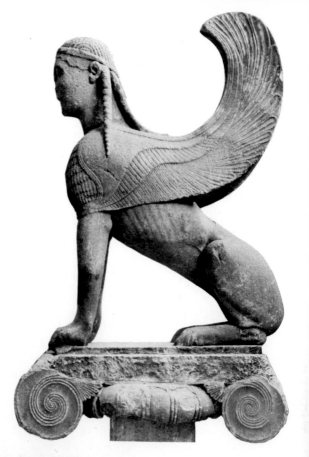

58 The Naxian sphinx at Delphi. Columns often support dedications in the Archaic period. This shows one of the earliest Ionic capitals, with wide-set concave volutes, which were probably separated in the centre by a floral (now missing). *c.* 560 B C. Height of sphinx 2·25 m

59 (*below*) Column capital from the unfinished Temple of Athena at Old Smyrna, overthrown by the Lydians *c.* 600 B C. Carved with leaf patterns which appear still between the volutes of later Ionic capitals

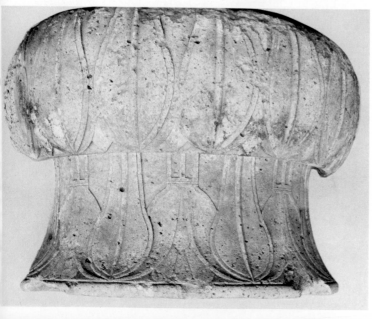

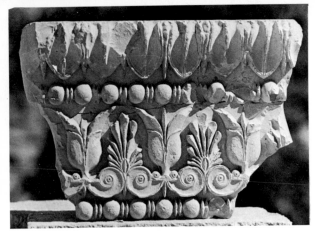

60 Carved frieze of leaves, bead and reel and lotus and palmette from an Archaic treasury at Delphi. Late sixth century BC

beside the Doric, and the contrast was one happily exploited by architects of the Classical period, as we shall see.

The orders were applied to the exteriors of temples, which retained their simple plan, of porch and hall (*cella*), but were now regularly surrounded by a colonnade. Smaller structures, the pavilions or treasuries set up by individual States at the national sanctuaries, have columns at the front only and on Ionic treasuries at Delphi we find statues of girls replacing the columns in the porch. The largest buildings, on the other hand, might double the rows of columns at the sides and even treble those at the front (as at Samos and Ephesus). Inside the *cella* more columns helped to support the roof at first axially down the centre, then in two rows to provide a nave-like approach to the cult statue. Altars stood outside the front door of the temple, normally in the east, and were either simple rectangular blocks with carved upper parts, or, in east Greece, monumental structures with broad flights of steps leading up to the sacrificial platform. Where wood was still used on the exterior of temples it was protected by painted clay revetments, but generally walls are all stone now, of precisely jointed rectangular ashlars, or, for some house and terrace walls, of polygonal blocks, sometimes with curved edges (the so-called 'Lesbian') which are no less precisely fitted. Ionic buildings especially were decorated with elaborately carved mouldings round doors, along the tops of walls, on gutters and over the columns, sometimes even on the columns. Similar floral and volute mouldings are repeated in many minor works of bronze or clay, and in painting, and they are successors to the Orientalizing florals and subsidiary ornaments. The sculptural decoration of temples will be discussed later in this chapter.

We have of necessity so far spoken only of temples. It was for these houses of the gods that the elaboration of the stone orders was reserved

60

64

at first, and not for private houses, which probably boasted little more than painted wooden exteriors. The colonnade shelters (*stoai*) and entrance gates to sanctuaries were also treated in the grand manner, but only in the succeeding period do public buildings, law courts and theatres, regularly attract this attention.

SCULPTURE

Of the statuary in the round the *kouros* figures of naked youths, with their set, symmetrical stance, hands clenched at the sides, one foot advanced, remain unchanged in pose throughout our period, and so serve as a useful standard on which to observe the advances in technique and treatment which appear in different ways on other figures.

The *kouroi* were long known as 'Apollos', but few can represent that or any other deity; most are dedicated as attendants to a god, while others stand as memorials – not portraits – over graves. Through the sixth century we can observe that a growing confidence in the

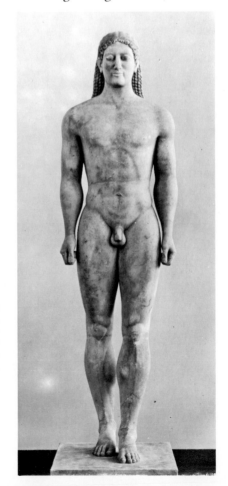

61 Marble *kouros* from a cemetery in the countryside of Attica (Anavysos). On the base was inscribed the verse – 'Stop and grieve at the tomb of the dead Kroisos, slain by wild Ares in the front rank of battle.' *c.* 530 BC. Life-size

carving of marble, and the development of better tools (such as the claw-chisel), lead to the disappearance of the block-like character of the earliest in the series. Anatomical details become more realistically treated and are better related to the mass and structure of the body. The Archaic smile, which came into fashion in the second quarter of the century, is relaxed into a straighter, sometimes sulky expression. The convention had given an impression of strained cheerfulness which the artist may have appreciated, but which was usually quite alien to what we expect of Greek funerary or votive art, and which cannot fairly be added to the few instances of emotion expressed in the features of Archaic statues. The figures are seldom now more than life-size, and this, together with the improved techniques, contributes to the impressive advance in realism which is achieved within the rigid convention of the pose. The body and its parts are still treated as pattern compositions by the artist, and this approach, which persists into the Classical period, is in no way impaired by the closer approximation to nature. We are obviously still far from the stage at which the artist draws or models directly and consciously from nature, but the symbols and patterns by which he expresses familiar living forms show a greater awareness of physical appearances, although not yet of anatomical function.

There are other free-standing statues of men which do not observe the *kouros* pose: from the Acropolis at Athens comes the famous calf-bearer and a series of horsemen. One of these is the 'Rampin horseman'. In the head we observe the Archaic smile; the exquisitely precise carving of the marble in curving planes meeting in sharp ridges which would have been picked out even more dramatically in brilliant sunshine; and the meticulous and heavy treatment of the curls and locks of this young Athenian cavalier dandy, whose oak wreath tells of his success in the games. Here too the strict frontality of the *kouroi* is relaxed. The head is inclined down and to one side, towards the spectator who would be passing across the front of the horse.

We have seen the way in which the artist treated the male body almost as an exercise in pattern and composition. In a country and society in which the fair sex was not seen in public as much undressed as it is today, it is not wholly surprising that female figure studies were not common in statuary until command of technique allowed a successful suggestion of the more sensuous qualities. In vase-painting it is otherwise, as we shall see. To the Archaic sculptor, however, women were little more than clothes-hangers. Faces are rarely any prettier or more appealing than those of the men, the hair not always more ornate. Patterns of folds, heavy and straight, fanning out across the body, or gathering into a zigzag hemline, exercised the sculptor's

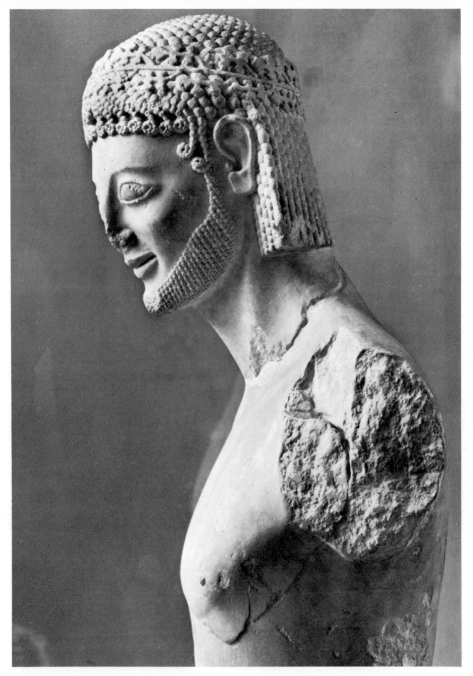

62 The 'Rampin horseman', a dedication on the Acropolis at Athens. The head was removed from Athens before the excavations which yielded the body and is still in the Louvre. Possibly by the same artist as *Ill. 68*. Mid sixth century B C

imagination and taste for variety of pattern. Breasts are admitted to exist, but not much admired. On later *korai* (maidens) the material is drawn tightly round the legs to show them and the buttocks as though bare, but the gesture and motif was one designed at first simply to offer a pattern of diagonal folds across the lower half of the figure. One early *kore* from Attica is, as a statue of a woman, gaunt and clumsy, redeemed only by the bold carving and simple drapery. The outer garment is the heavy *peplos*. This is the dress of what is perhaps the finest of the ladies from Athens, the '*peplos kore*', but it was not a garment which fully satisfied the Archaic artist's love of pattern. A new fashion and a new sculptural treatment of drapery arrived together from overseas. At this time in east Greece sculptors were experimenting with ways of diversifying the surface of the carved

63

68

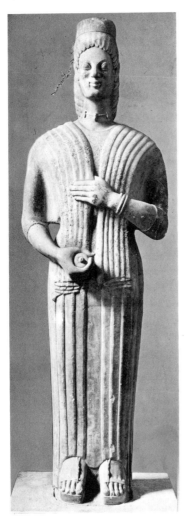

63 The 'Berlin goddess', from the countryside of Attica (Keratea). She is holding a pomegranate and wearing a *polos* head-dress. *c.* 570–560 BC. Height 1·9 m

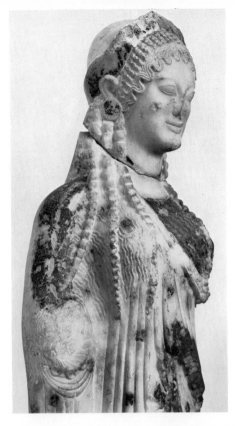

64 A *kore* from the Athenian
Acropolis, certainly the work of
an Ionian artist, probably a Chian.
She wears a *chiton* and *himation*.
The *chiton* was blue, and red and
blue were used in the patterns on
her dress, ear-rings and necklet.
c. 525 B C

drapery, suggesting the folds by incised wavy lines or close-set,
shallowly carved grooves. The lighter and more voluminous *chiton*,
which Athenian *korai* had worn as an undershift, lent itself more to
this sort of treatment, offering full sleeves and skirts which could be
gathered into a multiplicity of folds. These were further varied by
drawing aside the skirt, in the manner which was later to show off the
legs, by slinging the *himation* or cloak diagonally across the upper body
to answer the folds across the legs, and by painting the elaborate
patterns of embroidered hems. These new '*chiton korai*' have their 65
effect on the series known to us from the finds on the Athenian
Acropolis from about the mid sixth century on, and there is evidence
from signed bases and the style of some pieces that east Greek artists
(like Archermos of Chios) were in fact at work in the city. Under the 64
influence of these men (mainly Ionians and islanders) some of the *kore*
heads even begin to look feminine. Towards the end of the Archaic
period more attention is paid to the form of the body beneath the
drapery and the features change as did those of the *kouroi*.

69

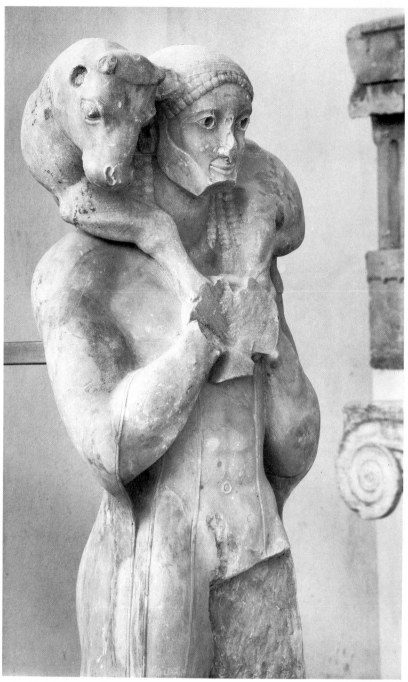

65 Marble figure of a man carrying a calf, the dedication of one [Rh]ombos on the Athenian Acropolis. Compare the motif of *Ill.* 54. About life-size

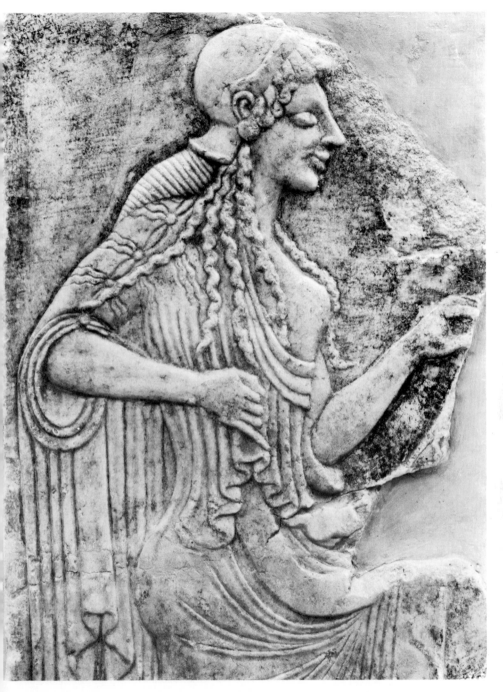

66 Part of a marble votive relief from the Athenian Acropolis, showing Athena, posed as a *kore*, but with a helmet (its crest is painted on the background). The rest of the relief shows a family of worshippers standing before her. *c.* 490 BC.

All these statues in the round are very much 'set-pieces', offering no variety of pose. For more ambitious sculptural compositions we have to look for work in relief, especially on buildings. The arts of sculpture and architecture in Greece were inspired by the same source and always went hand-in-hand. The architecture was never simply the vehicle for the sculptor, nor was the sculpture merely decoration: its position enhanced and helped to articulate parts of the building and its themes added something to the sanctity of the temple. On Doric buildings the sculptor filled the rectangular metopes with individual groups of two or more figures. Fights are a natural choice but pursuits are found too, and occasionally the action is carried across from one metope to the next. Series of metopes may be linked by a theme – like the Argonauts' story on the Sicyonian building at Delphi, or the

67 A metope from a Sicyonian building at Delphi. Castor and Polydeuces, Idas and Lynceus, stole cattle in the course of the Argonaut expedition. Heroes and cattle march in step, the beasts held in by the spears. Names were painted on the background. *c.* 560 B C

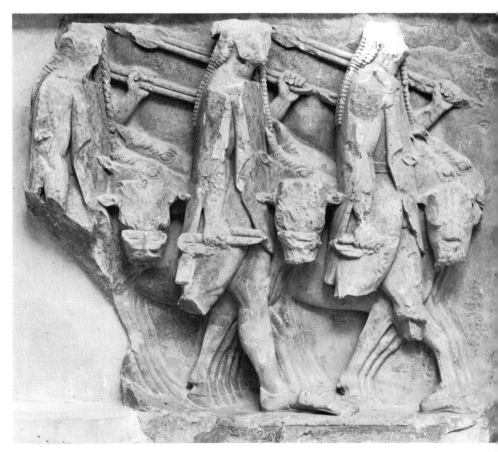

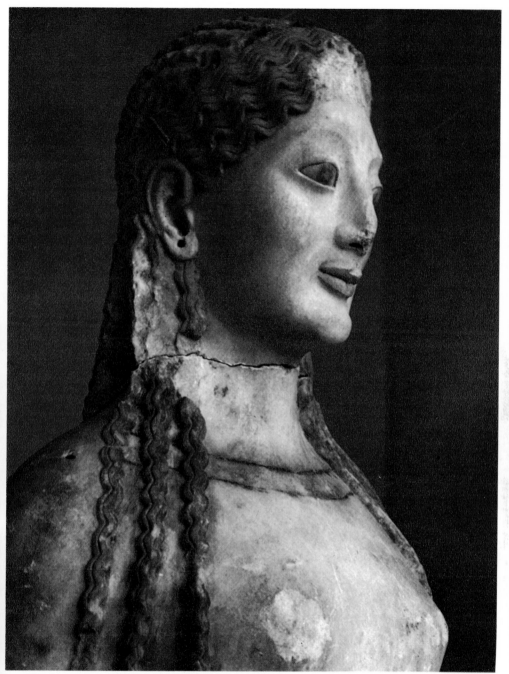

68 The 'peplos kore' from the Athenian Acropolis. A bronze wreath and ear-rings
had been added separately. Her hair and lips are painted red; lashes and brows black;
and the patterns on her dress green. c. 530 BC

deeds of Theseus and Herakles on the Athenian Treasury at the same sanctuary. Some of the early metope compositions are the most bold, with frontal views of horsemen, the proud march of the heroes turned cattle-rustlers, and the duels of men, or man and monster.

67

The low triangles at the ends of gabled roofs – pediments – offered an awkward field. At first it is filled by a massive central figure, flanked by other figures or groups at different scales, out towards the corners which were conveniently filled by prostrate bodies. Sometimes a single theme or story occupies the composition, but the diminishing scale away from the centre does not make for unity, and in some instances looks rather ridiculous. Fish- or snake-tailed monsters were favourites for corners, like the entwined heroes or demons with snake tails from Athena's Temple on the Acropolis at Athens. These, like many such early architectural sculptures, are carved in limestone, which is, if necessary, covered with a coat of stucco to provide a smooth surface, and is brilliantly painted. The backgrounds were painted deep blue or red to help the lighter figures stand out from the shadows of the gables. By the end of the Archaic period unity of scale is observed for all the figures in the pediment, except the central divinity, and

73

69 A warrior from the pediment of the Temple of Aphaea, Aegina. The statues from Aegina were much restored and worked over by the sculptor Thorwaldsen before exhibition in Munich, where they have recently been cleaned and mounted in a new display. *c.* 500 BC

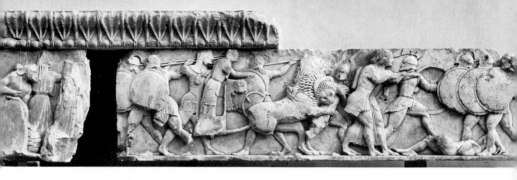

70 From the north frieze of the Siphnian Treasury at Delphi. Battle of Gods and Giants. The Gods fight from the left (the usual Greek convention for victors). We see one in an animal skin (Herakles or Dionysus) and Cybele in her chariot drawn by lions, one of whom also joins the fight. Hephaistos plies bellows heating coals to throw, at the left, and to the right Apollo and Artemis stride forward together. *c.* 525 BC. Height of frieze 63 cm

battle scenes were found (at Aegina and Athens) to provide the sort of stooping, falling or recumbent figures to fill the awkward frames.

69

The sculptures on Ionic buildings are applied according to less rigid rules – or rather, individual and local tastes were given free expression. Of the massive Temple of Artemis at Ephesus we have only scraps of relief figures which decorated drums of the columns and friezes from the gutter and, perhaps, the *cella* wall. A better example *57* of Ionic architectural sculpture is afforded by the Treasury dedicated by the islanders of Siphnos at Delphi in about 525 BC. Here the porch columns are replaced by *korai*; there are rich floral carvings (similar to *Ill. 60*) round the door and at the gutter, and figure friezes run on all sides just below the roof. They offer very different answers to the problem of composing a narrative frieze; and the hands of two artists of strongly differing temperament can be detected (east and north by one; west and south by the other). On the north there is the battle of gods and giants, surging across the frieze in such a way as to obscure *70* the divisions between individual duels and encounters; on the west there is the tripartite treatment of the Judgment of Paris, each goddess with her chariot, in which the story is conveyed by telling details of gesture; on the east a Trojan episode, where on one half we see the gods sitting in council on Olympus, on the other a duel of heroes on the Trojan plain; on the south a fragmentary processional which may include the Rape of the Daughters of Leucippus by the Dioscuri.

Finally, there are the acroteria which appear on both Doric and Ionic buildings – figures in the round at gable corners and crown, generally of monsters, sphinxes, griffins or gorgons.

The sculpture on these buildings is almost in the round, wholly so in later periods, but the poses and groups shown are far more ambitious

75

71 (*left*) Gravestone of Aristion, signed by the artist Aristocles. The background was painted red. There are traces of red and blue on the figure and the patterns on the corselet show up where the surface has weathered differently. *c.* 510 B C. Height without base 2·4 m

72 (*below*) Marble sphinx from the top of a gravestone. From a cemetery in the countryside of Attica (at Spata). She wears a *polos* (compare *Ill. 63*). *c.* 550 B C. Height 46 cm

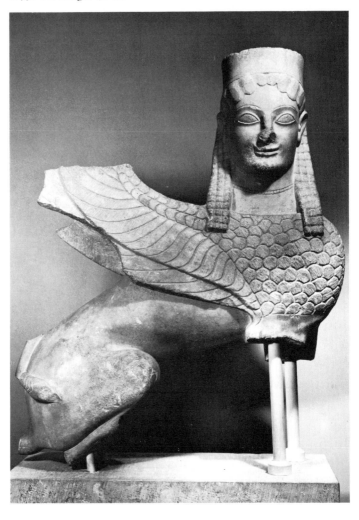

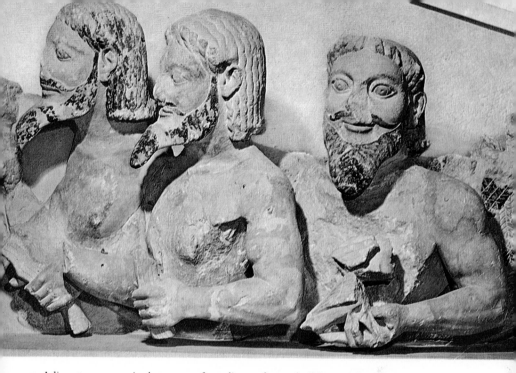

73 A limestone group in the corner of a pediment from a building on the Athenian Acropolis. The three male torsos, winged and with entwined serpentine bodies, have been variously interpreted. They hold symbols – water, corn, a bird. Hair and beards are blue, eyes black, skin yellow; and there is black and red on the feathers and scaly stripes. *c.* 550–540 B C. Height of foremost bearded figure 71 cm

than any for free-standing statuary in this period. We have rather to compare the figure drawing on vases, and in fact all Archaic relief sculpture is readily explained in terms of the line drawing on the uncut block, from which the sculpture started. Where the relief was shallow it meant that all the detail was brought to the front plane, even though the figures were shown as overlapping. Only on the very high relief of some metopes and pediments, where the figures are mainly or wholly detached from the background, do we have works carved properly in the round, allowing intelligible three-quarter views. But the compositions remain the same, uninhibited by the greater difficulties presented by the carving.

Shallow relief, picked out in colour, was used for another class of monuments – gravestones. We know best those of Athens. At the start of the sixth century the gravestones were tall shafts (*stelai*) topped

72 by sphinxes, but soon the shaft was carved in relief with a representa-
tion of the dead. Youths are shown as athletes, shouldering a discus
71 or holding their oil-bottles, men as warriors: all in an upright stance,
like profile views of the *kouroi* they so much resemble in the detail of
their carving. A youth is once shown with his young sister, another
fragmentary stone has a mother holding her child, but it is rare that
the tall thin shafts carry more than one figure. These reliefs represent
the dead without being real portraits (*kouroi* too could serve as grave-
markers, as did also some *korai* in east Greece). The distinctions between
adolescence, youth and middle age are observed and what might be
called generalized portraiture is seen in the puffy features of a boxer.

 After about 530 the sphinxes on gravestones had been replaced by
simpler palmette finials. This is another example of east Greek
influence in Athens, for the type had been known in Ionia for a
generation already, although the shafts there were not normally
carved. The type with the slim tall shaft was abandoned in Athens
116 before the Persian Wars, but persisted in the islands.

 Reliefs appear on other monuments as well. Statue and *stele* bases
may be so decorated. Several of these have been found in Athens'
74 main cemetery, carved with scenes of athletes or young men taking
66 their ease. They also served as votive offerings in sanctuaries. These
votive reliefs may be carved with representations of the deity, or of
an act of worship in which the dedicator may be thought to figure
among the worshippers. Some show the dedicator alone, like the
potter reliefs from the Athenian Acropolis. The best of these reliefs
were set in the rock or stood upon pillars. Indeed, apart from the
temple itself, the greater part of the decoration of a Greek sanctuary
was made up of private dedications set in positions of honour or

74 Relief from a statue base, which had been built into Athens' walls just after the
Persian Wars. It shows athletes training: a runner in the usual starting position with
one foot only a little advanced; wrestlers grappling; and a youth testing the point
of his javelin. Late sixth century B C. Length 82 cm

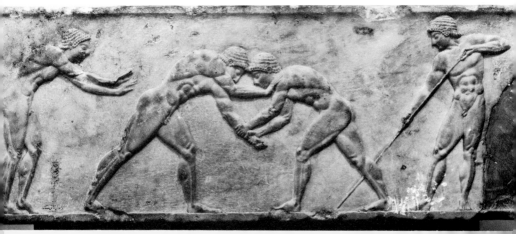

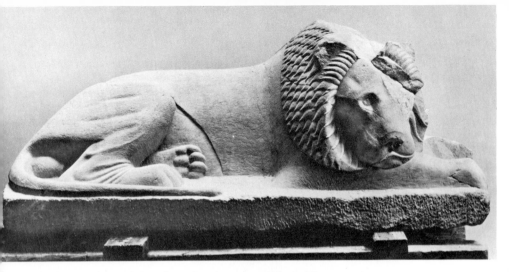

75 A recumbent marble lion from the cemetery at Miletus. Lions served as grave-markers from the late seventh century on in various parts of the Greek world. Sixth century B C. Life-size

obscurity according to their size or merit, or to the relative importance and popularity of the dedicator. A special class of votive is formed by the figures of lions (Delos) or seated figures (Didyma) which flanked processional ways in the Egyptian manner. Lions too could serve as tomb-markers, and, as a change from the threatening Eastern type, the more domestic Egyptian beast is copied by some east Greek artists, with fine regard for the quality of heavy pelt and pattern of mane. It is easy to forget how good Greek artists can be at animals. 75 Such personal or State commissions to architects and sculptors are an important feature of Archaic Greece. The artist is hired to do a job, to please or impress mortals or divinities. 'Art for art's sake' was an unnecessary conception.

With these monumental arts already so well established in Greece in the Archaic period it is inevitable that they take pride of place over what is still our most bountiful source of information about Greek art and taste – vase-painting.

VASE-PAINTING

By the end of the seventh century the Athenian vase-painter had adopted wholeheartedly the black-figure technique, which had already been practised at Corinth for a century. With it came also the animal frieze style of Corinth, and for a generation or more the greater part of Athens' vases is covered with rows of animals – lions,

goats, boars, sphinxes. But the monumental character of Athens' pottery had not been forgotten, and while at Corinth the gross creatures wandered lost in a maze of filling rosettes in a repetitive, mass-produced style, the Athenian beasts were better managed. The Nessos Painter (a scholarly sobriquet, such as is necessary for anonymous Greek vase-painters), was one of the first to use black-figure in Athens. He still painted large funeral vases, and beasts upon them are commensurately massive, precisely and boldly drawn in a manner not matched in Corinth. And the narrative scenes persist beside the animals on many vases, generally taking the prior position. The success of this new style in Athenian black-figure pottery is shown by the way it rapidly penetrates markets hitherto served only by Corinthian wares.

78

76 Corinthian *crater* showing a married couple in a chariot, with friends. Red and white are freely used and the detail on the white parts is painted, not incised. The background is artificially reddened to heighten the polychrome effect of the white, red and black. Painted by the Three Maidens Painter, *c.* 560 B C. Height 42·5 cm

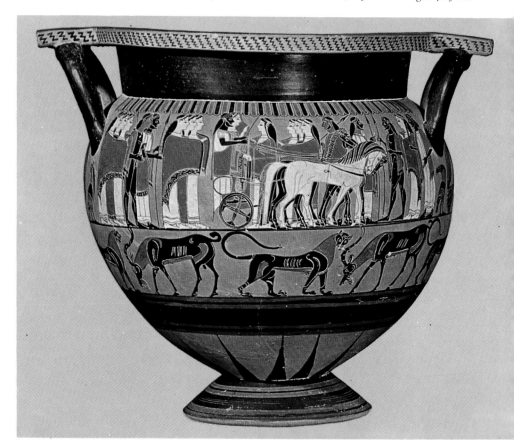

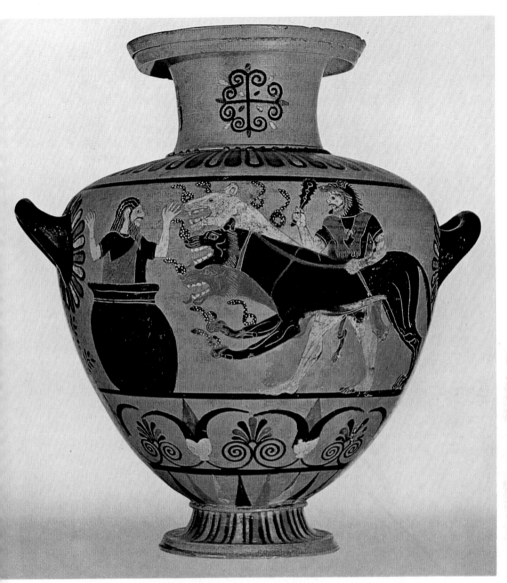

77 A Caeretan *hydria*, one of the most colourful classes of Greek black-figure vases. Herakles is delivering the hound of Hades, Cerberus, to his master Eurystheus, who has jumped, terrified, into a storage jar. *c.* 530 B C. Height 43 cm

78 Detail of a grave vase, from a cemetery at Vari, in the countryside of Attica. Notice the way the horse's head is pushed to the foreground of the picture. This is an early example of full black-figure in Athens. By the Nessos Painter. *c.* 620 B C

The Nessos Painter was succeeded, early in the sixth century, by others who worked in the animal frieze style as well as with narrative scenes, but by about 570 Athenian interest in figure scenes rather than animals is beginning to win the day. The 'François vase', a wine-mixing-bowl (*crater*) found in an Etruscan grave (the Etruscans were always good customers for Greek vases) carries six figured friezes on either side, of which only one is occupied by animals – fighting and posed heraldically over florals, while on the rest and on the handles more than two hundred figures act out mythological scenes. Almost all the figures, and some objects, are labelled with their names and both potter and painter, Ergotimos and Kleitias, signed their work. From now on animal friezes and florals are suppressed to subsidiary positions and the painter increases his repertory of mythological themes. Even the gorgoneion which serves to fill many circular fields in cups or on plates in the sixth century, is the product of an adventure, also shown on vases – Perseus' encounter with the Gorgon, Medusa and his removal of her (literally) petrifying head. The same head appears often as a device on shields (*Ill. 37* right, and Agamemnon's shield in Homer).

New artists set high standards in painting table vases (the big funeral vases had gone out of fashion). The Amasis Painter's lithe

79

81

79 Detail of the 'François vase', painted in Athens by Kleitias. It shows the ship coming to pick up Theseus with the young Athenians he rescued from the Minotaur. One eager sailor swims for shore, while to the right the dance of victory (the *geranos* or crane dance) begins. *c.* 570 B C. Height of frieze 6·5 cm

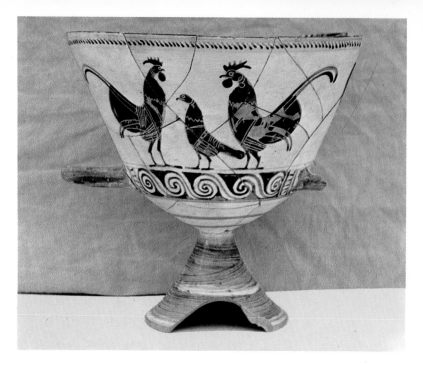

80 A chalice, made in Chios. The shape and fine surface are distinctive of Chian pottery, which was widely exported. This was found in a Greek colony (Taucheira) on the Libyan coast. *c.* 560 B C. Height 18 cm

figures show an unexpected, vivid humour. His potter-work is equally individual and it is likely that we have here to deal with a
84 painter-potter of rare distinction. His contemporary (of the mid century and after) Exekias offers a strong contrast in an almost
82 Classical style with figures of dignity and presence. The vases these artists decorate are wine- or olive-oil-jars (*amphorae*), water-jars (*hydriae*) or wine-mixing-bowls (*craters*). On cups we find a more miniaturist style reminiscent of Protocorinthian. Greek cups generally have two horizontal side handles. The Corinthian type, with a deep bowl, was replaced in Athens by varieties with a broad shallow bowl set on a high splaying stem, like that of a wine-glass. These may have their lips plain (lip cups) with small figures or groups decorating them, or black (band cups) with figures in the band between the
83 handles. Inside there may be a figure or group within a circle, and the rest of the vase is painted with the fine, lustrous black paint which is one of the most appealing features of all good Athenian vases. Their artists are the so-called 'Little Masters'.

84

The painters of the later part of the sixth century offer a somewhat racier, sometimes sketchy, style. It occasionally succeeds in combining the precision of Exekias with the new verve, but the influence is now that of another vase-painting technique, 'red-figure', to which we must turn in a moment. Before we do, it should be admitted that not all the fine black-figure vases of the sixth century are Athenian. The Corinthians continued in brisk competition for the first half of the century, emulating and in some respects still even inspiring the figure scenes of Athenian vases. They achieve a decorative effect in colour which the Athenian seldom looked for, preferring detailed drawing by incision and freer composition. But the output of painted pottery for export seems to have been an important factor in Corinth's potters' quarter, especially the colourful *craters* which were sent west to 76 Etruria. When the markets were successfully won by Athenian wares the painters went out of business and the long and distinguished series of figure-decorated Corinthian vases came to an end. Soon Athenian potters (like Nikosthenes) sought out the new markets with 'export models' especially designed for them.

81 Athenian plate, with a gorgoneion. Even on black-figure vases these heads are drawn in the older outline techniques. Painted by Lydos, *c.* 560 B C. Diameter 24 cm

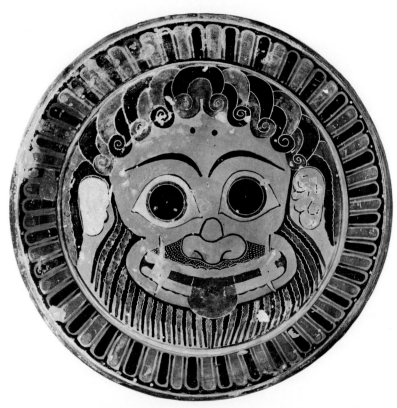

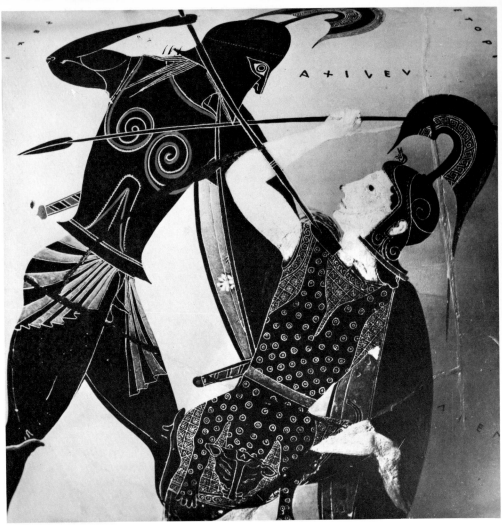

82 Detail from an Athenian black-figure *amphora* by Exekias showing Achilles slaying the Amazon queen Penthesilea at Troy. *c.* 540 B C

83 Athenian black-figure band-cup. Detail showing lions and a leopard attacking a bull and a mule. By the Oakeshott Painter, *c.* 540 B C

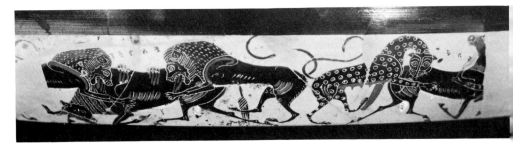

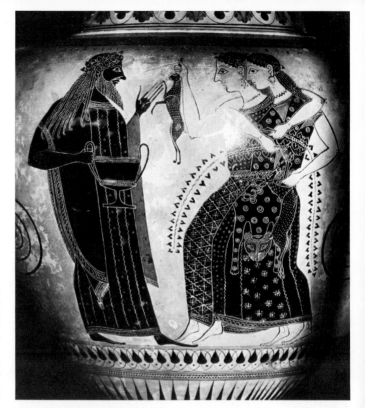

84 Detail of an Athenian
black-figure vase by the
Amasis Painter. Dionysus
greets two maenads who
carry animals and ivy ten-
drils. Notice how the girls'
flesh is painted in outline
and not white on black, as
is usual in black-figure
(contrast *Ill. 82*). *c.* 540 B C

Other schools, dependent in varying degrees upon Corinth and
Athens, produced black-figure vases for their local markets. Spartan
cups had some success overseas but their figures are stiff and lifeless *86*
though often very precisely drawn. Such east Greek schools as were
not ringing the changes on the old outline style of the Wild Goats,
also produced black-figure, generally fussy and highly coloured, but
also some delicate cups of great charm and originality. On these, and *80, 87*
the Spartan cups, we often see whirling compositions, or scenes
which own no top or bottom, such as the Athenian artists generally
eschewed; and more of the interior is filled with the scene. In the
West Chalcidian potters had set up shop perhaps in Rhegium (Reggio)
and had some success in Italy and Sicily with vases on which the finer
motifs of the other schools were combined with a superb decorative
sensibility and telling economy of line. Emigrant artists from *85*
east Greece had some success in Etruria and promoted distinguished
local schools of black-figure. An Ionian artist working in Caere
(Cervetri) made a series of superbly colourful *hydriae* which were
in some demand locally. He shows a rare sense of humour as well as *77*

87

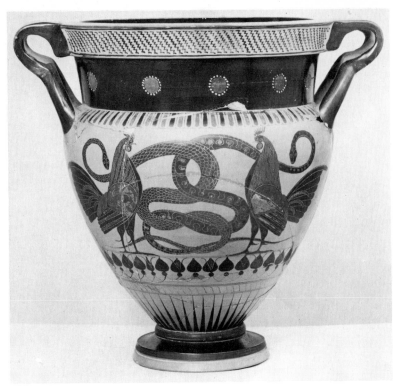

85 Chalcidian black-figure column *crater* (a mixing-bowl) with cocks and snakes. Note the characteristically plump buds in the floral. *c.* 530 B C. Height 37 cm

imagination in his treatment of myth – sometimes the story is outside the usual vase-painters' repertory.

Although the individuality of these schools, and of the different artists in Athens, can be appreciated at a glance, there were fairly rigidly observed conventions in black-figure, and an over-all unity of style which developed slowly. The black silhouette with incised detail remained the basic element. Red was used more often than in the seventh century – for hair and beards, on drapery, and for a while in early black-figure to show masculine sunburnt faces. Women's faces and bodies are in white, painted over the black silhouette which showed through the incised details, and white appears on drapery patterns. The male-red, female-white convention was observed in Egyptian art, and is, after all, an approximation to life. The figures are shown in a strictly profile view although it was

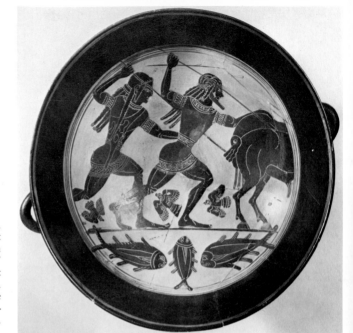

86 Spartan black-figure cup, the name-piece of the Hunt Painter, who specializes in these unusual 'porthole' views with the figures cut off by the circle frame. A boar-hunt is in progress; the beast has a broken throwing-spear in its back. *c.* 550 BC. Diameter 19·5 cm

87 East Greek cup, perhaps made on Samos. The detail is not in fact incised but left in reserved lines. A man dances between two trees. To the left a bird is bringing food to fledgelings in the nest, and there is a cicada on a branch. *c.* 550 BC. Diameter 23 cm

usually found easier to show the chest frontal, especially in moving figures. For running or flying the figures appear as kneeling with elbows thrown high. The eye too is frontal even in a profile head, a disc for men, almond shape for women, on Athens' vases. Frontal heads and bodies are rare except for grotesque or horrific creatures like satyrs, centaurs and gorgons. The representation of drapery changes from flat enveloping folds to elaborately patterned pleats and zigzag hems, exactly like the carving of the *korai* after the mid century. Emotion is expressed by gesture – hands tearing hair in grief, gestures of farewell, of animated conversation, of abandoned joy; rarely a facial detail like a furrowed brow or clenched teeth. The women are ageless, with an occasional matron. For the men a beard marks maturity or status, and white hair or partial baldness and bent shoulders old age.

Conventions, too, govern the way in which the more popular scenes are shown, and the accepted way of depicting, for instance, the Judgment of Paris is rarely changed or abandoned by artists. But within these conventions individual skill and imagination could still be expressed. Scenes of myth predominate, especially the deeds of popular heroes like Herakles. There are also more formal studies of the gods, alone or in groups. Many of the vases are designed to serve a drinking-party, and scenes with the god of wine, Dionysus, are naturally common. In his entourage is one of the most engaging figures of Archaic art – the satyr. An earlier poet had called satyrs

88

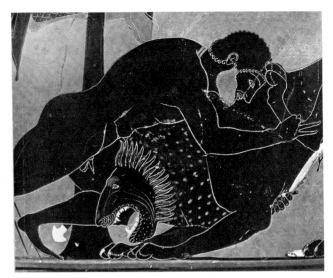

88 Detail from an Athenian black-figure *amphora*, painted by Psiax. Herakles has to wrestle with the Nemean lion since it cannot be hurt by ordinary weapons. The incision on later black-figure vases is often much lighter, recalling the brushwork of red-figure. *c.* 520 BC

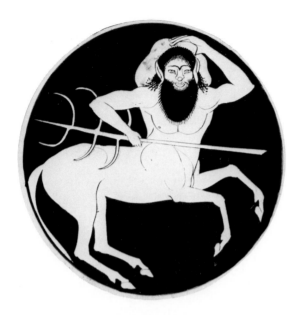

89 The interior and one side of a red-figure cup signed by Phintias. They show a centaur shouldering a rock; and a large satyr being assaulted by a small naked girl. *c.* 510 BC

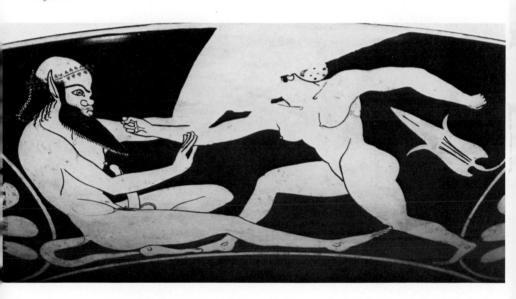

'unemployable layabouts'. Not until the sixth century did artists look for a way of showing these uninhibited creatures and their embarrassingly human weaknesses. The centaur type, part man, part horse, may have suggested the physical form, since the satyr is little more than an abbreviated centaur, with shaggy head, horse's ears and tail, and two human or horse's legs (a combination of the two in east Greek art). The centaurs had shown a fondness for wine and women; the satyrs added song, and in Dionysus' service they even play a part in the early development of the Greek theatre.

89, 95, 97

It is easy to interpret all these mythological scenes as expressions of no more than the Greek love for colourful narrative. Certainly, few seem to express any deeper religious feeling. But in other ancient cultures, and in later Classical art and literature, myth is freely used symbolically to illustrate views on contemporary problems of life or politics. In the absence of explicit references in texts it is not possible to be sure that this was also true of the Archaic period, but we may suspect that Herakles, as favourite of Athena, was rather exploited by the tyrant Peisistratos and his sons who also claimed Athena's patronage. Peisistratos once returned to power with a charade in which he was driven in a chariot by a mock-Athena back to the Acropolis, an event surely mirrored in the new way of showing Athena's Introduction of Herakles to Olympus by chariot. And after the Peisistratids, although Herakles is bound to remain popular, he has to yield to a new and rather more overtly political interest in a rival, local hero, Theseus.

Besides these scenes of myth everyday life was not neglected – weddings, burials, gossip at the fountain, courtship and love, and, of course, the drinking-party; but some of the finest examples of these subjects, and an even greater range of them, are to be found on Athenian vases of the new technique, which succeeded black-figure.

The black-figure vases were still being made in the fifth century, but in their last phase they take second place – except for some traditional prize vases which perpetuate the old technique (the Panathenaic *amphorae*) – to vases painted in what we call the 'red-figure' style. This had been invented in Athens about 530 B C. It is an exact reversal of black-figure. The background now, and not the figure, is painted black, and so the figures appear in the red colour of the clay ground, and the details are painted upon them in line detail where before they had been incised. In fact we are back with the outline drawings of the Orientalizing period, which had never been quite forgotten, even by some black-figure artists (like Sophilos and the Amasis Painter). The brush is a more subtle implement than the incising point, and although at first treatment of figures and detail is

90

90 Detail from an Athenian red-figure vase by the Andocides Painter, showing the goddess Artemis wearing *chiton*, shawl, wreath and elaborate ear-rings. Incision is still used round her hair. She holds flowers, stylized into scrolls, while she unconcernedly witnesses a contest between her brother Apollo and Herakles. *c.* 525 B C

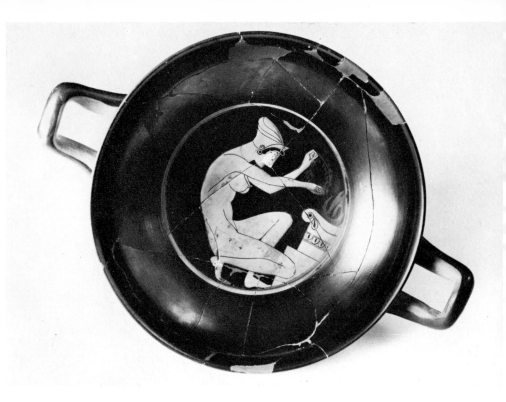

not much different from black-figure, in time the more flowing line assists the more realistic rendering of anatomy and drapery. The fact that the outline of the figure is limited by a line, and not the outer edge of the silhouette mass, also has its effect. Colour now plays virtually no part, and only the lightest touches of red and white – even occasionally gilding – appear, but variety is admitted by the use of thinned paint for light anatomical detail, fine drapery or hair, and a relief line of brilliance and body for more important outlines and strokes. Men and women have to be distinguished by features, dress and anatomy now, not colour. The line of the body is sketched through the intricate drapery patterns and there are plenty of brilliant
91 and perceptive studies of the female nude which we look for in vain in sculpture of this date. The musculature of the male body is more accurately observed, the abrupt transition between frontal chest and profile hips is managed plausibly, and even back three-quarter views
92 and bold foreshortening of limbs are brought off. The eye is gradually shown in a proper profile view, but frontal heads are still avoided, and three-quarter views of heads not attempted. There are even a few examples of light shading which helps to lend an illusion of mass to

94

the linear drawing. Within a generation the new technique effected greater advances in the graphic arts than black-figure had conceded in over a century.

The earliest of the red-figure artists, the Andocides Painter, decorated vases which also carried scenes in the old black-figure technique (done by him or a companion) and other artists produced these bilinguals. The new style had its effect on the old – quite apart from the way in which it gradually stifled it. Subjects and stories remain unchanged but there is a shift of emphasis in the representations of some myths and many more genre scenes of athletics or drinking-parties, and we see rather more specialization among the painters, who are attracted to work on either large or small vases (usually cups). The first half-century of red-figure produced most of its great masters. Artists like Euphronios and Euthymides were working before 500 in a Classic style which owed something to the work of Exekias and for its precision and command of line can compare with the very best in contemporary statuary. Euthymides is probably also the master of a larger work, a clay plaque from the Acropolis, with a

90

92

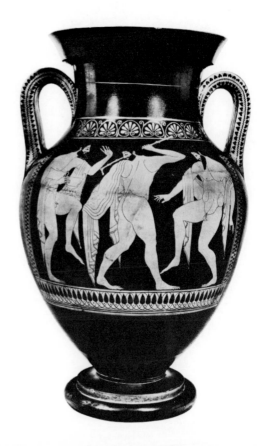

91 (*left*) Centrepiece of an Athenian red-figure cup. A naked girl kneels before an altar holding a wreath. The flames on the altar and the wreath are painted red. Late sixth century B C

92 (*right*) Red-figure *amphora* painted by Euthymides showing elderly revellers. The inscription (invisible here) on the left is a friendly challenge to a contemporary artist – 'as never Euphronios'. The figures offer early and successful studies of difficult three-quarter views. *c.* 510 B C. Height 59 cm

94 warrior painted part in outline, part in black-figure. Among contemporaries, working on smaller vases generally, are Oltos, a robust, economical draughtsman, and Epiktetos, whose figures are closer to those on the large vases but more delicately conceived. At the end of our period the greatest names (or pseudonyms) are the Berlin Painter and the Kleophrades Painter. The Berlin Painter appreciated the effect

93 that could be made with single figure studies or small groups. His is perhaps the most skilful use of this strange technique which forces all the figures to the foreground, before an inky backdrop. The Kleophrades Painter, more an intellectual to judge from his themes, lacked nothing in sober strength, but many of his subjects are treated

96 with an originality and verve that we associate more with the cup-

93 Detail from a vase by the Berlin Painter showing Herakles wearing the lionskin and with his club, bow and quiver. Notice the difference between the strong black relief line and the thinned lines for anatomy and on dress, also the relief ringlets in hair and beard. c. 480 B C

94 Clay plaque from the Athenian Acropolis, probably painted by Euthymides. It bore the inscribed motto 'Megacles is handsome', but the name was erased and that of Glaukytes substituted, probably after Megacles had been ostracized in 486 B C. c. 500 B C. Width 50 cm

painters. Of these there are several artists of the first rank working in Athens in the opening years of the fifth century. Their cups are the new, high-stemmed *kylikes* with a shallow open bowl which offered a circular field for decoration within (appearing to the drinker through his wine), and two broad arcs on the outside for frieze compositions which were best appreciated when the cup was hanging on the wall. Onesimos delicately combined residual Archaic vigour 95 with the dignity which is to typify the succeeding period, and which is especially characteristic of his later work. Douris, a rather finicky but expressive artist, also had a long career. His vase shown here is a *psykter* – or cooler. Filled with wine it would stand in a bigger bowl 97 full of ice-cold water or snow. The Brygos Painters' notable output included a magnificently full series of Dionysiac and drinking-party scenes with shrewd characterizations of drunkenness, excitement or lassitude, as well as more formal mythological scenes in the grand 99 manner.

It will be realized that painting is a misnomer for the art of red-figure. There is hardly any colour, and no more variety of intensity in the painting than can be copied in line drawing with a pencil. Euthymides' plaque shows what work on a larger scale might have looked like. The light background would have been the rule for any painting on walls or wooden panels, but virtually nothing has survived and we have to look to the work of Greek artists outside the Greek world – in Italy and Anatolia – to get some idea of what contemporary major painting may have looked like. For its conventions it seems likely that it was little more than vase-painting writ large, but enjoying the added realism of the light background and the greater range of colour.

94

98

95 Centrepiece of a red-figure cup by Onesimos. An excited satyr is squatting upon a pointed wine *amphora. c.* 500 B C

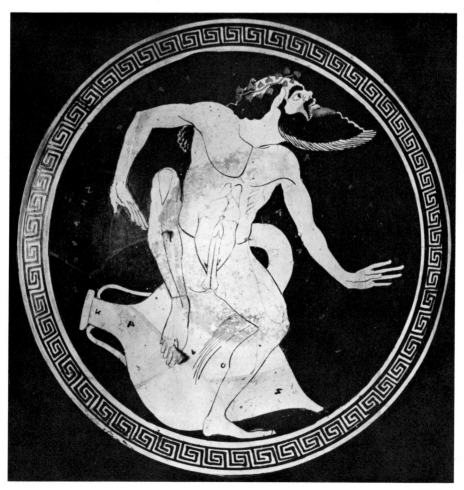

96 The head of a dancing maenad from a vase by the Kleophrades Painter. She wears an animal skin, painted in a pale wash, over her *chiton* and shawl. A snake winds up one arm and she holds a *thyrsos* – a reed with a cluster of ivy leaves at the top. *c.* 490 B C

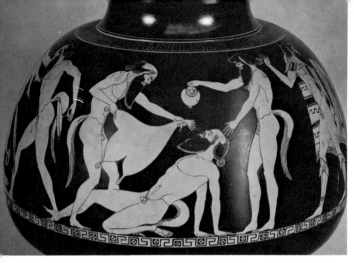

97 A red-figure *psykter* (wine-cooler) painted by Douris. Satyrs at a party. *c.* 480 B C. Height 29 cm

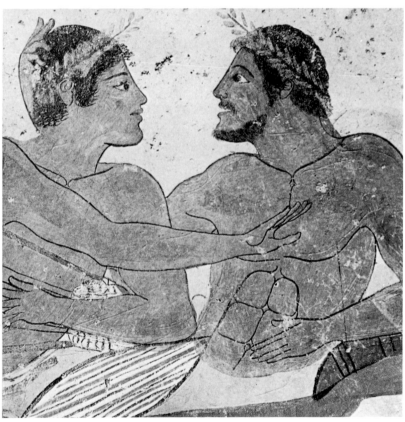

98 Detail from the painted decoration on the interior of a tomb recently found near the Greek colony of Posidonia (Paestum) in Italy. A banquet is in progress. Compare the red-figure vase-painting of these years in the adjacent pictures. *c.* 480 B C

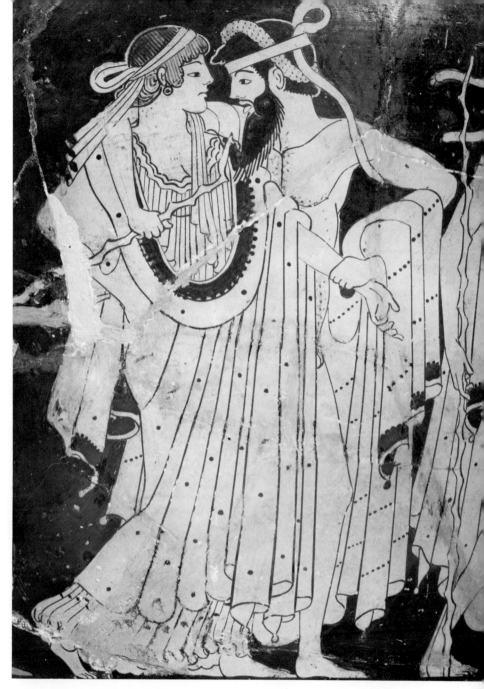

99 Detail of a red–figure cup by the Brygos Painter. A bearded reveller is persuading a girl to come along to another party. The way the eyes are drawn now suggests the profile view better; contrast *Ill. 90. c.* 490 B C

100 Clay antefix in the form of a satyr's head, from Gela in Sicily. By this time satyrs are often shown with human ears, but here they are still animal. Early fifth century B C. Height 19·5 cm

101 (*below*) Bronze figurine of a man reclining at a feast, from the rim of a bronze vessel. *c.* 520 B C. Length 10 cm

There are countless smaller objects, in clay, bronze or more precious materials, upon which the artists lavished their skill. Generally the style and subject-matter of the decoration is as that of the major or better documented arts like sculpture and vase-painting, but occasionally the special demands of material, technique or purpose produced original and new art forms.

Figurines in clay, mass produced from a mould and generally painted before being fired, are common dedications in sanctuaries, but they were naturally not accorded any place of honour and were from time to time swept out or buried to make way for more. The same figures, of men, women, gods or animals, could serve as offerings in a grave, toys for children or household decoration. The original models, from which the moulds were made, were often fine works of miniature sculpture, to which the decorative figurines which abound on sites and in museums rarely do justice. A different class of figure is the hollow figure vase serving as a perfume-flask. The type *102* had been known in the seventh century and is further elaborated in the sixth. Clay figures in the round or in relief also serve as revetments, acroteria or gutter terminals on the smaller buildings, and some of these are notable works of art, especially those from western Greek

102 Clay figure vase of a youth kneeling and binding a fillet round his hair. Probably Athenian work of *c.* 530 B C. Height 25·5 cm

100 sites (in Sicily and south Italy). Here there was no fine white marble and techniques of minor clay statuary were soon highly developed.

Figurines in bronze are cast solid. Larger statuary, up to life-size, was being made in bronze by the end of the Archaic period, using the *cire-perdue* method which produced light, hollow figures with a thin fabric. The figurines are sometimes independent works – votive or decorative – but more often were applied to other objects, especially *101* bronze vases. These were naturally more valuable than the clay vessels, but few have survived. The great mixing-bowls or *craters* had hammered bowls to which were applied cast-bronze figures – the volute handles fashioned with gorgons at the point of attachment to the bowl, elaborately moulded hoops for the lip and foot, and sometimes relief figures of animals, warriors or horsemen round the neck; but no decoration on the body where the clay vases have their figure scenes. The finest of these bronze *craters* are found in the export *103* market; the largest, and by far the best, from as far away as Vix, on the Seine, where the nearly six foot high vessel lay in the grave of a Celtic princess. Smaller bronze vessels may have patterns incised on their bodies, but their handles are cast, with heads, animals or palmettes at either end, sometimes the whole body of an animal or of a youth, serving as the handle of a jug. From Egypt came the idea of

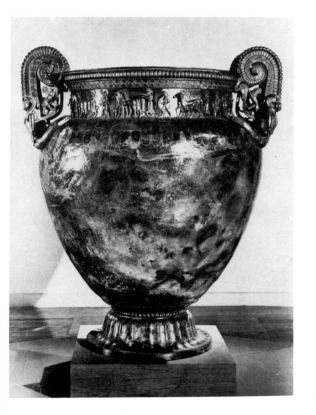

103 Bronze crater from Vix. The handles, foot and figures on the neck were cast separately and labelled for assembly on arrival. Perhaps made in Laconia, or at least in a Laconian style. *c.* 530 BC. Height 1·64 m

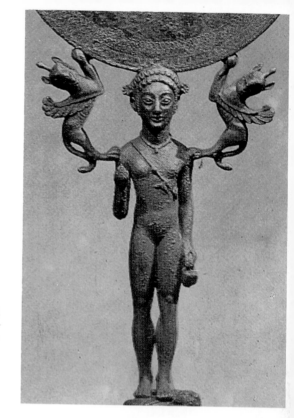

104 Bronze mirror support of a naked girl standing on a lion, with griffins helping to hold the mirror disc. *c.* 530 B C. Height 35·5 cm

using a human figure as the handle for a mirror or dish. The ladies supporting the Greek mirrors (the reflecting discs were burnished bronze) are sometimes naked, like their Egyptian kin, in the Archaic period.

104

In the art of gem-engraving there are striking innovations in materials and technique. Harder stones – carnelian, chalcedony and jasper – are introduced from the Near East, and with them the use of a cutting-wheel which managed tougher material more easily and had not been used in Greece since the Bronze Age. Scarab seals become the most popular, the Egyptian form with a beetle carved on the back, the stone being set in a pendant or on a swivel as a finger-ring. It is not wholly clear what the exact source of this new phase in gem-engraving can have been, but it seems likely to be the work of east Greeks in Cyprus or some other centre where the Phoenicians and Phoenician art were to be found. The Eastern influence, beyond the material and technique, was minimal, and very soon local schools can be distinguished in east Greece producing exquisite stones of a quality

105 Intaglio from an agate scarab showing a reclining satyr with cup and bowl. By the Master of the London Satyr, *c.* 530 B C. Length 2·2 cm

105

106

unmatched in the East for centuries before (if ever at all). The idiom and style are wholly Greek. The cutting of dies for coins is a craft akin to that of the gem-engraver. Electrum (white gold) coins were struck first in Asia Minor and east Greece before 600, and by the end of the Archaic period most Greek cities of importance (except Sparta who abjured this root of all evil) had their own issues of silver coinage. Some of the types are as delicately conceived as those on the best gems, although once a coin device is accepted a natural conservative tendency made against rapid changes of style or type. In this respect smaller States were often able to afford greater variety and originality in their coin types. As on the scarabs, with their oval fields, so the circular field of a coin presented special difficulties of composition which the Greek artist triumphantly faced, as he had done in the *tondo*

106 (*left*) Silver coin from Naxos in Sicily, with the head of Dionysus; (*right*) electrum coin from Cyzicus in the Propontis, with a winged woman. Late sixth century B C

centrepieces of painted cups. These miniaturist arts can sometimes offer works of major importance, although they are frequently ignored in favour of the more traditional or spectacular subjects.

By the early fifth century all the major arts which are to characterize Classical Greece have been established and the techniques mastered. Indeed, a great many of the special features of Classical art, its peculiar blend of idealism and realism, are already anticipated. If the main breakthrough in sculpture is the rejection of the stiff *kouros* pose, then this has happened already by the time of the Persian Wars. Not in the lively poses of relief and architectural sculpture, but in figures like the 'Critian boy' from the Athenian Acropolis, who is still a standing frontal youth – a *kouros* – but relaxed, with his weight shifted on to one leg, hip raised, body gently curved: the work of a sculptor who could now express his understanding of the human body as a structure of bones and flesh, rather than a stiff-limbed puppet. *107*

When the Persian generals left their treasures behind in their tents after defeat on the battlefield of Plataea, those Eastern *objets de luxe* offered no new art forms to excite Greek artists, and soon Greece was to repay in full, and more, its debt to those Eastern crafts whose effect we have observed in the last two chapters.

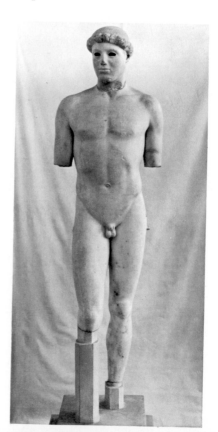

107 The 'Critian boy', so named from the similarity of the head to that of the tyrannicide Harmodius in the group by Critios and Nesiotes (which is known from copies). From the Athenian Acropolis, of just before 480 B C. Height 86 cm

Classical Sculpture and Architecture

The Persian Wars left Athens devastated, her temples burnt and
monuments overthrown by the invader, and although she soon won
back prosperity and an ascendancy over part of the Greek world,
which she had earned by her stand against the barbarian, the city had
for a while no time or money to lavish on monumental art. For the
first-fruits of the break with Archaic conventions which had already
occurred before the Persian Wars we have to look elsewhere. The
great national sanctuary of Zeus at Olympia, unscathed by Persian
attack, is the natural place to look for examples of the new, incipient
Classical style, and the accidents of survival have preserved here some
of the finest works of the generation after the Battle of Salamis. After
a flood in late antiquity, which covered the site with a deep layer of
sand, Olympia was barely visited, rarely robbed and for a long while
lost. From beneath the sand and from a rough, late fortification wall
has been recovered the greater part of the sculpture from one of the
Seven Wonders of the Ancient World – the Temple of Zeus – and
enough of its architecture to admit almost certain restoration on
108 paper.

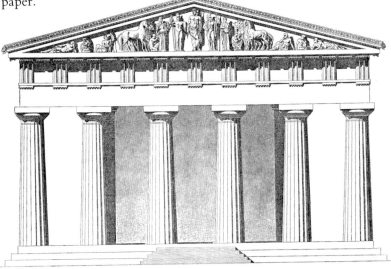

108 Restored drawing of the east end of the Temple of Zeus at Olympia

109 Clay group of Zeus carrying off the child Ganymede, who holds a cock (the usual Greek love-gift for a boy). The bright colours are well preserved on the fired clay. From Olympia. *c.* 470 B C. About half life-size

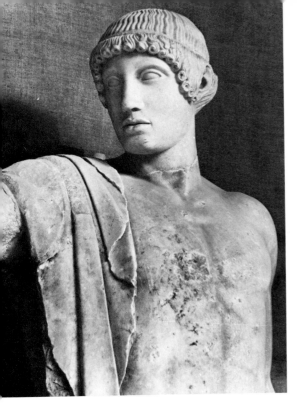

110 Detail of Apollo from the centre of the west pediment of the Temple of Zeus at Olympia. *c.* 460 B C

OLYMPIA

The temple was in the Doric order, and the largest completed in mainland Greece (over 27 metres long) before the Parthenon, which is some 3 metres longer. The coarse local limestone of which it is built is covered with stucco, but fine Parian marble was brought in for the roof-tiles and sculptures. The exterior had sculptural embellishment only for the acroteria on the roof and in the pediments – the metopes *108* were left bare. In the pediment over the main entrance in the east the line up of contestants and chariots before the fateful race between Pelops and Oenomaos is shown. Zeus himself towers in the centre, and the corners are filled by reclining figures of local deities. This is a static but impressive composition, only fraught with deeper meaning for those who knew the story. The other pediment has Apollo at the *110* centre, in control but not physically involved in the wedding brawl between the Lapiths of Thessaly and the drunken centaurs who tried to carry off the bride and women. Here all is action, like the earlier pedimental compositions of fights.

110

Passing through this outer ring of columns and looking up over the inner porches the visitor saw at either end six sculptured metopes. These showed the Labours of Herakles, starting with his triumph over the lion, ending with the local episode of his breaching the walls of the stables of Augeas, to flood and cleanse them. Within the main hall (*cella*) a central nave was formed by two tiers of superimposed Doric columns on either side, and at the end was Phidias' great gold and ivory statue of Zeus himself, seated, with a figure of Victory on his outstretched right hand. This seated statue which was said to have 'added something to accepted religion' (Quintilian), towered to the roof. It was eventually taken to Constantinople and burnt in a palace fire in AD 475. All that we can know of it is gleaned from later reduced copies or free adaptations of it, and from some of the clay moulds on which the gold drapery was beaten, which were excavated in recent years in Phidias' workshop at Olympia (see page 15). The marble statuary on the temple was in position by 456 BC, but the cult statue was supplied nearly twenty years later.

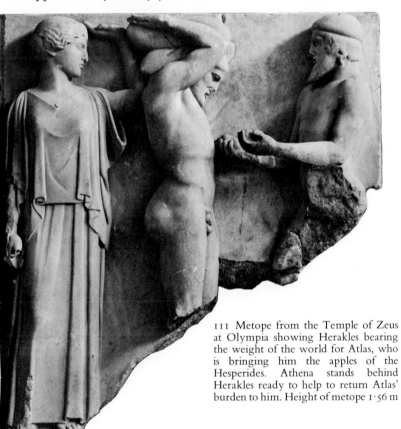

111 Metope from the Temple of Zeus at Olympia showing Herakles bearing the weight of the world for Atlas, who is bringing him the apples of the Hesperides. Athena stands behind Herakles ready to help to return Atlas' burden to him. Height of metope 1·56 m

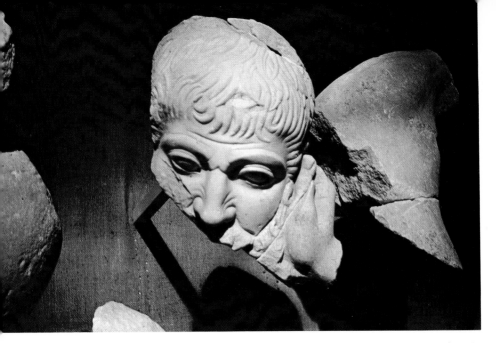

112 Head of a centaur from the west pediment of the Temple of Zeus at Olympia

It is naturally the style of the pediments and metopes at Olympia that occupy our attention, and which can give the measure of how far the artists had progressed since the Archaic period. Set high on a building, sculpture of this sort is most effective if carved in fairly simple and bold planes. But at Olympia, as on the Parthenon, where the work is far more detailed, much of the subtlety of the sculpture was lost at the height at which it was displayed. For there is considerable individuality in the treatment of bodies and features here. Herakles' expression reflects his feelings in the face of his various

112 labours, and in the fights pain and bestiality are vividly portrayed.

The male figures stand in the new, easy pose, with one leg relaxed and the weight of the body lightly shifted on to the other; a pose which marks them off so clearly from the Archaic. The nude bodies are strongly and accurately modelled. A clay group of Zeus and

109 Ganymede at Olympia shows the new style well, the heads still slightly Archaic, especially in the treatment of hair, but the features cast in a new mould. Another Zeus (or other deity) is the fine bronze

113 from the wreck off Artemisium, more than life-size, and certainly the most vigorous surviving example of Early Classical statuary. This is nearer in date to the Olympia sculptures and shows an advance in the freer treatment of hair and build. Full-size bronze statues and groups

112

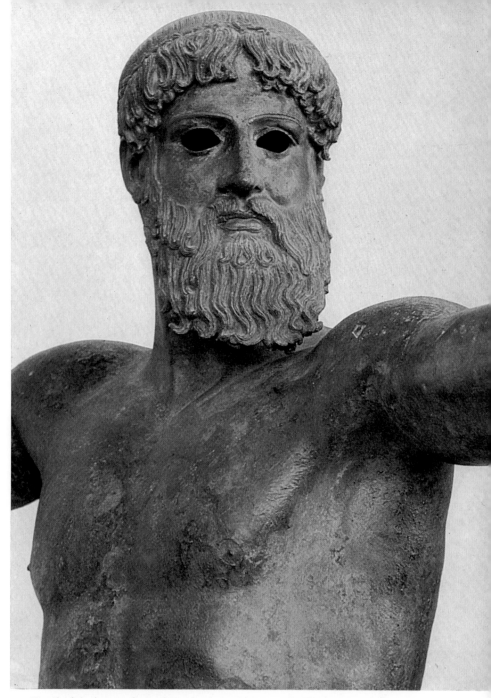

113 Detail of the bronze figure from the Artemisium wreck. The brows and lips had been inlaid with other metal and the eyes inset. *c.* 460 B C. The figure is just over life-size

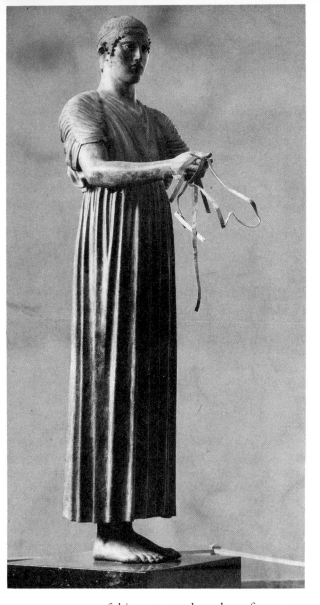

114 Bronze charioteer from Delphi. He stood in a four-horse chariot, led by a groom. The group was dedicated by Polyzalos, tyrant of Gela in Sicily, celebrating a victory in the Games of either 478 or 474. The eyes are inlaid with glass and stone, copper on the lips, silver for the pattern in the headband. Life-size

of this sort must have been far more common at this time and parts of
114 others have survived. The famous charioteer from a group at Delphi
is an obvious example, and now we can add the remarkable bronze
7 warriors from Riace which outdo even the charioteer and the
Artemisium Zeus for their presence and quality.

114

The gaudy pleated *chiton* in which the Archaic *korai* were dressed is generally replaced now by the heavier *peplos*, which is sleeveless and has a heavy, straight overfall to the waist. The change in fashion also offered a style of dress more in keeping with the new spirit. The simple broad folds hang naturally and acknowledge realistically the shape of the body beneath. The *peplos* figures sometimes seem heavy and dull. There is little to show for the style in Athens where there are no carved tombstones of this date to display the new dignity which would suit them so well, but we may look for examples on tombstones from the Greek islands. Here the narrow type of *stele* with a palmette finial, which had been invented in the islands of east Greece and had been copied by Athens in the sixth century, was still being *116* made. The islands, a source of fine statuary marble even after the resources of Athens' Mount Pentelikon had been realized and exploited, always had important studios, and the sanctuary island of *115* Delos in their midst attracted rich offerings. East Greece, too, despite

115 *(below)* Marble relief, probably island work. A hunter with his dog returns home holding the hare he has killed with the throwing-stick he carries in the same hand. *c.* 460 BC

116 *(right)* Gravestone of a girl from one of the Greek islands, probably Paros. The lid of the box she holds is on the floor. Her loose *peplos* is open all down the side. *c.* 450 BC. Height 1·39 m

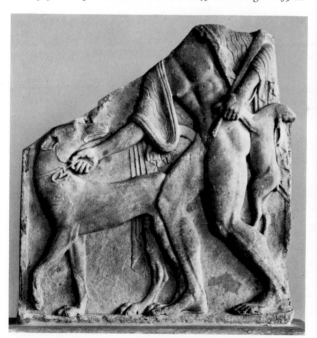
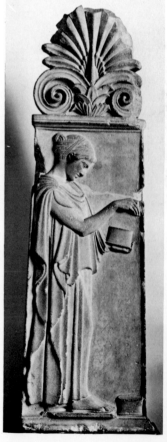

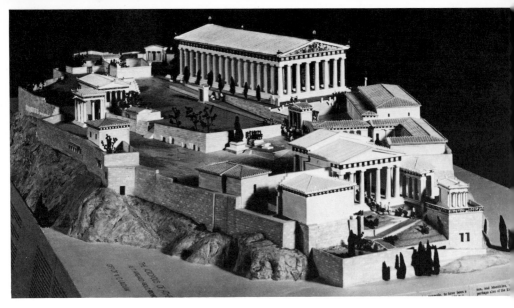

117 Model restoration of the Acropolis at Athens with the Propylaea and the Temple of Athena Nike in the right foreground, the Parthenon beyond and the Erechtheion to the left centre

118 The Parthenon, seen from the north-west, just within the Propylaea. This unimpeded view was not possible in antiquity (compare *Ill. 117*). Built 447–433 B C, to the plans of Ictinus and Callicrates

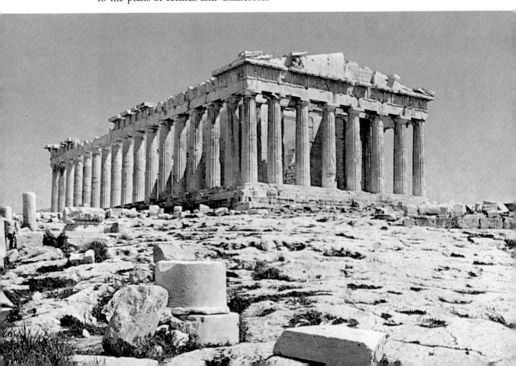

119 The west end of the Hephaisteion in Athens, looking up between the outer columns to the frieze over the back porch. In the frieze two centaurs beat into the ground the otherwise invulnerable Lapith, Kaineus. *c.* 440 B C

the even more imminent and continuing Persian threat, still had an active sculptural tradition, more often now turned to the service of their native, Persian-dominated neighbours in Lycia or Caria, and it had been east Greek masons whom the Persians had taken to work on their homeland palaces.

By the middle of the fifth century Athens was secure in her position at the head of a large tribute-paying confederacy which was formed to defend Greek liberty against the Persians. The treasury of the confederacy was transferred to Athens itself in 454 B C and the states-man Pericles set aside part of the revenue for a programme of rebuild-ing which was to make the city the show-place of the Ancient World. The construction of temples and public buildings on the Acropolis citadel and in the lower town went on despite expensive wars in which Athens was not always victorious. By the end of the century she had been severely defeated by Sparta, but the visitor to Athens then would have seen the city at its very best.

The Acropolis, ravaged by the Persians, was completely replanned. Approaching from the west the visitor was faced by a monumental *117* entrance way, in the Doric order, but with tall Ionic columns flanking the central passageway. The Classical approach is still that in use, *121* but little obscured by an outer gateway and monument of the Roman

period. There is no sculpture here but we can already appreciate the exquisite finish of the masonry, the fine joints, the precision of every moulding which is never merely mechanical, and the way in which the qualities of white marble, be it a plain surface or carved in gentle curves and sharp ridges, are appreciated.

Within the entrance stood the colossal bronze Athena Promachos, the work of Phidias, wholly lost to us. The crowning glory of the citadel – the Temple of Athena Parthenos (the Maiden) or the Parthenon, as it is better known – was not revealed in its full height *118* so quickly to the ancient visitor as it is today, but had to be approached through a second gate and court. The temple, wholly of the Doric order, displays the same precision in the carving and fitting of all its parts as does all Greek architecture of the Classical period. Moreover, it reveals refinements of plan which subtly correct the rather static, matchbox effect of Doric temple architecture. The eight columns of the front, instead of the more usual six, give it an unfamiliar breadth and dignity. The refinements of detail had been practised on many other buildings; a crude early example is the *entasis* of Archaic column *56* shafts. The same feature, much refined, appears on the Parthenon; the whole platform from which the columns rise sinks in a gentle curve away to the corners; the columns lean slightly in, the upper works slightly out. These are refinements that can be measured and with care observed by the naked eye. It is only when we look at buildings in which they were not applied, or were applied less skilfully, that we can appreciate the effect their absence might have had on the Parthenon's forest of columns and heavy upper works.

The pediments, most of whose figures are in London, illustrated important moments in Athens' myth-history – the birth of the

120 Group of three goddesses attending the birth of Athena, from the east pediment of the Parthenon. *c.* 435 BC

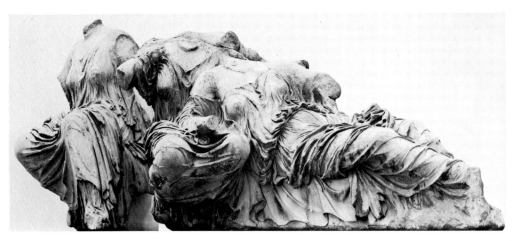

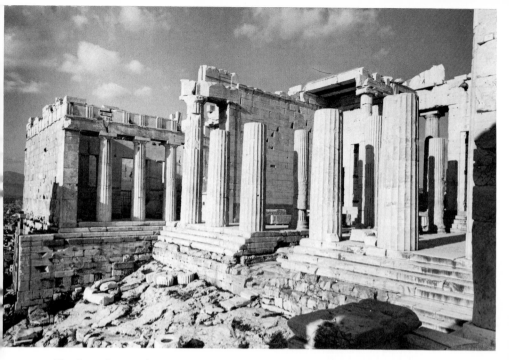

121 The Propylaea to the Acropolis at Athens, from the south-west. An Ionic column from the centre passageway can be seen centre right. Built 437–432 B C, to plans of Mnesicles. Width of entrance front 18·5 m

goddess Athena attended by the other gods, and the dispute between Athena and Poseidon for patronage of the city. The massive figures from these pediments tell us how far the sculptors have progressed in their attitude to the figure and drapery in the years since the Olympia pediments. The restless swirl of massed drapery is shown by deep-cut folds which catch the shadows. The material now has a mass, almost 120 a life of its own, but at the same time the forms of the body beneath are clearly understood and as firmly expressed. The wholly relaxed poses of the reclining and seated figures show a new confidence which even the Olympia sculptures still lack. The figures are carved wholly in the round, and finished as carefully at the back (never seen once they were in position on the building) as at the front. The few remaining heads are badly battered, and for an idea of the way heads were treated by this school of artists we must turn to the relief-work on the temple – the metopes and frieze.

The metopes all round the outside of the temple were carved with reliefs, unlike at Olympia. There are simple groups of struggling figures – gods and giants, Lapiths and centaurs, Greeks and Trojans

at the sack of Troy, and Greeks and Amazons. Some groups are poorly planned and others seem to burst the frame of the metope. The best

122 are tautly composed and set neatly in the field.

The frieze was set in the same place as the carved metopes at Olympia, that is inside the outer colonnade; but in the Parthenon the relief runs over the end porches and along both long sides of the main *cella*. It is thus continuous all round the centre block of the building. Its subject is the preparation for the Panathenaic procession in honour of the goddess, in itself an unusual, secular, subject for the decoration of a temple. It shows the progress from the preparations in the town,

123 with the horsemen moving through the streets, headed by burghers and attendants leading animals for sacrifice or carrying offerings, and culminating in the ceremony with the goddess's sacred garment, watched by an assembly of the Olympian gods. The starting-point was at one corner (the south-west); the culmination at the centre-east, over the main door. With the pediments so poorly preserved we have to turn to the frieze to judge the Parthenon's art at its best. The set, Classical features are calm and thoughtful, passionless. The artists, who had now little interest in portraying the emotions in features, only rarely admitted nuances of expression or feeling. The idealized mortal is near-divine, self-sufficient and above ordinary passions.

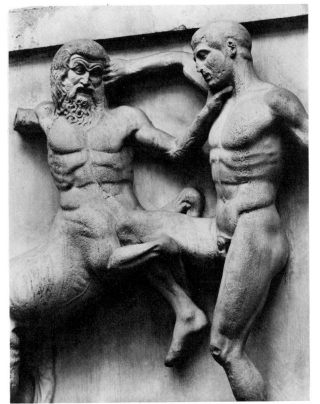

122 A metope from the south side of the Parthenon showing a cen-taur struggling with a Lapith youth. *c.* 445 BC

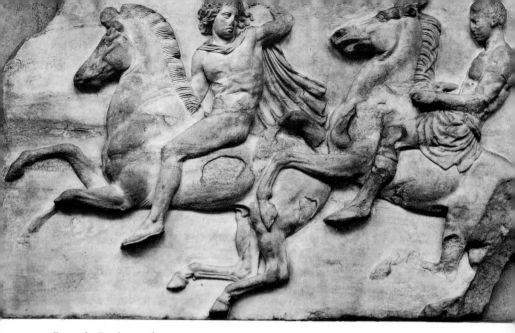

123 From the Parthenon frieze, west side. Horsemen preparing for the Panathenaic procession. *c.* 440 BC. Height 1·03 m

While this certainly represents an advance on the Olympia sculptures, it is not perhaps the advance we might have expected, and for the further development of the incipient portrayal of emotion and mood at Olympia we have to wait nearly a hundred years.

We speak of the 'artists' of the Parthenon, for although Phidias may have determined the design for all the sculptured decoration and may have supplied models for much of it, still he could not himself have been responsible for more than a small part of the actual carving. This was left to other masons, some of them notable artists, for there is outstanding work among the various hands which can be distinguished, but not identified. Where these artists and masons were found in an Athens which for more than a generation had offered few orders for major statuary or architecture remains something of a problem, but the islands' studios may well have been called upon.

The procession shown in the Parthenon frieze did not in fact have as its object the great gold and ivory Athena which was its cult statue – lost for us, like its sculptor's other masterpiece, the Zeus of Olympia, except in reduced copies. The older and more sacred figure of Athena had been kept in an older temple, opposite the Parthenon and this building too was replaced in the new plan by a strangely beautiful, asymmetrical shrine we know as the Erechtheion. Its Ionic order, the *124*

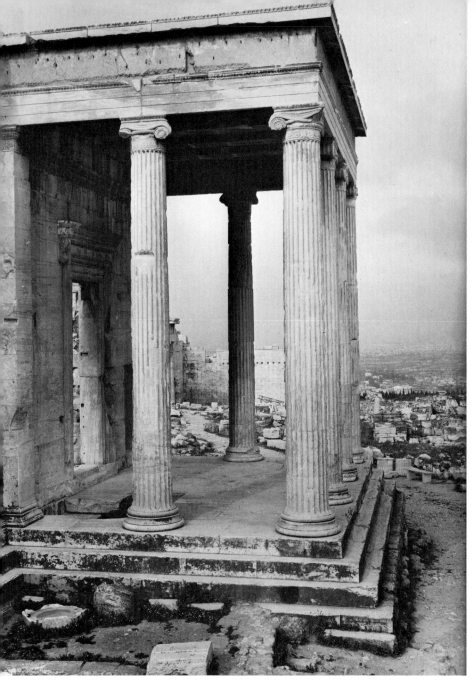

124 The Ionic north porch of the Erechtheion, on the Acropolis at Athens, from the east. The holes which fastened the frieze figures to the darker backing marble can be seen just below the roof. Built intermittently between 421 and 405 B C

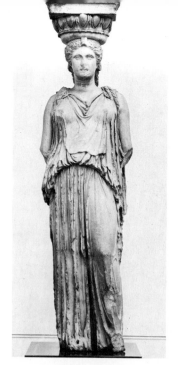

125 A Caryatid from the south porch of the Erechtheion. The figure is in London and is the best preserved; those in Athens have now been removed from the building and from exposure to the damaging atmosphere of the city, to the Museum. *c.* 410 BC

fine floral carving on the column necks and walls, and the carved external frieze serve as a foil to the austerity of the Doric Parthenon only fifty yards away. Its most unorthodox feature was the veranda-like porch, inaccessible from outside, whose flat roof was supported by six statues of women – the Caryatides (one in London). These figures perform their functions as pillars with some grace. The *peplos* hangs close to the body but the flow of the material is broken by the lively, deep-cut folds, in bold contrast to the Early Classical *peplos* figures, and the straight folds covering the leg which is braced to take the weight recall the flutes of the column we would normally expect in this position. 125

The Ionic order of the Erechtheion offers more contrast with the Ionic of the Archaic period, than does the Doric Parthenon with its predecessors. In the capitals concave channels in the volutes were now the rule where earlier, but for rare and primitive exceptions, they were plump convex. In the Erechtheion capitals there are even double channels, and the usual eggs and darts between the volutes have a cable pattern above and a floral band (as in Archaic Samos) below. There had been some variety in the bases too, the Erechtheion having a type developed in Attica. The shafts have twenty-four flutes, with flat ridges between, against the Doric twenty with sharp ridges; and the Ionic column as a whole retains its tall slim proportions against 58

the squat Doric, which made it a natural choice for positions where the mass of a Doric colonnade could have looked unbearably heavy.

A visitor to the Acropolis would have done well to save for the end his inspection of the little Temple of Athena Nike, on the bastion overlooking the entrance. It was a small Ionic building, erected over what had become the traditional position for this shrine, a mirror in miniature of the more elaborate Ionic of the Erechtheion. A low stone balustrade surrounded the sanctuary, and the relief carving upon it offers perfect examples of the statuary style typical of the end of the fifth century, successor to the rather heavy and Classic idealism of the Parthenon. Figures of Victory are shown in a frieze leading animals to sacrifice and erecting trophies. The thin material of their dress is pressed so close to the body that some are in effect nude studies, the transparency and swirl of the drapery lending emphasis to the form of the body, and not either concealing it or having a mass and movement of its own apart from the body beneath. The treatment of drapery and of the human body, especially of women, has come a long way since the sculptures of the beginning of the fifth century.

126

126 Figures of Athena and a Victory (*Nike*) from the balustrade round the Temple of Athena Nike on the Acropolis at Athens. *c.* 410 B C. Height 87 cm

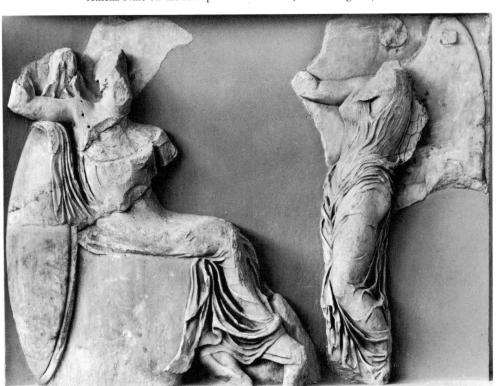

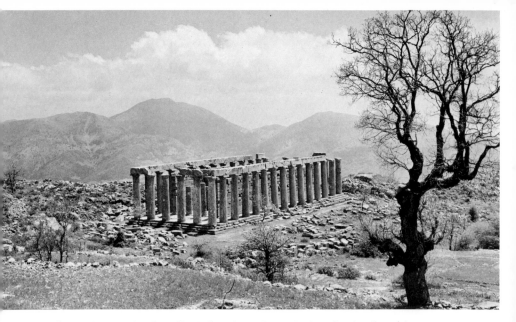

127 The Doric Temple of Apollo Epikourios at Bassae in Arcadia. Attributed in antiquity to Ictinus, the architect of the Parthenon. Built in the second half of the fifth century B C

Down in the city of Athens there were other buildings which attested the civic pride and scope of the Periclean building programme. Among the temples the Hephaisteion (often still called the 'Theseion') stands still well preserved, a smaller and less subtle building than the Parthenon. On it, too, there were friezes within the outer colonnade, but only at each end and not all round, as on the Parthenon. One end showed the now familiar fight of centaurs and Lapiths. The view in our picture is from the angle at which all such carved decoration was *119* seen in the colonnades, as in the Parthenon or at Olympia (for the metopes). It hardly does justice to the proportion and detail of the figures, and the lighting, here facilitated by the absence of the roof, would have been wholly from the reflected light of the bright marble surfaces around: barely adequate by any standards.

As well as temples Athens now reared monumental public buildings – law courts, council-halls and the *stoa* colonnades which provided offices, shops or shelter for the passer-by and which were to become an important feature of Greek market-places. Outside Athens the same new trends in sculpture and architecture were observed in

125

other Greek cities, and because we turn to Athens as the yardstick for the excellence and good preservation of its marbles, we should not forget the other flourishing schools in the Greek world. At Bassae, near Phigaleia, hidden in the mountains of Arcadia, stood a Doric Temple of Apollo said to have been designed by the architect of the Parthenon himself, Ictinus. Although intact to just below its roof it was lost to the Western world until 1765. Provincial in position and workmanship, it incorporated dramatic new features: a side door to the *cella* with the cult statue facing it, Ionic capitals of unique pattern with high swinging volutes for the engaged columns in the *cella*, and a single example of a new type of capital, the Corinthian. This has

127

128

128 Restored drawing (by F. Krischen) of the interior of the Temple of Apollo at Bassae. The Ionic columns are engaged on the side walls, and at the end stands one Corinthian column, opposite the side door (invisible). For the frieze see *Ill. 129* and the restored cast in *Ill. 4*

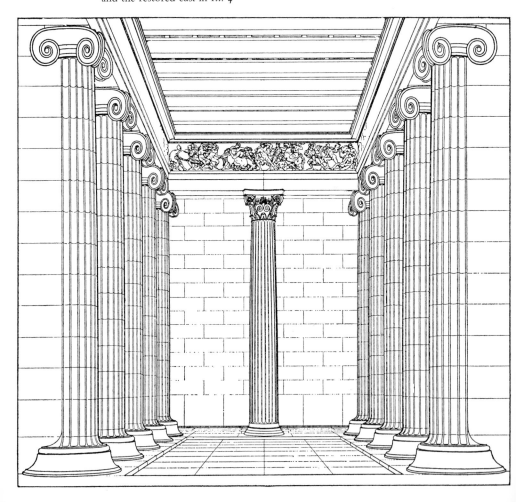

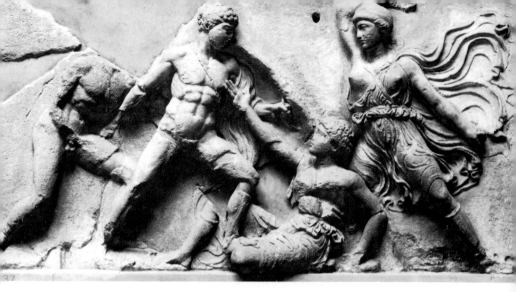

129 A slab from the frieze within the cella of the Temple of Apollo at Bassae. Fight of Greeks and Amazons. *c.* 400 BC. Height 63 cm

small volutes at each corner and a girdle of acanthus leaves beneath. It was more versatile than the Ionic capital, offering the same aspect from all sides, and it served the same type of column and other mouldings, but not until the Roman period did it become really popular. This temple, too, though Doric, had a frieze, here running round the top of the wall inside the *cella*. The stockier, more athletic figures of Greeks and Amazons, Lapiths and centaurs, are in marked contrast to the Classical Athenian style, but betray characteristics which had long been the hall-mark of sculpture in southern Greece. The drapery has the clinging quality we observed at Athens towards the end of the fifth century.

129 (cf. 4)

For the other achievements of this High Classical period, we have to turn to tantalizing fragmentary works which still carry something of the Phidian dignity of the Parthenon. After much of the work on Athens' public projects was done the sculptors turned again to the carving of relief tombstones, generally with two-figure groups of a seated woman with her maid or husband bidding his wife farewell. The unruffled dignity of the Classical convention is perhaps seen at its best on these reliefs. Something of the same quality is apparent in a type of statue in the round, of a mourning woman, which first became popular in the middle of the fifth century. The pose was employed for the figure of Penelope, grieving over her lost Odysseus,

130

as well as mortal mourners. Votive reliefs portray deities, occasionally mythological scenes, rarely the worshipper himself. A different class of relief appears at the head of inscribed decrees on some of which the personifications of States (their patron deities) seal with a handshake the treaties inscribed below them.

The children of Niobe, struck down by Apollo and Artemis, were the subject of the pediment from some unknown temple. The sculptures had been taken to Rome in antiquity and some pieces have survived. The girl shown here is a good example of the sympathetic

130 Fragmentary statue of a mourning woman – the so-called 'Penelope' type – shown with her right arm resting on her knee; the hand would be at her cheek or chin. Found at Persepolis. Greek work of the later fifth century B C

131 Votive relief from near Athens. The hero Echelos abducts Basile. The other side of the relief shows a river-god and nymphs, and is inscribed with a dedication to Hermes and the nymphs. *c.* 400 B C

treatment of adolescent form which can be remarked at Olympia. But there is nothing sensual in this treatment, and the sculptor remains less interested in the female figure than the male. Man was the measure of all things to the Greeks, and the artist's aim was to portray him at his idealized best, indistinguishable from the gods whom he conceived in man's likeness. The heroic nudity of the gods, warriors and mortals shown by artists was a natural expression of the Greeks' open admiration for the perfectly developed male body, and would not have seemed so strange in a society where athletes regularly trained naked and in public, and where clothing for men seems often to have been minimal. The idealization of the female nude in sculpture, with its elimination of all detail, even hair, in the genital area, presents a rather

129

odd contrast with the explicitly detailed male. The use of colour on statuary, which would have heightened the realistically naked effect, remained normal through the Classical period and we hear of the association of distinguished painters and sculptors. Later it seems to have become less common, perhaps not used at all on Roman copies, and this, plus the loss of colour through time and burial, determined the Renaissance's colourless view of the Classical nude.

Perhaps we make too much of the Greek 'cult of the nude', which reflects rather the popular and uncritical attitude of a hundred years ago to anything Classical, and was encouraged by the Renaissance's often far less healthy preoccupation with the same theme, and its more sensual aspects. But after the fifth century the full sensual appeal of white marble *was* exploited, as we shall see, and our appreciation of realistic or semi-realistic representations of naked bodies is inevitably

132 A daughter of Niobe, falling, struck in the back by a shaft for which she gropes. Two other pieces from the group are known. *c.* 430 BC

130

133 Marble head, probably from the colossal cult statue of Asclepios on the island of Melos. *c.* 330 B C. Height 59 cm

conditioned by this sensual appeal. How far is the quality of the modern response to and appreciation of Classical statuary determined by the sex of the connoisseur or scholar?

FOURTH CENTURY

The fourth century was a troubled time for the Greek world. Athens struggled to regain her supremacy, while new powers and leagues arose to challenge her position and that of Sparta: first the Thebans, then the Macedonians, and it was the Macedonian Alexander who, from 336 to his death in 323, completely changed the course and climate of Greek life and political thought. In the arts this century saw important innovations and experiment, although still rigidly within the framework of the fifth-century Classical tradition. The ethos of Phidian sculpture pervades still the more sober studies, like those of senior divinities. In sculpture greater attention is paid to figures in the round, and a final break made with the earlier one-view figures in compositions which positively invite the spectator to move round them by the twist of the body, by contrasted directions of gaze and gesture, or by a pose which from no one position offered a fully

131

134 A nymph from the 'Nereid
Monument' (a funeral monument)
at Xanthos in Lycia. *c.* 400 BC

satisfactory view of all important features. All this lends a sort of con-
trolled restlessness, which is only to break out into near-Baroque
abandon in the succeeding period. Drapery is treated with greater
134 skill and virtuosity. The transparent drapery which leaves the body
beneath almost naked remained popular, but also admitted in time
the presence of the folds of under-garments.

In the treatment of the naked body it seemed that all anatomical
problems had been solved and attention could be paid to the quality
135 and texture of the flesh and muscle. This leads for the first time to a
deliberate sensuality in the carving of statues of women. At the end
of the fifth century Aphrodite could be shown in closely clinging

132

135 Bronze statue of a boy, retrieved from a wreck off Marathon. It is in the
Praxitelean style. The eyes are inset limestone, with glass pupils; the nipples are
inlaid with copper. *c.* 340 B C. Two-thirds life-size

136 (*left*) Hermes holds the infant god Dionysus. Perhaps an original work by Praxiteles, which stood just within the Temple of Hera at Olympia. *c.* 340 BC

137 (*right*) Seated figure, perhaps a cult statue, from the sanctuary of Demeter and Kore at Cnidus. The head was made in a separate piece of the same stone (Parian marble). Perhaps the work of Leochares. *c.* 330 BC. Height 1·02 m

drapery. Now she is naked, and so successful was Praxiteles in his cult statue of the goddess in Cnidus that (in later times) the marble was exhibited under peep-show conditions and was the object of indecent assault. The illustration shows a Roman copy.

145

 Certainly a new dexterity in the carving and finishing of white marble contributed to this effect. We can judge it from the Hermes at Olympia, almost certainly from Praxiteles' hand, though no doubt waxed and polished by generations of temple attendants. The relaxed languor of the figure just stops short of effeminacy. The athletic

136

statues of the day present new proportions – heavier bodies, smaller heads. In the treatment of the heads themselves there is the same softening and relaxing of the set Classical features which can be observed in the carving of the bodies, but the conventions of the ideal Phidian head were not forgotten. For deities or figures at rest the convention is a satisfying one. Its unreality when applied to figures in *137* violent action or under the stress of emotion was at last acknowledged. An intensity of expression was realized by sinking the eyes deep below the forehead, and even the more placid figures take on a serious and thoughtful air. This treatment applied to the two-figure groups on Athenian grave reliefs heightens and charges the atmosphere, and for *138* the first time we have studies in grief, conveyed by features as well as

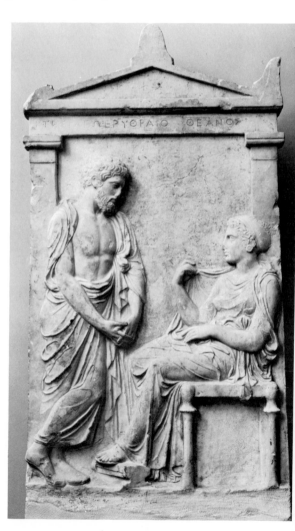

138 Gravestone of Theano, who is shown here seated before her husband. The architectural setting, with the pediment above, is the rule in Athenian gravestones of the fifth to fourth centuries B C. *c.* 370 B C. Height 90 cm

pose and gesture. The figures are cut nearly in the round on some of these monuments, and the deep shadows behind them, together with the more restless, turning postures, enhances the effect of both spatial and emotional depth.

PORTRAITURE

It was a short step from this to the representation of more violent feelings, and in an age of great names – generals and emperors – experience gained in portrayal of individual emotions was readily transferred to the problems of individual portraiture. At first the subjects chosen were the great men of the past, artists and politicians. As there can rarely have been any contemporary portraits of them, other than written descriptions, the heads were more like characterizations of a personality in the light of what was known of his temperament and achievements. This almost idealized portraiture remained a feature of Greek work. It tried to express ethos at the expense of realism, where Roman portraiture (or rather, portraiture for Romans, since Greek artists were still normally the executants) sought this end through the more limited, but equally effective means of sheer realism.

On the fringes of the Greek world portraiture of contemporaries was admitted even before Alexander the Great's appointment of a Court Artist for this work. The Carian dynast, Mausolus, had built for him by his widow a massive tomb (which gave its name to all subsequent 'mausolea') on which the King may have been shown *139* in a portrait statue. The sculptured decoration of the Mausoleum at Halicarnassus was by Greeks, and its friezes exhibit the artist's confidence in all variety of poses for men and animals, and a new approach to the rendering of flying drapery which is used to help to bind the whole composition and not merely to enhance individual figures.

ARCHITECTURE

Monumental tomb architecture was still unknown in Greece itself, but there was a growing variety of other monumental buildings, both temples (fewer with elaborate sculptural decoration now) and public buildings. Theatres now regularly received elaborated entrance passages. The stage buildings were given architectural façades, usually functional, for stage front and scenery, but nothing yet to rival those of the Roman period. Tiers of carved marble seats replaced the bare slopes of the hillside which in earlier theatres overlooked the flat *140* dancing-floor – *orchestra*. Colonnades and façades are bound still by the Classical orders, but increasing use is made of the Corinthian

136

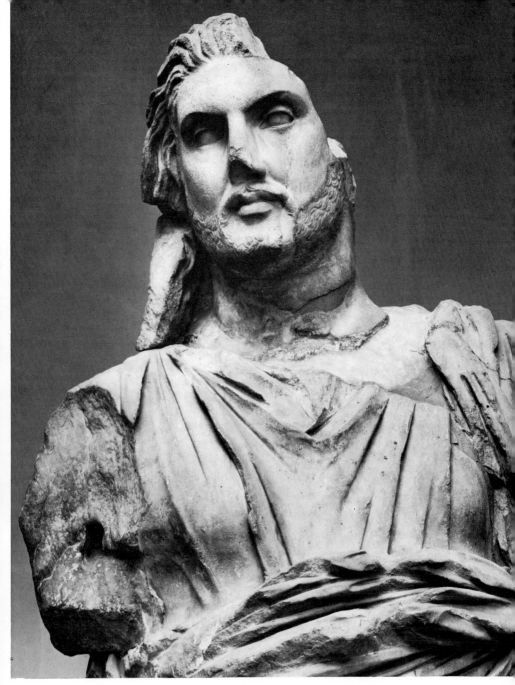

139 Portrait statue of Mausolus (?) from his tomb (the 'Mausoleum') at Halicarnassus. The Carian's un–Hellenic features and wild hair are faithfully copied by the Greek sculptor. Third quarter of the fourth century B C. Nearly twice life-size

capital, and interesting new ground-plans are developed. There had
been circular and apsidal temples in Greece before the Tholos at
142 Delphi, but here the canonic Doric order of the outer colonnade was
answered by slim Corinthian columns engaged on the interior of the
walls. Yet another circular building offers an example of the new style
in subsidiary decoration – the plump and pithy Archaic florals trans-
lated by now into writhing hothouse shrubs at the sanctuary of the
healing god Asklepios, at Epidaurus, where we have the Classic
141 statement of what a Corinthian capital should be. Among other
monumental buildings we find now council-houses and music-halls,
stoa shops and hotels. The city-states were becoming better and better

140 (*above*) Reconstruction draw-
ing of the theatre at Priene in its
Hellenistic form, with a raised stage
and panels between the engaged
columns for setting stage scenery.
The theatre seated more than five
thousand

141 (*left*) A Corinthian capital from
Epidaurus, evidently a model pre-
pared by the architect Polyclitus
for capitals installed on the Tholos.
Mid fourth century BC. Height
66 cm

142 The Tholos on the lower sanctuary terrace (Marmaria) at Delphi. Built from the plans of Theodorus of Phocaea, whose book about the building has not survived. Early fourth century B C

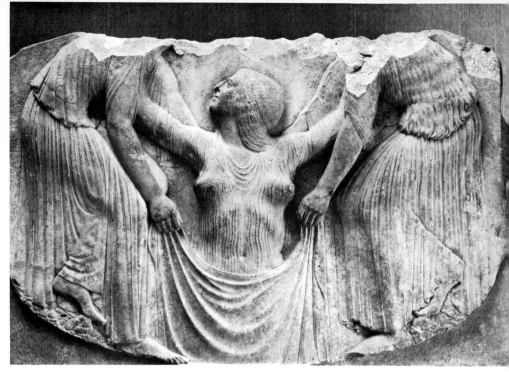

143 Front of the so-called 'Ludovisi throne', which may be part of an altar. The goddess Aphrodite is assisted from the sea by two nymphs. Found in Rome, perhaps the work of a western Greek sculptor, *c.* 460 BC. Width of front 1·4 m; original height *c.* 1·02 m

equipped with public buildings to serve their citizens, while private architecture remained unpretentious; but the day of the palace and luxurious private house was not far off – when new public buildings in old Greece were as often as not the gifts of princes overseas.

Before we leave the monumental arts of Classical Greece there are two other subjects to consider briefly: one concerns the Greeks in colonies, the second, our evidence for the famous lost works of Classical sculptors.

WESTERN GREEKS

The Greek cities in Sicily and south Italy were founded in the later eighth and seventh centuries B C. They quickly grew rich and powerful, in the early fifth century they resisted the power of Carthage successfully, and they were soon being courted by the cities of mainland Greece for their support in internal disputes. Their rulers and tyrants made great show in Greece, with their victories in the Olympic

140

chariot-races, and no mortal prince of that day could have wished for more.

The outward signs of the wealth of the Western cities are the temples they built at home, and the pavilions and presents they dedicated at *114* the major sanctuaries of the Greek homeland. Their architecture was predominantly Doric but it admitted Ionic details, and even sometimes Ionic columns. In the wide spacing of porches and colonnades some of the temples seem to be deliberately planned in emulation of the great temples built in east Greece. The western Greeks lacked a ready supply of fine marble, such as was available in the Greek islands and Attica, and as a result their architecture is largely of limestone, stuccoed over, and they paid more attention to major sculpture in clay. But some marble was imported from Greece and important works were executed by local artists. Indeed, there is also record in *143* ancient authors of Greek artists emigrating to the Western colonies. The style of their work is generally conservative and often lacks the delicacy of treatment which we observe in Greece itself. The Archaic conventions of dress and features died hard and the severe style of the first half of the fifth century lingered on. The full Classical style is poorly represented. Our main interest in the art of the western Greeks lies in the fact that it was their rather provincial versions of Greek art that had a profound effect on their immediate neighbours, the Etruscans and Romans.

COPIES

The account of Classical sculpture given above is based primarily on the preserved original works and the evidence of date given by style, context or inscriptional authority. Few statues have survived which either carry their artist's signature or can be identified in the references of any ancient author who names the artist. But we know the names of the great men whose work set new standards for their contemporaries. They are preserved in the writings of scholars, encyclopaedists and travellers of the Roman period. These writers often describe the most famous and influential works, and it has sometimes proved possible to recognize surviving copies of these statues, which had been made for Roman patrons and others while the original work still stood. Comparing copies of the same work, and on rare occasions comparing copies with originals, we can see that many were probably most accurate, lacking only the artist's touch in the final carving of details and features, and sometimes adapted in pose or expression by the copyist. Another difference, readily recognized in marble copies of bronzes, is the addition of struts and supports (like tree-trunks) which were unnecessary to a bronze original.

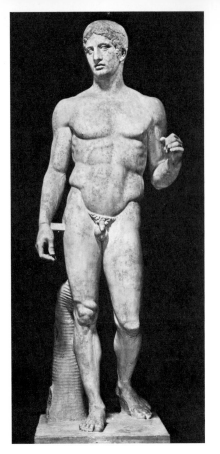

144 Copy of the Doryphorus of Poly-
clitus, a youth shouldering a spear. In
this successor to the *kouros* type the
weight of the body is now carried
wholly on one leg. The tree-trunk and
strut are copyist's additions. The
original was of *c.* 440 B C

With the help of these copies of works whose artists are named we
are able to associate with individuals and schools some of the innova-
tions observed in the surviving series of originals. This is their main,
perhaps their only value, and for this purpose some are illustrated here.
But it would be wrong to dwell too earnestly on details of carving
which may be far from their model.

It is comforting to attach names to periods and styles, and to indi-
vidual works. From the copies of Myron's Discobolus and his group
of Athena and Marsyas we can see that he contributed much to the
development of the full Classical style after the comparative severities
of Olympia and other work of just after the Persian Wars. Phidias'
guiding hand may be read into surviving statuary from the Parthenon,
but in copies of other statues by him we may judge better his personal
style and glimpse a shadow of the majesty of his finest lost works, the
great gold and ivory cult statues. Polyclitus' new canon of proportions

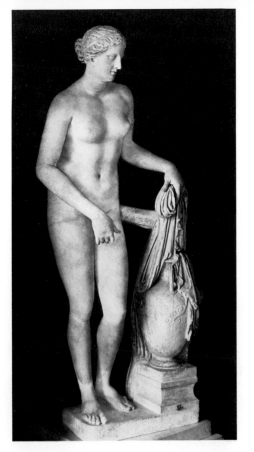

145 Copy of the Cnidian Aphrodite by Praxiteles. The goddess is shown leaving her bath. Her modest gesture recalls that of display made by the seventh-century Astarte–Aphrodite figures. The original was of *c.* 340 BC

and model for stocky athleticism is preserved in copies of his Dory-phorus. This seems to represent a conscious effort to supply a properly *144* worked out canon for the representation of the male body, and the artist wrote a book about it. Another story, about a competition between famous artists at Ephesus, enables scholars to dispute the attribution of differing copies of wounded Amazons to Phidias, Polyclitus, Cresilas or Phradmon. Alcamenes' Aphrodite in the Gardens may have been one of the earliest statues to wear the exag-geratedly transparent drapery. What we think to see of Praxiteles' style in the surviving Hermes of Olympia is confirmed by the other statues *136* attributed to him and of which copies exist. His naked Aphrodite for Cnidus was copied time and again, but it is hard to see beyond the *145* copies what there was to their original which made it so famous, apart from its suggestive near nudity. Scopas' style seems to have been more vigorous and work from his hand may be preserved in

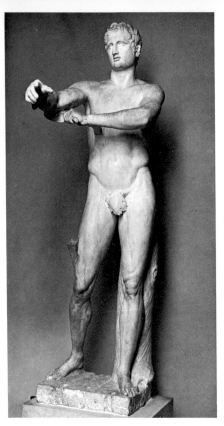

146 Copy of the Apoxyomenus by Lysippus. The young athlete is scraping the oil from his forearm with a strigil. Once wrongly restored with a dice in his outstretched hand following a misreading of Pliny. The supports for leg and arm were required by the ancient copyist, rendering bronze in marble; the fig leaf, by modern prudery. The original is of *c.* 320 B C

fragments from the Temple of Tegea. We can judge something of his style – the intensity of expression and swirling compositions which look forward to Hellenistic statuary – in copies of works like his

146 Dancing Maenad or Meleager. In copies of Lysippus' statues we have the new, fourth-century, canons of proportion for the human body, and we can also judge how much Alexander's favourite artist did to break with the one-view frontality of most Classical statuary. We learn too that Lysippus and his brother were the first to use casts from life in their studio. These are all names and facts which lend life to a subject which seems beset with anonymity, but they are the trappings only, and our conception of Classical statuary must be gained from what has survived, with or without an artist's name, and not from the copies. Yet Greek sculpture is still often taught with reference primarily to ancient texts and Roman copies, and it is not surprising that many people remain unaware of its quality until they are faced by original works, and until the postcard views of the copyists' gods, heroes and girlies have been set aside.

144

Other Arts in Classical Greece

There is no one art in Classical Greece that is without its masterpieces. We might add almost that there is no period in which the Greek artist did not realize his full potential, limited only by the available techniques and materials, which he soon mastered: no period of incompetent experiment – no period of effete decadence. If we have dwelt upon sculpture and architecture it is because it was these monumental arts which had the more profound influence on the later development of Western art. Despite the individual brilliance of particular sculptors, painters, engravers, jewellers and workers in bronze and clay, there is still an overriding unity in style which informs the work of each generation in whatever material and at whatever size. This might not seem so surprising in such a small country, but we have to remember too the many different artistic centres and the intensive activity of the major artists, many of whom may have turned their hands to more different crafts than our texts record or our wits can identify. The display of dedications in the great national sanctuaries may of course have contributed to this unity, but it is more difficult to distinguish the works of different schools in the fifth and fourth centuries of Greece than to distinguish the paintings of Cinquecento Florentines and Venetians.

CLAY FIGURINES

The correspondence between a major and a (miscalled) minor art is well illustrated by the clay figurines which so closely match the larger works in marble. There were, in fact, also some large clay sculptures in Greece, but these represent a legacy of Archaic practice and are not common. The smaller clay works are found still as offerings – standing or seated figures of worshippers or divinities, and beside them more original studies of mortals or animals, the sort of thing that was probably becoming more common in the house as well as serving as a dedication in grave or sanctuary. Hollow masks, intended to hang from the wall, were another form of clay votive, and we see them shown on vases hanging, for example, by a bronze sculptor's furnace, to solicit divine protection for the firing. In the later fifth and fourth

145

147 Clay group of actors dressed as an old woman and a man. They wear masks and the man has the usual comic costume of padded tunic, phallus and tights. Mid fourth century BC

centuries the small clay figures offer a variety of subjects which the sculptor generally ignored. Of particular importance are figures of
147 actors, which can tell us much about the dress and masks worn on the
148 Athenian stage. Beside them are graceful genre studies of dancers and women at ease or in their best dresses, such as are to become charac-
212, 213 teristic of the succeeding Hellenistic period. The western Greeks were particularly adept at preparing fine moulds for such figures, and they also provide examples of a different sort of votive, the clay relief plaque. Locri, in south Italy, has yielded an important series of Early
149 Classical plaques with ritual scenes. There are others from Tarentum, while in the Greek homeland the island of Melos produced a notable

146

148 Clay figure of a dancing maenad wearing a fawn-skin over her dress and holding a tambourine. From Locri, south Italy. *c.* 400 B C. Height 19 cm

149 (*below*) A clay plaque from Locri. It shows Aphrodite in a chariot, with Hermes just mounting. The chariot is drawn by Eros and Psyche (?) carrying a cock and a perfume-flask (*alabastron*). *c.* 460 B C. Height 23 cm

series of cut-out plaques showing mythological scenes. Later on we find gilt-clay *appliqués* used in various parts of the Greek world to decorate wooden boxes and coffins.

Coroplast and vase-painter often collaborated in figure vases. These are usually elaborate cups, in the form of human or grotesque heads, or sometimes of more complicated groups. The animal-head cups copy a familiar Eastern form, and there are clay versions of the more expensive metal cups in this shape, either painted or in relief. Some of these are not simple cups but *rhyta* – pourers – for their mouths are pierced. This is a version of an Eastern type of ritual vase, and there are also many examples in which the drinking-horn shape is closely followed.

150
151

150 Clay vase in the form of a Negro boy attacked by a crocodile. The neck was painted with satyrs and maenads, in the manner of the Sotades Painter. *c.* 460 B C. Height 24 cm

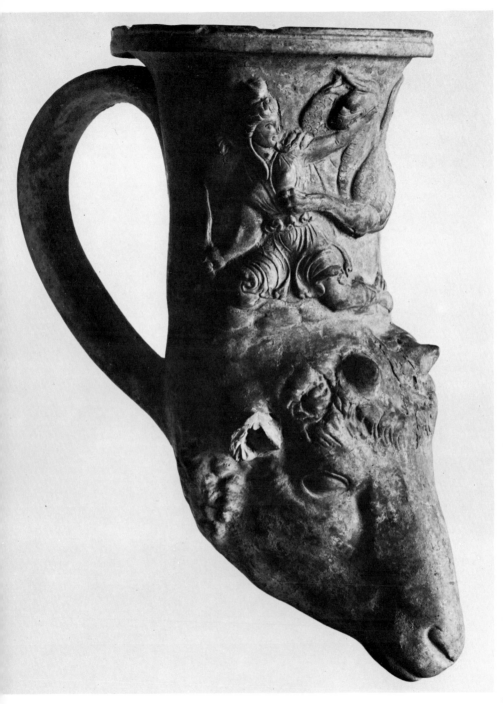

151 Clay cup in the form of a sheep's head. The relief group on the neck shows a
fight between a griffin and an Amazon, probably copied from a metal relief. Made in
south Italy. Fourth century BC

Decorative bronze-work in relief was more often now cast, the linear details being incised on, and occasionally patches of precious metal inlaid. This sort of work at times produced figures in exceptionally high relief and most delicately modelled. It appears on vases but on other objects too – the cheek-pieces of helmets, belt-clasps, and the folding backs of circular mirrors. The reflecting surface of the mirror was a bright, polished bronze, and this may remind us that all ancient bronzes, fresh from the artist's studio, had this bright appearance, far warmer and more realistic than the dark patina of age or the chocolate-

152

152 Bronze mirror-cover with relief scene of a tired or drunken Herakles with a nymph. Fourth century B C

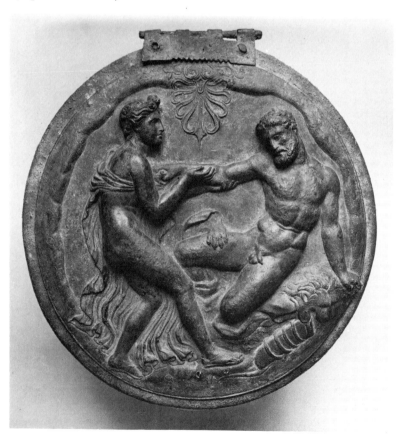

153 Bronze mirror-cover, with incised design of Aphrodite teaching Eros how to shoot. Fourth century B C

coloured surface produced by some modern cleaning methods. Incised lines would stand out black on the light surface, and there is an important class of mirror-covers with incised scenes only upon them, *153* which were as popular as those with reliefs.

The practice of casting handles and decorative attachments for bronze vases continued from the Archaic period, with less variety of subject than hitherto; sirens adorn handle bases, heads their tops.

154 Occasionally figures in the round appear on the lip or shoulder of the larger vases – another Archaic practice; or a whole relief group is fastened on the body of the vase beneath the handle. The figures of women supporting mirror-discs survive also, and in the details of their hair and drapery they follow closely the patterns of contemporary

155 sculpture. They often stand on neat, folding stools, while figures of Eros fuss around their heads, and tiny animals and florals run over the attachment to the disc and round it. This sort of finicky embellishment

154 Detail of reclining satyr from the shoulder of a large bronze *crater*, the body of which is decorated in relief with Dionysiac scenes. Found in 1962 in a tomb at Derveni in Macedonia, where it served as an urn for the ashes. It also contained a gold coin of Philip II. Late fourth century B C

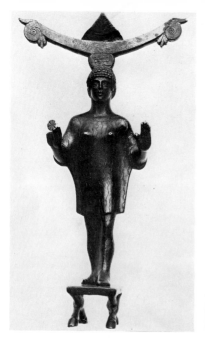 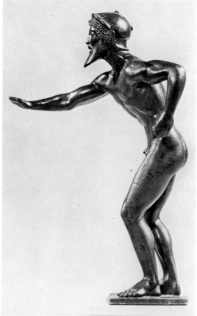

155 (*left*) Bronze mirror-support. The woman is wearing a *chiton* and pointed slippers. She stands on a stool with animal's legs. Early fifth century B C. Height 24 cm

156 (*right*) Bronze figure of an armed runner (*hoplitodromos*). He is in the usual Greek starting position, with one foot only slightly in advance of the other. *c.* 480 B C. Height 16·5 cm

157 (*below*) Bronze statuette of Pan from Arcadia. He stands shading his eyes. Mid fifth century B C. Height 9 cm

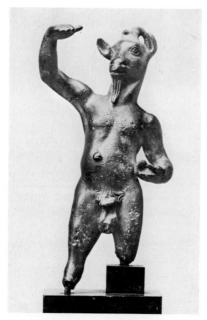 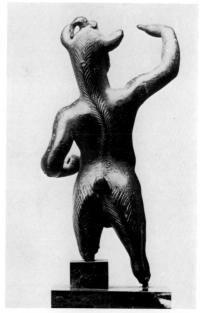

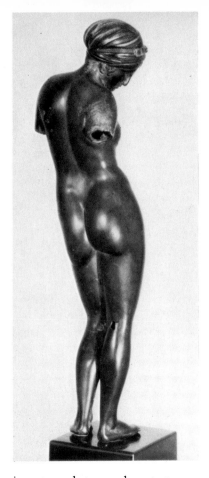

158 Bronze figure of a naked girl from Verroia in Macedonia. Late fifth century B C. Height 25·5 cm

156, 157

158

is not much to modern taste nor easily reconciled with the popular idea of Classical simplicity. In the free-standing statuettes of bronze we also see a greater variety of figures – athletes, deities, dancers. In much of this sort of work we begin to feel perhaps for the first time in the history of Greek art, that the artist is producing an object which has no function but to please mortal eyes, something which is more than a decorative addition to an implement or article of toilet, more than a proud expression of wealth or piety in a god's shrine.

Major works of bronze sculpture have to be discussed in terms of contemporary marble sculpture. Pitifully few pieces have survived but enough to show that, for all the technical differences, there were no very distinct idioms for work in bronze rather than marble. The big statues were cast hollow, by the *cire-perdue* method, as were the larger statuettes; the other bronzes mentioned were cast solid.

154

Precious metals were used for the small vessels, especially with hammered or cast relief decoration. A special class is formed by *phialae*, shallow bowls with small round centres (navels – *mesomphalic*) beneath which the fingers would fit. From representations on vases we *159* see that they were particularly used for pouring libations, and at an earlier date, at Perachora, bronze *phialae* seem to have been thrown into a lake and oracles taken from their behaviour – sink or swim. The jeweller had mastered the arts of filigree and granulation, and oc- *160* casionally now inlays of coloured stones or enamel are to be found. The tombs of south Russia, both those of the Greek colonies and those of the neighbouring Scythians for whom Greek artists worked, are a rich source of fine Classical gold-work. The Solocha comb is a masterpiece of miniature statuary in gold, illustrating a local en- *161* counter. Signet-rings of solid bronze, silver or gold become common

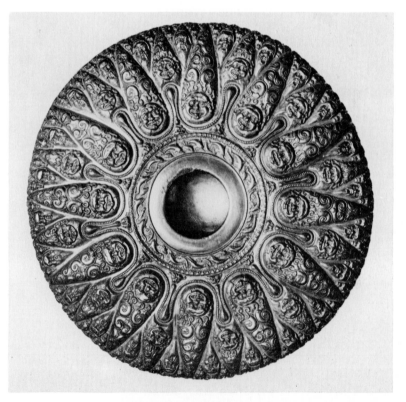

159 Gold *phiale* from a Scythian tomb at Kul Oba in south Russia. The basic floral pattern is covered with heads of gorgons, men and animals, while dolphins and fish encircle the central 'navel'. The same tomb held the ivory plaques, see *Ill. 164*. Fourth century B C

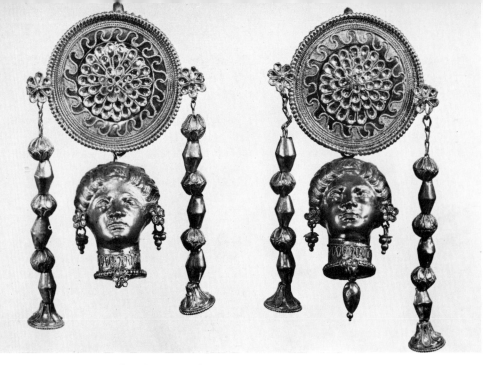

160 Pair of gold ear-rings from Tarentum with wire, granulation and enamelled patterns on the discs and pendant heads of women. Fourth century B C. Height 6 cm; diameter of disc 2·2 cm

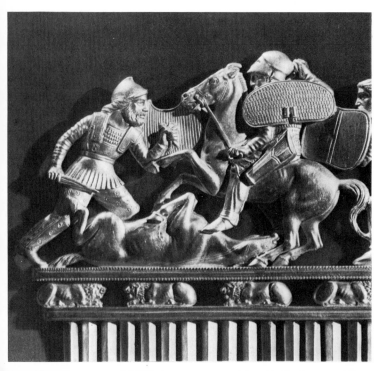

161 Detail of the handle of a gold comb from Solocha in south Russia. The figures are executed wholly in the round, standing only 5 cm high

for the first time in the fifth century. The devices on them are often of women, seated or standing, with wreaths or a tiny Eros, or of Victories (*Nikai*). They were probably as much decorative as personal seals. Impressions from them are commonly found on clay loom-weights. They may have been more popularly worn by women, but it is odd that they are not worn by any of the figures shown on contemporary vases, which otherwise give us vivid details of dress, jewellery and furniture.

Engraved gem stones could also be set on swivels and worn as finger-rings, or be worn as pendants on necklaces or wristlets. The practice of setting an engraved stone immovably in a metal ring only becomes at all common towards the end of the Classical period. The scarab-beetle form of seal remained popular for a while after the Archaic period, but was generally replaced by the plainer scaraboid form with a domed back. The stone is usually larger now – of chalcedony or white jasper, and the subjects are somewhat more limited. Studies of seated women and of animals are particularly common. Few artists' signatures are preserved, but we know one, Dexamenos of Chios, who in the second half of the fifth century cut a brilliant portrait head and some sensitive and detailed studies of birds and *162*

162 Flying heron on a chalcedony gem signed by Dexamenos of Chios. *c.* 440 BC. Width 2 cm

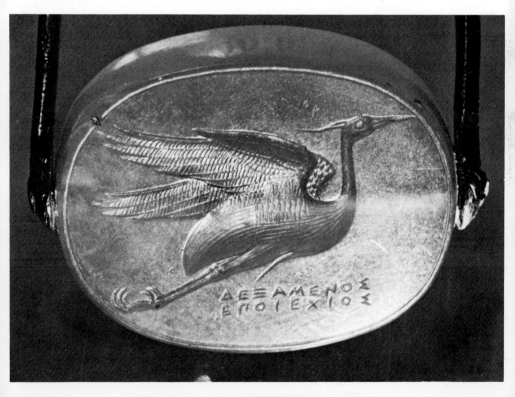

horses. Gem stones of this type were popular all over the Persian Empire, and there is a large class, made in the East, which owes as much to Greek as to Eastern models. The arts of the Persian, Achaemenid Empire, give us a further glimpse of the return current of ideas and art forms, from West to East.

COINS

163
The related art of the engraver of metal dies from which silver coins were struck flourished beside that of the gem-engraver. We may suspect that the same artists were involved but this is hard to prove from style alone since the techniques of die-engraving were coarser than those of gem-engraving, and there are more signed coin dies than signed gems. In the heads of deities and, later, of princes and kings, which appear on many coins we see a fully sculptural style and often unusually high relief – a positive disadvantage in objects so much handled and so easily rubbed, and particularly unfortunate when frontal heads were attempted. There is a great variety of animal studies too – greater than that offered by gems because coins were mass produced and more different types have survived, while each gem was a unique creation. Conservatism dictated the devices on the better known issues of coins, which relied on the ready familiarity of the types. But although the devices on coins of States like Athens and Corinth change but slowly, other States issued a succession of types with brilliant and different devices, sometimes with an abandon rivalling that of the postage-stamp issues of some countries today. A few issues commemorate particular events or are at least occasioned by them, and in this way have combined the characters of medallions and coins.

PAINTING

Of all the major arts of the Classical period painting on wall or panel is the one about which we know least, although in antiquity it was most highly valued. The names of such painters were honoured and remembered, which is more than can be said of any vase-painters. We read of the great paintings by Polygnotus and Mikon on the public buildings of Athens and Delphi in the years before the mid fifth century. These early paintings were, we are told, done in a four-colour technique – black, white, red and brown, and Polygnotus especially sought to express emotion or atmosphere by nuances of pose or gesture, often repeated on vases or sculpture (as the Penelope type). To later artists are attributed notable innovations in shading, in

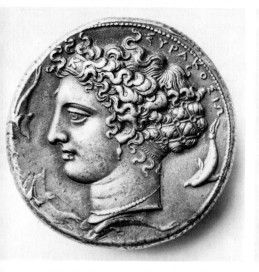
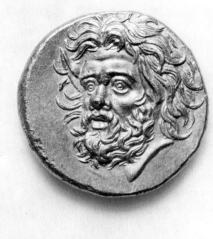

163 (*left*) A silver coin of Syracuse with the head of the nymph Arethusa surrounded by dolphins, *c.* 405 B C; (*right*) a gold coin of Panticapaeum, a Greek colony in the Crimea, with the head of Pan, *c.* 350 B C

suggesting depth and roundness, and in *trompe l'œil* compositions. Of all this we can know nothing beyond the suspected influence of such work read in contemporary vase-paintings, and works like the ivory plaques found in south Russia, which were once painted, although now only the incised outlines of the figures are at all clear. The paintings in Greek-built tombs of south Italy can tell us hardly anything of the finest styles of mainland Greece.

164

Famous Classical paintings were often copied, like the statuary, but the wall-paintings of Roman Pompeii and Herculaneum translate their originals in a way that makes it an even more difficult matter to recover an idea of the model than it is with copies of sculptures. Only the new finds in the royal Macedonian tombs show us how brilliant the panel paintings of the day must have been, and their successors of the third century confirm a quality unmatched on Roman walls. The techniques of shading and a rudimentary perspective (never totally understood in antiquity) were slowly mastered. A mirror of the painting can be seen in the pebble mosaics decorating floors from about 400 B C on. Otherwise we have only some poor painting on tombstones. The linear effects of earlier painting were being abandoned for realistic effects of colour and chiaroscuro, but we have rich evidence for superb line drawing on vases, and to these we may now turn.

165
231

233

164 Incised and painted ivory plaques from the coffin in a Scythian tomb at Kul Oba in south Russia (whence the gold vessel, see *Ill. 159*). They show (*above*) women, and a youth in a chariot; (*left*) Athena and Aphrodite with Eros at her shoulder (from a Judgment of Paris scene). Fourth century B C

165 Painting of Hades carrying off Persephone on to his chariot. On the wall of a
royal tomb at Vergina. *c.*340 BC. The frieze is 1 m high

166 Red-figure *lekythos* by the Pan Painter, showing a huntsman with his dog. He wears the usual light cloak (*chlamys*) over a short *chiton*, and a sun-hat (*petasos*). *c.* 470 B C. Height 39 cm

VASE-PAINTING

Persian occupation of Athens in 480 and 479 B C drove the citizens and artists from their homes, and when they returned they had to build afresh. Old wells and pits in the neighbourhood of the potters' quarter are found filled with the debris from the potters' shops. But there is no significant break in production or style. The same painters are at work. In their hands the transition from Archaic to Classical was accomplished, as we have observed it already in the work of sculptors. The cup-painters continue the tradition of the early years of the century, but have at last abandoned the formal, almost Geometric fussiness of the Archaic pleats, and zigzag hemlines. The drapery is shaking out into freer folds. In details of drawing we find at last a proper view of a profile eye in a profile head. Bold foreshortening and three-quarter views are successfully shown and the artist can experiment further with pose and gesture to suggest emotion, and even give atmosphere to a scene where before a simple event was enacted by, as it were, lay figures.

162

A group of Mannerists, led by the Pan Painter, represent the old
guard, clinging still to some of the Archaic conventions and leaving
their figures to act with a stiff prettiness which seems awkward in the
hands of all but the best artists. The monumental styles of contem-
porary sculpture are best reflected in the work of artists such as the
Altamura Painter and the Niobid Painter. Their statuesque studies of
warriors and women are a close match for the *peplos* figures and heroes

167 Detail from a vase by the Niobid Painter showing Greeks fighting Amazons.
The latter wear Greek corselets over Oriental tights and the one shown here has a
leather cap. *c.* 460 BC

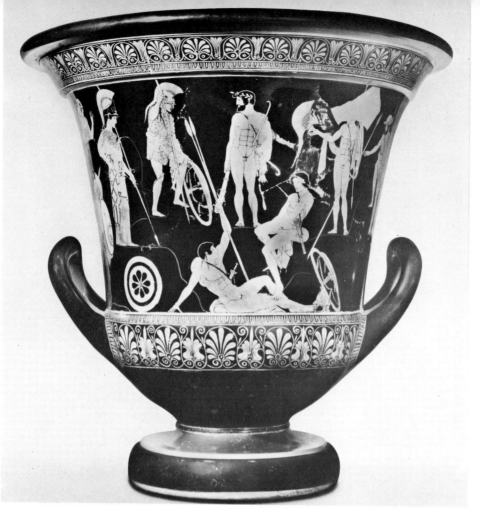

168 The reverse of the name-vase of the Niobid Painter, showing an assembly of heroes and gods. *c.* 460 B C. Height 54 cm

167 of, for instance, the Olympia sculptures, and their battle scenes must owe much to contemporary wall-paintings, both for subject and compositions. The Niobid Painter admits another feature which must be inspired by wall-paintings. He sets his figures on different ground lines up and down the field of the picture in the manner adopted by
168 wall-painters to suggest space and depth. The device is not particularly suited to vase-painting and the Niobid Painter's use of it is unique at this time, but it recurs on later vases.

164

169 Detail from a vase by the Chicago Painter, showing a girl playing the pipes for dancers. She wears the ungirt *chiton* usual for such artistes. *c.* 450 B C

The Chicago Painter and the Villa Giulia Painter offer more delicate and less ambitious styles beside the Niobid Painter's imposing compositions, and the lightest work of these years is that of the Pistoxenos Painter, or the Penthesilea Painter (in all but his name-vase where he crammed a composition from a wall-painting into a recalcitrant circle and spoilt the delicacy of his drawing by crowding detail). It is the sorry fact that when the vase-painters overreach themselves in their figure compositions, which are so seldom properly suited to the

169

170

curving surface of a vase, the quality of their work can be better appreciated in deliberately selected details, or even fragments.

The subjects shown on the larger vases are more often now of epic encounters between Greeks and Amazons, or Greeks and centaurs, inspired in part by contemporary wall-paintings, in part by the popularity of myths which seemed to reflect Greek supremacy over barbarians and Orientals just after their success against the Persians. Except for the work of a few cup-painters who retain the Archaic manner we miss the fine, though short-lived tradition of the free and original pictures of dancing and drinking-parties which were so popular early in the century. Their subjects may have been trivial but they released the painter from the iconographic conventions of the usual scenes of myth and let his fancy play over poses and situations of everyday life. There was promise in this Late Archaic exuberance of a whole new phase in Greek representational art, but it was stifled.

Wall-paintings showed their figures against a white background of paint or plaster. The red-figure vase-painter had eschewed the pale background of clay for his outlined figures but had experimented with a white-painted ground, such as late black-figure artists had sometimes used. The effect was of course closer to that of major painting but, at first, the figures themselves were drawn as if in red-figure and masses

170 A cup (*skyphos*) by the Pistoxenos Painter. The young hero Herakles goes unwillingly to school (he later slew his teacher) accompanied by an old Thracian woman, with tattooed neck, forearms and feet, who carries his lyre for him. *c.* 470 B C. Height 14·5 cm

171 A white-ground cup by the Pistoxenos Painter. Aphrodite riding a goose.
c. 470 B C. Diameter 24 cm

of different colour avoided. Moreover, the white ground was not
particularly durable. The interiors of some cups are painted on a
white ground in the second quarter of the fifth century, but the tech- *171*
nique came to be reserved for oil-flasks, *lekythoi*, which were mainly
intended as grave offerings and so did not have to survive heavy
handling or even exposure for much of their life. The earliest, with
figures such as the red-figure, and by the same artists, carry a variety of
scenes, but by the mid century the majority are decorated with *173*
appropriate funeral scenes showing the tomb with passers-by,
relatives or attendants bringing offerings, departure scenes, even the *172*
crossing of the Styx with the ferryman Charon. For these a new
technique was adopted. The outline and details of the figures are
drawn in mat paint instead of the brilliant black, and broad washes of
colour laid over drapery and details. This fully polychrome style is

167

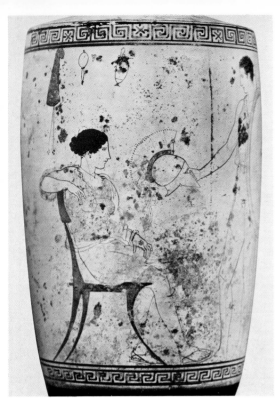
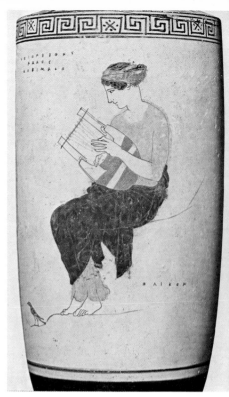

172 (*left*) A white-ground *lekythos* by the Achilles Painter. The woman, seated at home, bids farewell to her soldier husband. The lines of the body show clearly through the lightly painted dress. *c.* 440 B C

173 (*right*) A white-ground *lekythos* by the Achilles Painter. A Muse with a lyre is seated on Mount Helicon (the name is inscribed) with a nightingale on the ground before her. The inscription above praises the beauty of the youth Axiopeithes. *c.* 440 B C

perhaps the closest we come to Classical major painting. The pity is that the white ground is fugitive and few vases have survived in good condition. The Achilles Painter was an important artist of white-ground *lekythoi*, some of them impressively large vases nearly half a metre high. The subjects are, in their spirit at least, close to those of the carved grave reliefs, and there are many points of comparison 174 between the vases and Phidian sculpture or the dignity of contemporary gravestones. The class of white-ground *lekythoi* barely outlives the fifth century.

168

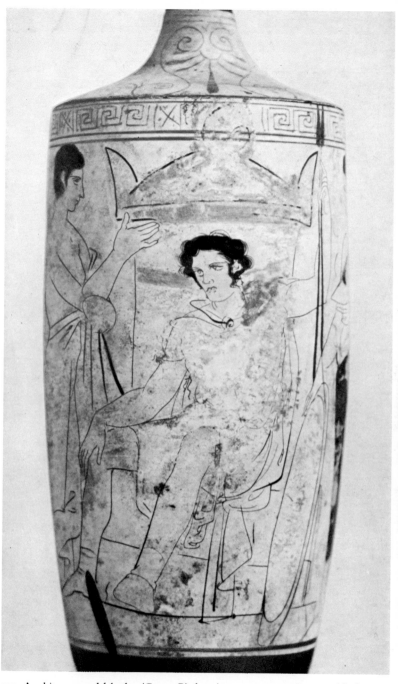

174 A white-ground *lekythos* (Group R) showing a young warrior seated before a gravestone, with a youth and a girl who holds his shield and helmet. The outlines are here painted in a mat paint. End of the fifth century B C. Height 48 cm

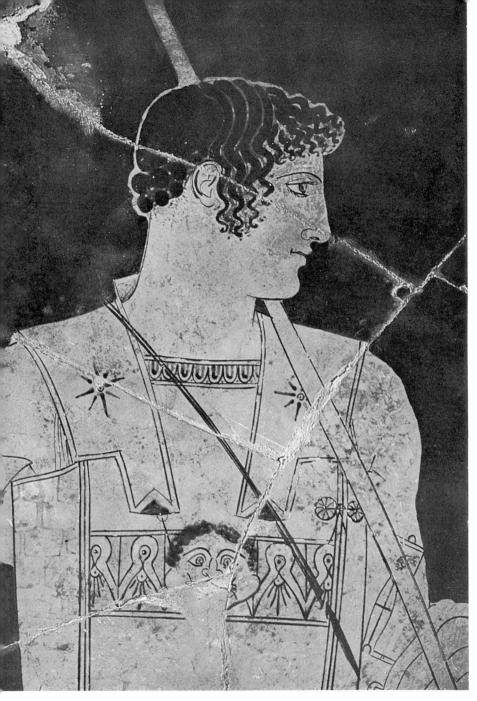

175 A detail from the Achilles Painter's name-vase, showing the hero shouldering a spear. At the centre of his corselet is the tiny head of a gorgon. *c.* 440 BC

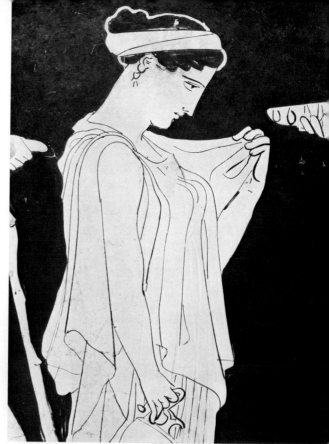

176 Detail from a vase by the Kleophon Painter showing a girl with a jug. The guide-lines sketched on the clay before the painting can just be made out. *c.* 430 B C

The Achilles Painter has been named for his work in red-figure – a fine, rather dapper study of the great hero. His contemporaries, of the Parthenon period, include fewer artists of top rank than we have met hitherto. But their work shows the same sort of advance as does the sculpture of these years. The proper rendering of anatomical detail – profile eyes and three-quarter views – is thoroughly mastered. The equivalent to the massed drapery of the Parthenon marbles is, in vase-painting, the breaking of the straight or flowing folds into interrupted lines and hooks which suggest the same sort of bunching or broken fall of material. There are still many vases later in the century of worth and dignity, but there is a marked preference now for either large and showy pieces, or thoroughly domestic boudoir scenes. Both set the pattern for what is to come in the fourth century. We soon come to learn the detail of an Athenian girl's dressing-room, her gestures before the mirror or the wash-basin. The tiny figures of Eros swarm

175

176

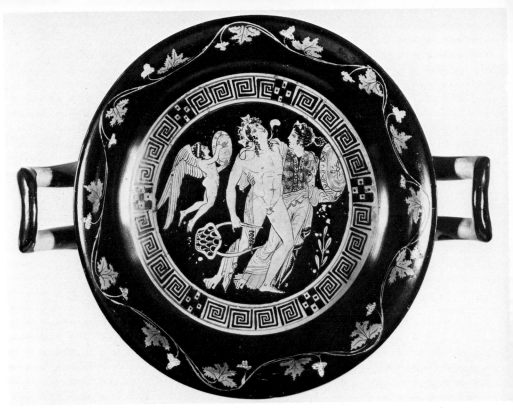

177 Interior of a cup by the Meleager Painter. A limp Dionysus, holding a lyre, is supported by a girl with a tambourine (perhaps Ariadne) while Eros plays for them. The vine wreath round the scene would appear to settle over the level of the wine when the cup is used. Early fourth century B C. Width 24 cm

like gnats to adjust a veil or hold a mirror. Even Dionysus is by now a beardless effeminate youth, his maenads are well-mannered dancing-partners, his satyrs sleek gigolos. Landscape is still ignored.

177

The transparent draperies of late fifth-century sculptures are matched by the close-set linear contours of folds which embrace the figures. For the first time on vases, where the nakedness of women had appeared long before it was commonly shown by sculptors, we find a near-sensual treatment of bodies and drapery. The vases of the Meidias Painter and his circle show this new approach at its best.

179

The challenge of major painting led the fourth-century painter to experiment again with varying ground lines, and to attempt a more polychrome effect within the limitations of red-figure, by the generous use of white paint and sometimes gilding. This, together

172

178 A red-figure *pelike* by the Marsyas Painter. Peleus has surprised Thetis while bathing. The sea-goddess's mutations, to evade capture, are shown by the serpent attacking Peleus. Other nymphs are spectators and Eros is crowning the successful hero. Third quarter of the fourth century B C. Height 42·5 cm

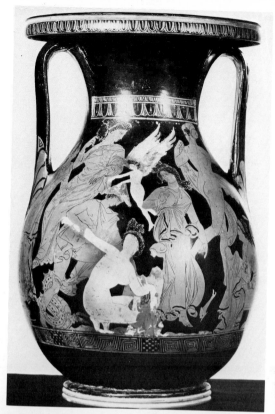

179 (*below*) Detail of a vase by the Painter of the Carlsruhe Paris. The Judgment of Paris. The Trojan Prince, in Eastern dress, sits with his dog, holding a throwing-stick, before Hermes. He is being suborned by an Eros to give the prize for beauty to Aphrodite, who sits with another Eros to the right. Athena is on the left and the other contestant, Hera, out of the picture. The bust above is of Eris, 'Strife', for this episode was the source of the Trojan War. Late fifth century B C

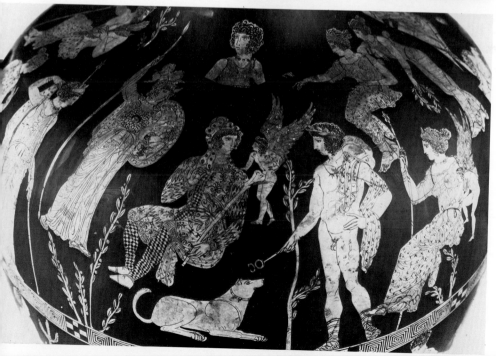

180 (*left*) Detail from a south Italian red-figure vase by the Karneia Painter. A girl plays the pipes for Dionysus. The close-set lines on her dress accentuate her figure. Her necklace and bracelets are rendered in low relief. Contrast the rather earlier Athenian treatment of this subject in *Ill. 169. c.* 400 B C

181 A red-figure squat *lekythos* (its lip missing) made in Apulia (south Italy). Aphrodite suckles and plays with Erotes who tumble from a box. Early fourth century B C. Height 18·5 cm

with the more florid types of subsidiary decoration, produced gaudy and ambitious works which seem to have enjoyed some success. It is *178* none too easy to suppress distaste at some of these florid productions, but in detail there is much to enjoy in the extremely accomplished line drawing which some of these vases display.

So far in this chapter we have mentioned only Athenian painted vases. The success of Athenian black-figure, and the new red-figure technique had succeeded in driving the wares of all other schools out of the markets of the Greek world, and virtually all figure-decorated vases used by Greeks are now from Athens' potters' quarter. Only among the western Greeks was there any notable production of red-figure, and this was a direct offshoot of the Athenian tradition. Athens sent settlers to Thurii in south Italy in the mid fifth century. With them, it seems, went potters and some painters, and in the second half of the century we find painting on south Italian vases of a quality which can at times match the best in Athens, although the more lively *180* Athenian styles of the later century are not represented. In the fourth century other schools appear in the Greek or Hellenized areas of Sicily and south Italy. Few are at all distinguished but the Westerners' *181*

love of the theatre (and the theatrical) is reflected in a number of large
and grotesquely over-ornamented vases made in Apulia (the heel of
Italy) and decorated with tableaux representing the action and actors
of plays. And from the Paestan studios come engaging studies of a
local variety of farce – the *phlyax* plays – in which padded and masked
actors parodied the heroic and epic stories which were treated in a
more solemn manner by the Athenian tragedians. It is easier to catch

182 A *phlyax* vase. A calyx *crater* made in Paestum by the artist Assteas who signs the
work. The scene is apparently of the robbing of a miser. The stage is shown supported
by short pillars. A mask hangs overhead. *c.* 350 B C. Height 37 cm

183 A Boeotian Cabirion cup. A hairy ogress (? a gorilla) is chasing a traveller, who has dropped his baggage, towards a tree. Two men have already abandoned their plough and taken to its branches. Fourth century B C

something of the spirit of Aristophanes in these later *phlyax* vases than on anything made in Athens.

A similar mocking spirit – and humour on Greek vases is usually hard to find – is seen in a class made mainly for dedication at a sanctuary (the Cabirion) near Thebes in central Greece. For these the old *183* black-figure technique was employed. It had never been forgotten in Greece, and even in Athens it was practised on into the Hellenistic period for the Panathenaic prize vases.

The finer styles of vase-painting did not survive the end of the fourth century in Athens. The attempts to imitate major painting could not succeed through the severe limitations of the red-figure technique, not least its black background and essentially bichrome appearance. But plain vases painted with a fine black gloss paint were already popular

in the fifth century, as were cups and other vessels with a very simple, but often elegant, floral pattern. It seemed inevitable that these simpler vases would remain in favour for ordinary use while the painters of figure-decorated vases went out of business through the coarseness or over-elaboration of their work. The plain vases admitted simple impressed decoration, and eventually, in imitation of metalware, relief decoration. These are to be the dominant styles for clay vases for many years to come.

184 A Boeotian clay jar (*pyxis*) with floral patterns of the sort met in Boeotia, Euboea and, to some degree, Athens in the late fifth and fourth centuries B C. This is of the late fifth century. Height 14 cm

Hellenistic Art

Deinde cessavit ars: 'then art stopped'. Thus the Roman scholar Pliny recorded the course of Greek art after the achievements of Lysippus, and although he admits a rally after a hundred and fifty years it is Classicizing, and unoriginal. He condemned to oblivion the artists who worked for the Hellenistic kings and who brought to fruition – if not over-ripeness – all the experiments in technique and composition of the earlier centuries. Yet we may concede something if we take him to mean (as he surely did not) that everything achieved by Hellenistic artists had been foreshadowed by their predecessors, since only in certain respects (which we might have thought to have appealed to a Roman) – in realism, the expression of violence, movement and personality – does the progress represent a real or valuable contribution to the development of Classical art.

The word 'Hellenistic' was first applied by scholars who thought that the period and arts displayed a fusion of Greek and Oriental traditions, which we can better now see to be a serious misconception – especially for the arts. These arts of the new age are deployed more for the satisfaction of men and kings, for the embellishment of private houses and palaces, than for the glory of the gods and the State. Even dedications display a degree of pride and propaganda rather than anonymous piety. In these respects at least the political and social climate of the day had a most profound effect on the arts. The change was brought about by the vision, brilliance and ruthlessness of one man.

Alexander the Great was a Macedonian – only by courtesy a Greek *185* and, in the opinion of his political opponents in Athens, of a race better suited to the rearing of slaves than of generals or politicians. Yet he carried the boundaries of his kingdom by force of arms – of Greek arms – to beyond that Persian Empire which had once threatened to overwhelm Greece. When he died, in June 323 in Babylon, at the age of thirty-two, Greece itself had been united for the first time since the days of Mycenae, and the limits of Greek rule stretched to the Indus in the east, from south Russia to Egypt in the north and south. Only in the west was Greek influence still contained by the power of Carthage and Rome.

185 Portrait head of Alexander on a gem of tourmaline. He wears the ram horns of Zeus Ammon. Late fourth century BC. Width 2·4 cm

After Alexander's death this empire shrank and split, but the pattern of empire had been set, and the country of Greece itself was no longer the only, or even the main, centre of influence and wealth in the Greek world. Alexander's successors created their own, smaller empires, centred in Macedon in the Greek peninsula, at Pergamum in Asia Minor, at Antioch in the Near East, and at Alexandria in Egypt.

The style, scale and content of Greek art had changed profoundly, in ways foreshadowed under Alexander. New dynastic centres promote palace architecture which is Oriental in magnificence and of a sort not seen in Greece (again, since Mycenae). The new Courts acted as foci for artists from all parts of the Greek world, and the new royal patronage had different demands to those of the city-states and private individuals who had hitherto sponsored major works. The great works of statuary now commemorate events like victories in Asia Minor over Gauls, they create new personifications, show new Greco-Egyptian deities, or they are portraits of new royal families. In Greece

186

itself many of the new buildings are gifts of the Macedonian princes overseas, just as later they were to be the gifts of Roman emperors. In the years that were to pass before the Roman conquest of Greece and eventual establishment of the Roman Empire the Greek homeland was to play a much-reduced part in the story of Greek art. The cities and the great buildings, as those on Athens' Acropolis, had been long established and there was no room for the magnificent new architectural and town-planning projects such as could be indulged in the many completely new foundations which were made in Asia Minor, Syria and Egypt. And even there many of the sites of the older great cities were abandoned for new foundations in yet more commanding positions near at hand – as at Smyrna, Cnidus and the Seleucias in Syria and on the Tigris (supplanting Babylon).

186 Copy of the statue of Tyche, 'Good Fortune', the city-goddess of Antioch. She wears a castle-crown and before her swims the River Orontes. The original was of the early third century B C

The great city of Pergamum in Asia Minor and the buildings and sculptures commissioned by the Attalid kings could almost serve as texts for a study of all Hellenistic art. It is still not clear where the earlier town was, but it was certainly not centred on the massive hill which rises some three hundred metres above the plain by the River Caicus and where the Hellenistic kings built their palaces. The crown of the wind-swept rock was laid out by successive kings as their *187* capital. The view we have of it in drawings and models is one never appreciated in antiquity, except by the birds, and we should rather put ourselves in the position of a visitor climbing to its walls, and being presented with a seemingly endless series of terraces and colonnades reaching up and away into the heavens. On the lowest stood an open, colonnaded market-place (*agora*). The *stoai* flanking it are versions of the buildings which had come to play such an important part in Greek public life – long colonnades with rows of shops

187 Restored model of the Acropolis at Pergamum, in western Asia Minor

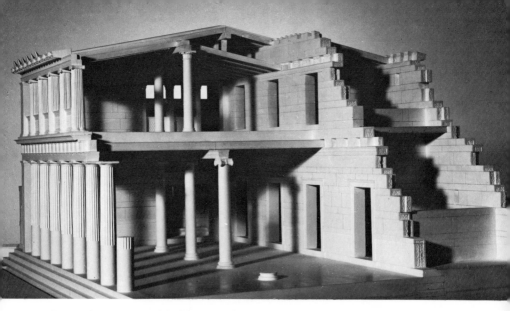

188 Restored cut-away model of the Stoa of Attalus in the market-place at Athens, showing the broad colonnaded walks (Doric and Ionic below; Ionic and Pergamene palm capitals above) in front of the rows of shops and offices. Second century B C. Length 115 m; depth (with promenade) 20 m

behind and often on two storeys, providing not only a market but a shelter and meeting-place (as for the 'Stoic' philosophers of Athens), even a hotel. It was a Pergamene king who gave Athens' *agora* a new *stoa*, now reconstructed as a museum. Above Pergamum's *agora*, in an open court, stood the Great Altar of Zeus (to whose sculptures we shall return), a monumental version of a type with a long history in east Greece – a broad flight of steps rising between projecting bastions to a high flat platform. Higher still stood a Temple of Athena in its own colonnaded court, which gave entrance to the library (our word 'parchment' derives from *pergamena charta*, 'Pergamene paper'). At the top of the hill stood the palace courtyards, barracks, and, later, a temple built by the Roman Emperor Trajan. Cut deep in the side of the hill was the theatre, seating some ten thousand spectators.

188

 The colossal temple buildings sponsored by the Hellenistic kings were anticipated by the rebuilding of the great Temple of Artemis at Ephesus in the fourth century. At Sardis a new temple for Cybele is distinguished for the elaboration of its Ionic order, notably the capitals. At Didyma, near Miletus, the new temple is in effect a massive screen whose ruins still dominate the Turkish village beside it. Within its open court stood a separate small shrine. The outer columns, Ionic,

183

stood nearly twenty metres high, many of them on elaborately carved, polygonal bases. Here too we meet sculptured heads and busts emerging from the volutes of the capitals, and more sculpture applied amid the usual floral mouldings. The near-Baroque character of this decoration will be met again in the major sculpture of the period.

Apart from the temples and other public buildings we have mentioned there are other major architectural works of the Hellenistic period, including some quite new conceptions executed still within the canons of the Classical order. Theatres received more architectural ornament, though not as much as in the Roman period. Less common are buildings like the Tower of the Winds at Athens – a clocktower of the first century B C; and the great lighthouse (*Pharos*) at Alexandria, one of the Seven Wonders of the Ancient World. We know it only from descriptions and sketchy representations of it on minor works. It stood over one hundred and thirty metres high.

189 A tower in the city wall at Perge in southern Asia Minor. The windows on the upper floors were ports for catapults. Third century B C

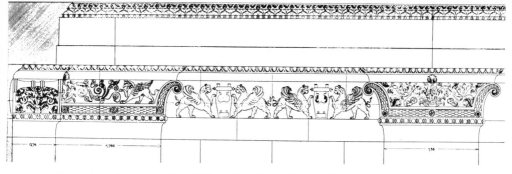

190 Decorative pilaster capitals and frieze from the wall top within the open court of the Temple of Apollo at Didyma. Griffins confront lyres and florals based on the acanthus pattern. Second century B C

The architecture of private houses is a little more enterprising than hitherto. They offer more opportunity for painted and mosaic decoration now and are larger and more sumptuously appointed, but they observe still the common Mediterranean introspective plan of rooms grouped round a courtyard, and there was not usually any exterior architectural order or decorated façade. The appearance of the streets in even the richer quarters of Hellenistic cities must have been as dull and unvaried as Pompeii. In the big and crowded cities like Alexandria we may suspect tenement-like buildings of the sort built by the Romans in Ostia. With the advent of the catapult and improved siege techniques fortification walls became more complex and massive, *189* and heavily 'rusticated' masonry is appreciated for its decorative effect as well as its real and reassuring solidity.

Greek architects had hitherto avoided the arch, possibly for aesthetic reasons since they were aware of its value. It is occasionally used now in conspicuous positions, as for the market-gate at Priene or in fortifications, while barrel-vaulting is normal for the Macedonian chamber tombs, which also often have elaborate architectural façades although all was buried in a tumulus. For monumental above-ground tomb buildings we have still to turn to the Anatolian kingdoms.

SCULPTURE

In the Hellenistic period we are happily able to deal still with a large proportion of original works of sculpture rather than Roman copies, but the range of surviving work is not great – so much was soon removed or overthrown – and we are bound to turn to copies for the full picture. Indeed, the practice of copying Classical works begins in the Late Hellenistic period and is one of the leading characteristics of the Hellenistic view of art.

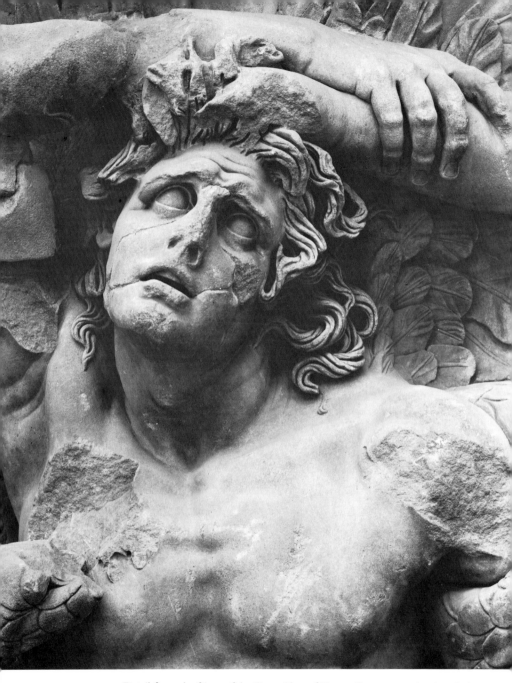

191 Detail from the frieze of the Great Altar of Zeus at Pergamum. A winged giant (Alkyoneus) is seized by the hair by Athena. A snake encircles his body. *c.* 180 B C

Pergamum, whose architecture has already occupied us, is also the source of some notable statuary, and, it seems, was the seat of an important and distinctive school. On the Great Altar of Zeus King Eumenes II (reigned 197–59 B C) had carved a colossal encircling frieze representing the battle of gods and giants. The action virtually seethes around the monument with the figures climbing and crawling up the steps leading up to the sacrificial platform. The fullest dramatic use is made of swirling drapery, but the main force is lent by the vigorous carving of muscles and the writhing, tense bodies. If this alone were not enough to convey the horror of the struggle the faces too were carved with expressions of extreme anguish. This work of the second century B C shows the Pergamene style at its most intense and offers us the full measure of the difference between the approaches of the Hellenistic sculptor and that of his still Classical, fourth-century predecessor. The antecedents of this mature style can be traced at Pergamum in the third-century dedications (by Attalus I; reigned 241–197 B C) celebrating the victories over Gauls. One series includes the

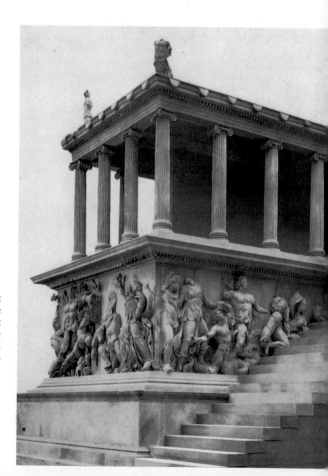

192 The north wing of the Great Altar of Zeus at Pergamum. The upper colonnade is Ionic. Beneath it and beside the stairs runs the frieze showing the battle of gods and giants. c. 180 B C. Height of sculptured frieze 2·25 m

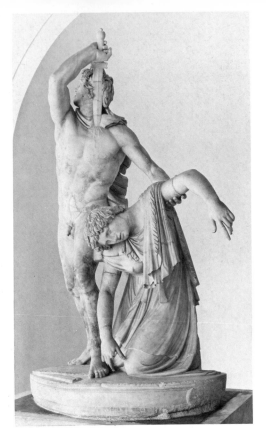

193 Copy of the group showing a Gaul slaying himself and supporting the dead body of his wife, from the series dedicated at Pergamum by Attalus I. The original was carved in the late third century BC. Height 2·1 m

193 group of a Gaul and his wife, and the famous Dying Gaul (long miscalled the Dying Gladiator). The other, dedicated in Athens, is of smaller figures of Greeks and Amazons, Athenians and Persians, gods and giants, and Gauls. Both are known only in copies. The dramatic qualities of the later Pergamum altar are seen already here, together with studies in exhaustion or despair which are not so highly stressed, and so look back to the art of the fourth-century Athenian gravestones. These figures and groups are impeccably carved in the round, and

194 offer many viewpoints. The closely related Laocoön group, which is one of the most famous original works of the Hellenistic period, was designed for a single viewpoint and reproduces all the expressive modelling and anguish of features seen on the altar.

Introducing Hellenistic sculpture with the Pergamene style highlights the contrast with what went before, but does little justice to the strong Classical tradition in the treatment of features and drapery which can be observed in the work of other cities. This seems left to

188

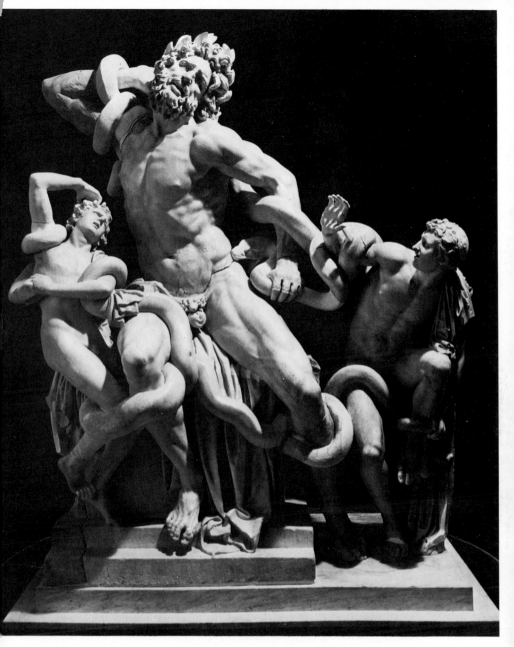

194 Laocoön, priest of Troy, with his two sons struggles against the serpents sent
by Apollo. The newly restored group, shown here, has Laocoön's right hand in the
correct position behind his head. Signed by Hagesandros, Polydoros and Athanadoros
of Rhodes. Second–first century B C. Height 2·4 m

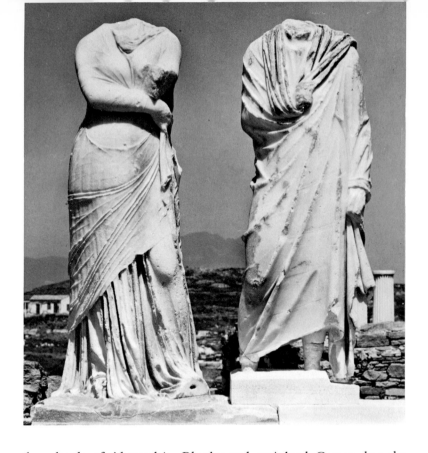

the schools of Alexandria, Rhodes and mainland Greece, but the
definition of the styles of these regional schools is not at all clear-cut.
The all-round viewpoints for free-standing statues which Lysippus
had introduced, is achieved by the composition of drapery with folds
running counter to folds, even seen through upper garments as though
195 they were transparent, and by twisting poses which force the spec-
tator to move round the statue if he is to appreciate it fully. Drapery
can even be used to express mood, from the swirling folds of fighting
196 groups, or even flying figures, to the quiet foldless dress of more
197 reflective subjects, like the boy from Tralles. Sheer size was appreciated
as never before, and new skills in bronze-casting made possible works
like the colossal statue of Apollo at Rhodes (*the* Colossus), thirty metres
high. It fell in an earthquake, just over fifty years after its erection
in the early third century. More than a millennium later it took a
train of one thousand camels to carry off the scrap-metal.

190

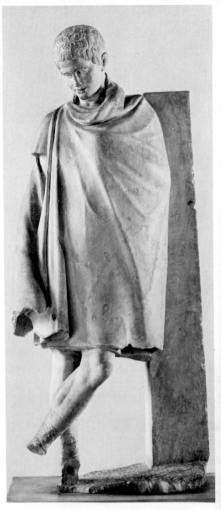

195 (*left*) Figures of the Athenian couple, Cleopatra and Dioscurides, from their house on Delos. Note the play of folds seen through the upper cloak. *c.* 140 B C

196 (*below*) The Victory from Samothrace. The figure is shown alighting on the forepart of a ship, and was set in the upper basin of a fountain to commemorate a victory at sea. *c.* 190 B C. Height 2·4 m

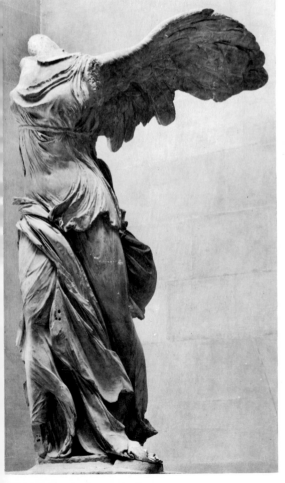

197 Statue of a boy dressed in a short cloak. He is perhaps an athlete (a boxer?; his ears are bruised) and he leans against one of the turning-posts of a race-track. From Tralles in Caria. Perhaps first century B C

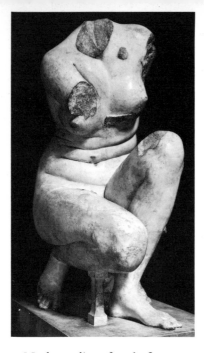

198 Copy of the crouching Aphrodite at her bath. The type was often copied in the Roman period after the original of the mid third century BC. Life-size

Nude studies of male figures remained the norm for heroes, gods, and even distinguished mortals, but the female nude is also a very common subject. Praxiteles' Aphrodite was famous enough, but the Hellenistic figures with their slim and sloping shoulders, tiny breasts and swelling hips are almost aggressively feminine. The softer modelling, blurring details, such as seems to have been introduced by Praxiteles, is carried further in Hellenistic studies of femininity. The Cnidian Aphrodite was often copied but there are new poses now, as of the goddess crouching at her bath. In the great Venus de Milo, the new, restless spiral composition is expressed vividly in a variant on the old pose. The hermaphrodite figures offer a mean between the current fashions in male and female physique.

198

200
199

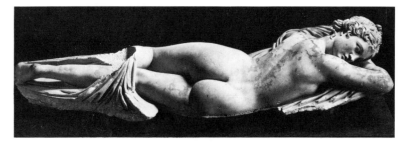

199 A sleeping hermaphrodite. Apart from the boyish hips the forms of the body are mainly feminine. Copy of an original of the second century BC

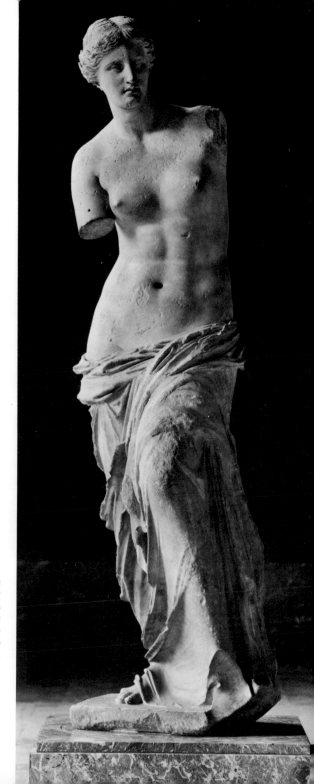

200 The Venus de Milo. The type
derives from the fourth century
whence the Classical features, but this
is a second-century version to judge
from the relaxed, twisting composi-
tion. She was found on Melos in 1820
with other marbles intended for a
limekiln. Height 1·8 m

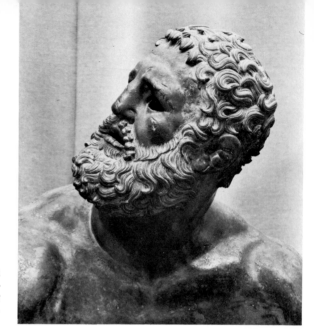

201 Detail of a bronze statue of a seated boxer. The brutalized features, broken nose and cauliflower ears are carefully observed. Second century B C

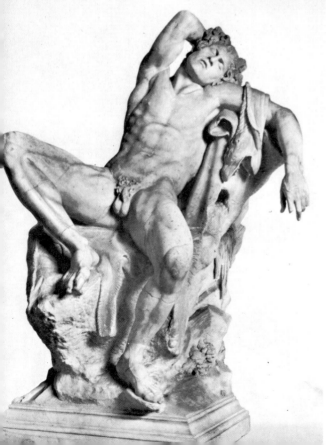

202 A sleeping satyr (the so-called 'Barberini faun'). The statue was found in the early seventeenth century in the Castel S. Angelo in Rome, and partially restored by the artist Bernini. Early second century B C. Height 2·1 m

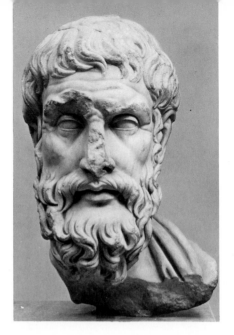

203 Copy of a portrait head of the philosopher Epicurus. After an original of the third century B C. Height 40·5 cm

We have so far dealt mainly with single-figure studies but far more characteristic of the age are the groups – narrative groups we might almost call them – which tell a story and study the emotions of the protagonists. The silen Marsyas, bound to a tree, waits helplessly to be flayed by the brutish slave who sharpens his knife, watched by a bored Apollo; rough Pan teaches young Olympos how to play his pipes; an hermaphrodite wriggles free from a satyr. The realism of expression and emotion seen in Pergamene sculpture has its counter-part in the characterization of over-developed athleticism (the Terme boxer), wasting old age (the drunken woman in Munich or the *201* Louvre fisherman) and – at last – good child studies (the boy and goose, Erotes). The sleeping satyr in Munich is a fine study of relaxed exhaustion. Its massive musculature, like that of the famous Belvedere *202* torso, reminds us of Michelangelo, and both these works were indeed known to Renaissance sculptors.

Portraiture is very much in the spirit of the age, heralded by Alexander's appointment of Lysippus as Court Artist, the only one allowed to carve portraits of the King. Portraits of poets, philosophers *203* and statesmen remain largely character studies. Portrait types of Socrates are instructive in this respect. There are two fourth-century types, one a fairly simple portrait of an elderly snub-nosed man, the other (probably Lysippus' creation) a highly idealized version of the great philosopher. The Hellenistic type shows him rather as the bitter,

195

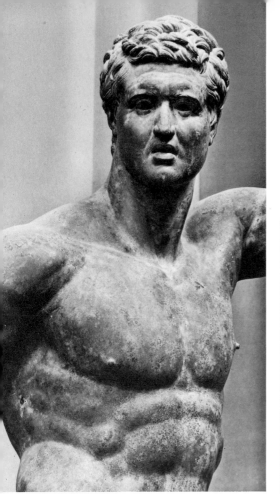

204 (*above*) Detail of a bronze portrait statue of a prince, thought to be Demetrius I of Syria. Second century BC. Rather more than life-size

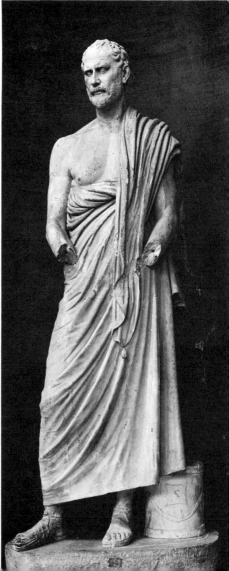

205 Copy of a portrait statue of the orator and statesman Demosthenes. The original, a bronze by Polyeuktos, was made about 280 BC and stood in the Athenian Agora. The figure is sometimes wrongly restored with a scroll in the hands

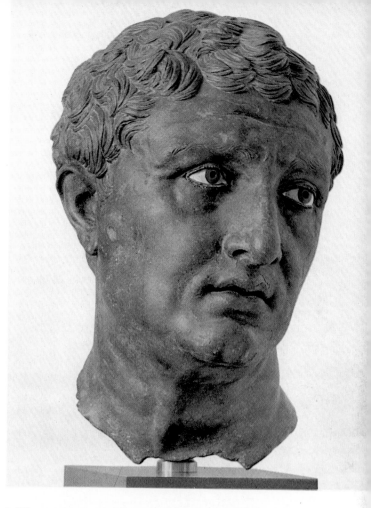

206 Bronze portrait of a man from Delos. *c.* 100 B C. Height 33 cm

hen-pecked intellectual. The treatment of the whole figure plays its part in the characterization, even of contemporaries – the statesman *205* Demosthenes in pensive mood, obese seated philosophers, surly open-air athletic rulers. We do not know who the figure in *Ill. 204* was, but may doubt whether he often appeared naked in public. The unruly hair, heavy furrowed brow and disdainful mouth are abetted by the massive and proudly displayed body in this study of princely arrogance. This attention to the character of the sitter, making a portrait compromise between realism and an idealized study of statesmanship or intellectual power is the hall-mark of the Greek *206* portrait; beside them the portraits of the Roman period are more like effigies.

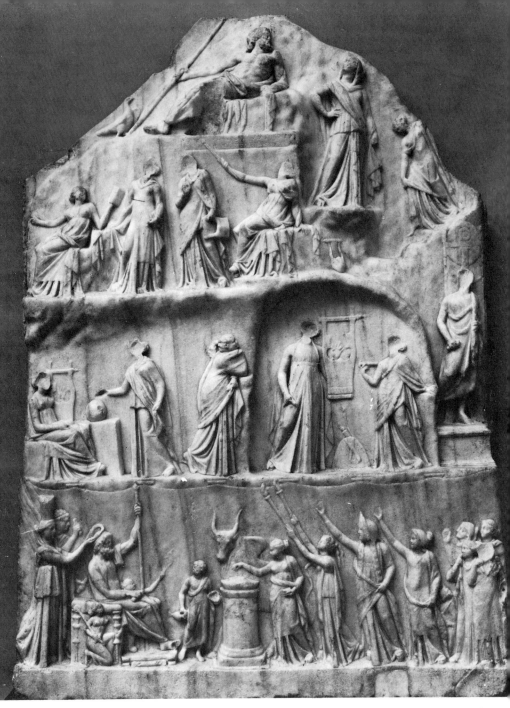

207 Votive relief showing the deification of Homer, who is being crowned in the lowest register, greeted by actors and others. Above are the Muses and other deities, while to the right is the statue of a poet, possibly the epic poet, Apollonius of Rhodes. Second century B C. Height 1·15 m

The fine series of Athenian gravestones had been stopped by an anti-luxury decree passed by Demetrius of Phaleron, some time between 317 and 307 B C. We look now rather to the marble sarcophagi, generally made in the eastern Hellenistic kingdoms, on which whole friezes or single figures are shown in an architectural setting. The spirited scenes on works like the so-called 'Alexander sarcophagus' bring us closest to the architectural reliefs of earlier years. The tradition of the Classical gravestone with relief figures is continued only in east Greece, but there are many new varieties of votive relief being made, including a common type showing the deity or, more often, hero, approached by a family or worshippers shown on a smaller scale. Some of these reliefs admit landscape elements and attempts at perspective by reducing the height of figures – features borrowed, not usually with great success, from contemporary paintings. Sculptural decoration on buildings is now less common although there are notable exceptions, like the Great Altar of Zeus at Pergamum. The arabesques which decorate architectural members and smaller marble objects like funeral vases, and the friezes of heavy floral swags on altars and walls represent the last stage in the development of the old Orientalizing florals, and a style which found much favour in Rome and Renaissance Italy.

<div style="text-align:right">209</div>
<div style="text-align:right">207</div>
<div style="text-align:right">208</div>
<div style="text-align:right">cf. 245</div>

208 Votive relief showing a sacrifice in a rustic shrine. A hero and his consort, their altar before them, are approached by worshippers. By the tree are statues of Apollo and Artemis on a pillar. The architectural frame is usual for such reliefs. Second century B C

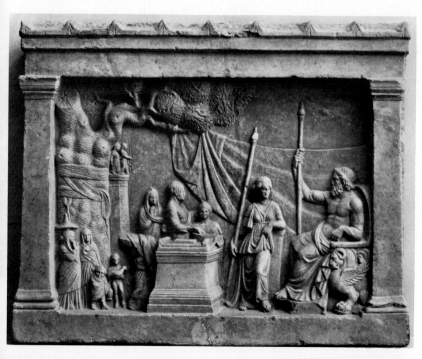

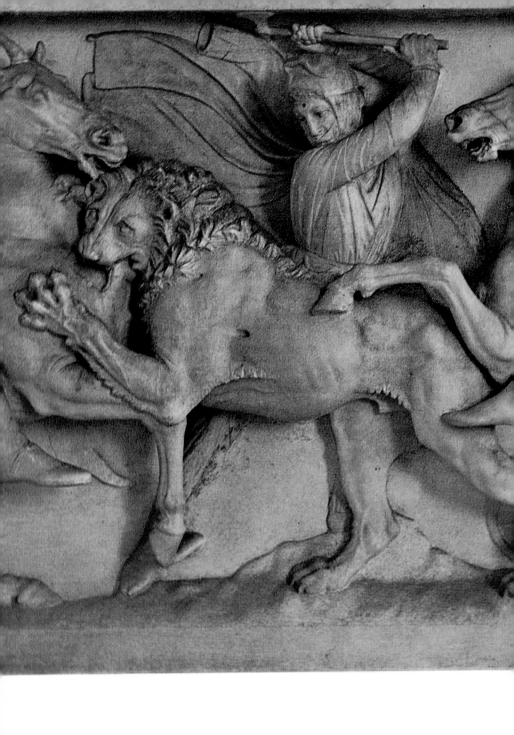

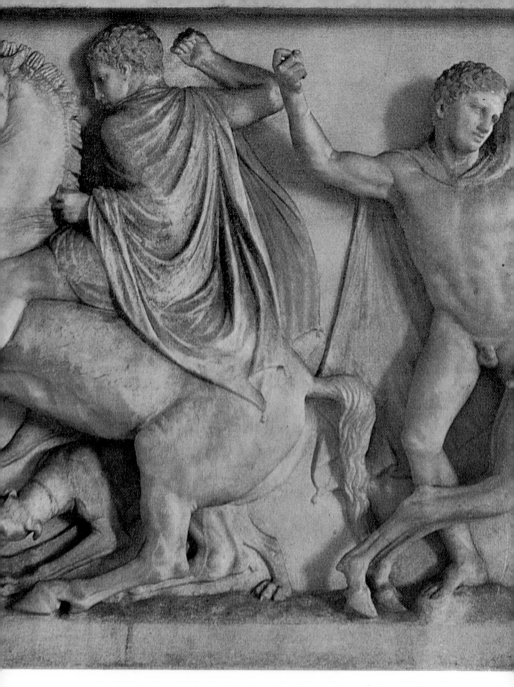

209 Detail from the relief coffin known as the 'Alexander sarcophagus', from the royal cemetery at Sidon in Phoenicia. Part of a hunting scene with horsemen, dogs and a lion. The colours on the marble are unusually well preserved. Late fourth century BC. Height of frieze 58·5 cm

The small clay figures of the Hellenistic period offer many ambitious and original compositions in which the use of the mould, or of several moulds combined, lent greater variety to what had become *210* a rather repetitive and trivial art form. The model girls of the Tanagra figurines are deliberate essays in prettiness with their mannered pose *213* and coy charm. It is little wonder that they won immense popularity in the last century and that they were widely (and skilfully) forged or mocked up, with their bright colours restored to them, for the collector's cabinet. They are named after the site in Boeotia where they were first found, but the style is common to all parts of the Greek *212* world, with important schools in south Italy and Asia Minor. The south Italian schools had always been active and original centres for the production of terracotta figures and plaques. In Asia Minor, though, it is the example of the new Hellenistic capitals and their art which probably inspired the new activity. One important class of figurines, best known in examples from Smyrna, copied closely well-

210 Clay group of two girls playing knucklebones, from Capua. Third century BC

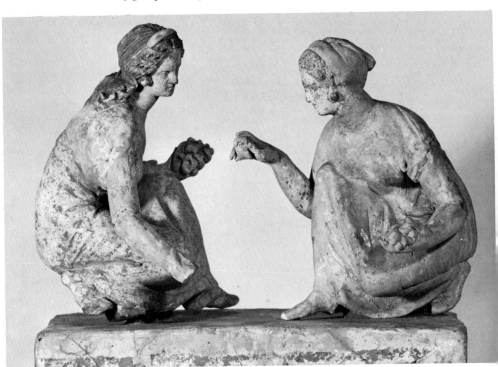

211 Clay mask of a grotesque head from Tarentum; a type more commonly met in figures from Alexandria in Egypt at this time. Second century B C. Height 26·5 cm

known types of major sculpture in gilded clay. The realism of major sculpture is reflected in miniature in the studies of the grotesque or *211* deformed, and the semi-portrait studies of non-Greeks. Alexandria was a meeting-place of the races, and the Macedonian conquests in the East had offered the artists even more opportunity to reflect on the un-Greekness of the barbarians, in looks at least. Hellenistic (Ptolemaic) Egypt has yielded engaging clay studies of typically foreign faces – Scythians, Persians, Semites, Indians, Negroes. The Negro head had occupied the Greek artist long before, in the Archaic period, when he had used Negroid features to depict any African. There were no doubt more dark-skinned slaves in Hellenistic Greece, and we find more sympathetic treatment of Negro slaves and entertainers in the clay figurines and bronzes of the period. *215, 216*

212 (*left*) Clay figure of a woman from Tarentum. She wears a blue and white *himation* over a red *chiton*. The small head, long neck, slim shoulders and heavy hips are characteristic of this period. Second century B C. Height 25 cm

213 (*right*) Clay figure of a woman with a fan, wearing a sun-hat. Traces of blue paint and gilding are still visible. From Tanagra. Third century B C. Height 33 cm

Hellenistic bronze figurines are technically as fine as their predecessors and offer all the new devices and mannerisms of major sculpture. *217* There must certainly have been more life-size bronze statues being made. Even in the Classical period we hear of sculptors who preferred bronze to marble but the conditions for the survival of large bronze works (a disaster like earthquake or shipwreck which removed them from the sight of scrap-merchants) have denied us a full series to study, and we have to be content with the finer statuettes. *218*

Decorative metalwork was applied to the same objects as hitherto: vases, mirrors, boxes. Precious metals suited the taste of the new kings, and the Eastern victories and loot had offered new sources. Relief cups, especially the animal-head vases, are well represented,

214 Lid of a silver box with the relief pattern of a sea-nymph riding a serpent, picked out in gold. Found near Tarentum. Late second century BC. Diameter 10 cm

215 Bronze statuette of a Negro boy singing to the music of an instrument, now missing from his right hand. Second century B C

216 (*below*) Clay flask in the form of a squatting Negro boy. Late third century B C. Height 29 cm

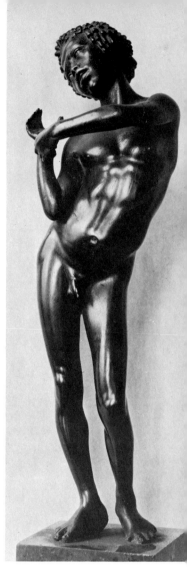

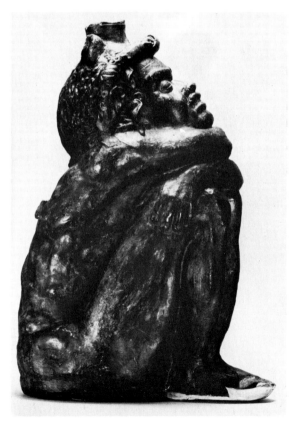

as in the recent find at Panagurishte in Bulgaria. Simple, semicircular *221*
bowls of a type which seems to have been developed in Egypt serve
as models for a popular clay-ware. More decorative use is made of the
colour contrast between silver and gold, and inlays in glass or semi- *214*
precious stones are also far more common. These techniques, and
enamelling, are also features of the jewellery, for which our main
sources are the princely tombs of north Greece and south Russia. A
new belt form, with a false clasp like a reef-knot, becomes popular, *219*
and the new ear-rings are plump crescents with human or animal
heads as terminals. Gold funeral wreaths reproduce the forms of oak
and laurel leaves with startling virtuosity. *cf. 220*

217 (*left*) Bronze statuette of a philosopher, perhaps Epicurus (compare *Ill. 203*). The
figure stands upon an Ionic column. Early third century B C. Height 35 cm

218 (*right*) Bronze statuette of a god, probably Poseidon striking with his trident.
The eyeballs were inlaid silver, the nipples copper. Second century B C. Height 25·5 cm

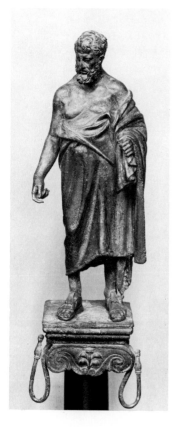
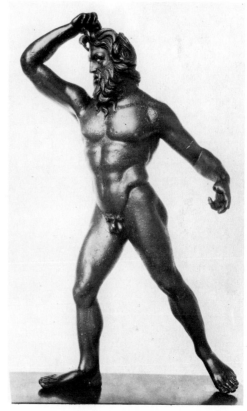

219 (*above*) Gold diadem from Thessaly, with a 'Heracles-knot' at the centre. Inlays of semi-precious stones only become common in the Hellenistic period. Second century BC

220 Gold ears of wheat found in a tomb near Syracuse

221 Gold *amphora* with figures of centaurs as handles. In relief on the body is shown
the attack of the Seven Heroes on Thebes. From a rich find of gold vessels at
Panagurishte in Bulgaria, in 1949. Probably third century B C. Height 29 cm

222 A plate showing a battle elephant (Indian), its turret manned, leading a youngster. Yellow, white, brown and red paint is used. Third century B C

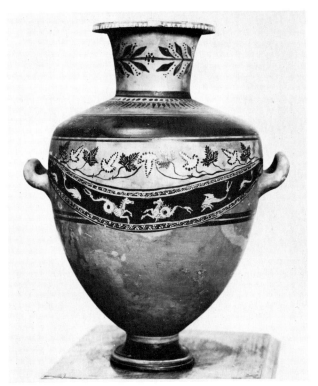

223 Clay *hydria* from Arsinoe, in Cyprus. An elaborate example of a type common in the Ptolemaic cemeteries near Alexandria. Third century B C

The art of the vase-painter went into a rapid decline at the end of the fourth century BC, but the more simply decorated wares persist in the Greek East, and some classes, like the Hadra funeral vases of Egypt, offer a lively variety of floral and animal decoration. Only *223* among some of the western Greek schools do we find a polychrome style of painting, usually over the black paint covering the vase, *222, 226* which approximates to the new realistic styles of major painting, with their greater command of colour and shading. Plain black vases, sometimes metallic in their shapes and in the bright gloss of the paint, had been increasingly popular in the fourth century. The paint, often miscalled a glaze, is in fact a clay preparation which will fire to a permanent black gloss if the atmosphere of the kiln is changed from oxidizing to reducing, and then back again. The technique of this painting has only in recent years been rediscovered. Wedgwood sought it without success, then turned to imitating the easier dull black bucchero, and making relief vases, the technique of which is again Hellenistic in origin, as we shall see.

224 Gnathia vase, painted in south Italy. The black bowl is painted in white and brown with festoons and a comic mask. Third century BC. Height 18 cm

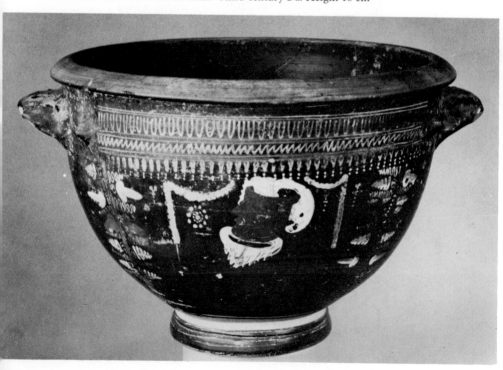

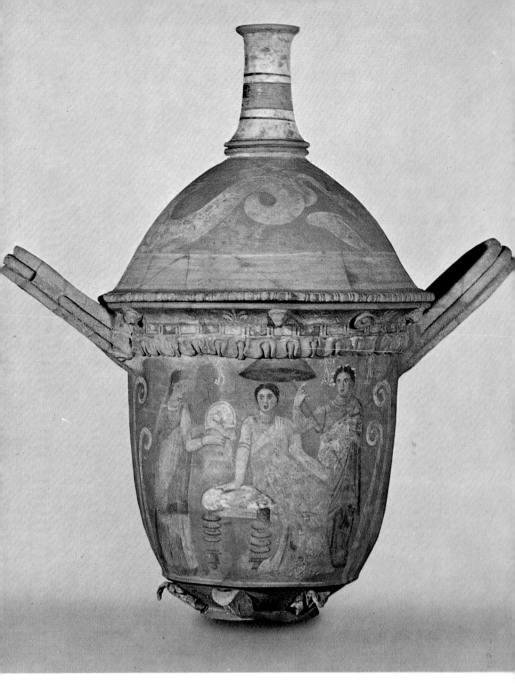

225 Polychrome vase made in Sicily. A funerary vase probably showing the dead woman. The painting was done after the firing of the vase, unlike that of ordinary black- and red-figure. Third century B C. Height 56 cm

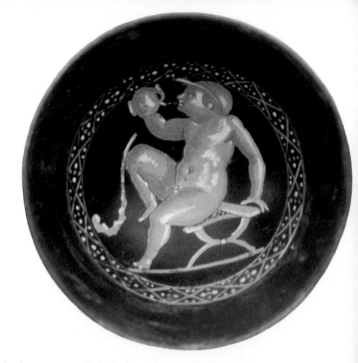

226 Interior of a cup from Vulci showing a boy relaxing with a wine-flask, his throwing-stick leaning against his knee. Made in south Etruria (the 'Hesse' group) in the third century BC

Where before the black vases carried slight impressed decoration there may now be white-painted floral patterns, as on the Gnathia vases from Italy, or scrolls picked out in low *appliqué* relief (West Slope ware). This is a style of decoration which must be copied directly from the more expensive metal vases, and an even more direct influence from this source can be seen in the so-called 'Megarian bowls' (made in all parts of the Greek world). These are semi-spherical cups, made in a mould and painted black or brown, with low-relief patterns of florals and figures, very similar to metal and glazed cups found in Egypt. Rarely, on the 'Homeric bowls', do we see elaborately composed mythological scenes. There are generally only vignettes of figures or groups in floral settings. The type was copied in the Roman period on the Arretine and Samian bowls of red ware.

224

227

228

cf. 245

OTHER ARTS

Only towards the end of the Hellenistic period are the techniques of blowing glass learned in the Greek world. Before then we find only opaque, coloured glass, moulded, cut or built up in coils, used for small flasks or decorative inlays.

Moulded glass intaglios are found also set in metal finger-rings. The earlier types of engraved gems, set in swivels or worn as pendants,

213

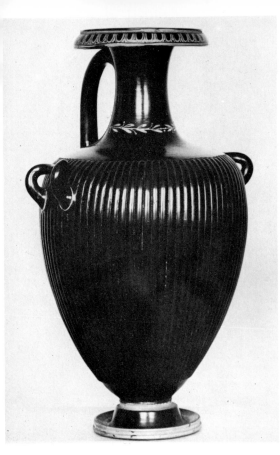

227 Black clay *hydria* with a ribbed body and a gilt relief wreath at the neck. Made in central Italy. Third century BC. Height 43 cm

228 (*below*) Clay relief bowl. The devices on it include goats rearing on either side of a *crater*, a Triton and a nymph riding a horse. Second century BC. Height 9 cm

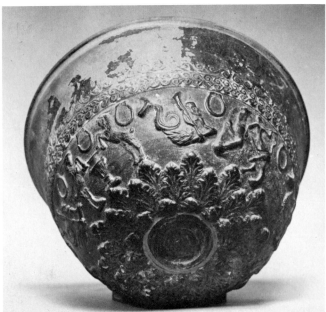

229 The Gonzaga Cameo, cut in three-layered onyx, with portrait heads of Ptolemy II and his queen, Arsinoe. Third century B C. Height 15·7 cm

give place wholly now to stones set in rings. The stones themselves are generally smaller, and less well carved, except for some notable portraits. Gold, silver or bronze signet-rings remain popular, often with devices showing women (Aphrodite) or Victories. There is not so much a decline in gem-engraving as an increase in production and a corresponding increase in proportion of more trivial works, of a sort which go on being made throughout the Roman period. At the same time a new type of gem-cutting is practised – that of the cameo. Stones with multi-coloured layers (onyx, readily imitated in glass) are cut in relief so that different colours are picked out in different strata, generally pale figures against a dark background. The cameos 229
are set in rings or pendants. In the cognate art of the engraver of coin dies it is again in the field of portraiture that the masterpieces are found. Where before the idealized features of a god or local deity graced a city's coins, there are now portrait heads of princes and their families – 230
a tacit comment on the decline of the city-state and forms of demo-cracy – and a fashion which has persisted, even for many republics, to the present day.

230 Silver coins with portrait heads of Mithradates III of Pontus (died *c.* 185 B C) and Arsinoe III of Egypt (died *c.* 204 B C)

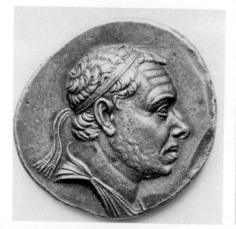
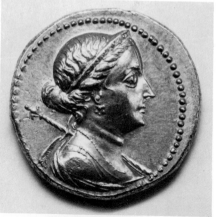

231 The figure of a Judge of the Dead, Rhadamanthys, painted on
the façade of a Macedonian tomb. It was accompanied by figures of
another judge, Aiakos, Hermes and the dead man. First half of the
third century B C

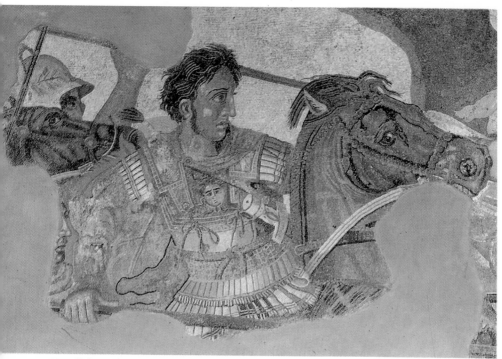

232 Detail from the 'Alexander mosaic', found at Pompeii, showing Alexander defeating the Persian King Darius at the Battle of Issus. Copy of a Greek painting of *c.* 300 B C

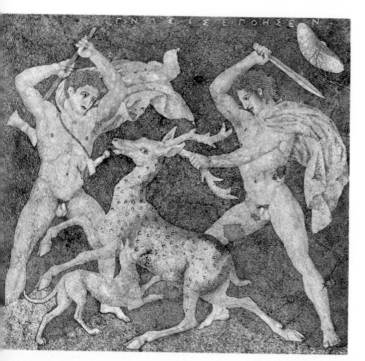

233 Pebble mosaic from Pella in Macedonia, Alexander's capital, showing a stag-hunt, with the signature of the artist Gnosis. Apelles had visited and worked in Pella. *c.* 300 B C

Original evidence for wall-paintings is as scant as it was for earlier periods, and what has survived in the way of major painting is either second rate or, we may suspect, untypical. Again, many of the wall-paintings in Roman houses may reflect Hellenistic originals, but the nearest we come to the sure handling of light and shade in these is on a few of the painted tombstones from the Hellenistic cemetery at Pagasai (modern Volo), or in the painting which decorated the interiors and sometimes the façades of the Macedonian chamber tombs. Here we can recognize a style of painting which might pass as 'modern' beside the earlier outline-drawn figures with their flat washes and rudimentary indications of depth. It makes us yet more conscious of our loss of Classical originals.

231

There are other sources from which we may get some idea of the appearance of ancient paintings. There is polychrome painting on some clay vases of south Italy and Sicily, while some gravestones in Chios and Boeotia continue an earlier, Classical tradition, with designs outlined on the polished stone against a roughly picked background. Colour must certainly have been applied to these stones, though it is still not clear with what effect. We find on them hunting scenes and some engaging still-life.

225
234

The school of Sicyonian painters had been influential, and to Pausias can be attributed the invention of intricate floral and leaf patterns which become an important element of decoration in metal relief work and on painted vases. It is perhaps no accident that Sicyon was also Lysippus' home-town. The Ionian Apelles had studied at Sicyon. He was Alexander's Court Painter, famous for his portraits and Aphrodites. Of his work, and that of his fellows, who are often associated with famous sculptors of the day, we can only guess from the accounts and descriptions of ancient authors. But we may be sure that it was they who evolved the brilliant techniques which inform the Pompeian paintings. There will be more to say of these in the next chapter. We get close to the works of these artists in some mosaic copies of their compositions, notably the 'Alexander mosaic', from the floor of a Pompeii house. The scene is Alexander's victory at Issus, the young King storming against the Persian Darius, who is already being cut off by the Greeks whose long spears are seen passing across the background. Bold foreshortening and skilful use of highlights lend depth to the complicated but brilliantly lucid composition. In this mosaic the tiny cubes (*tesserae*) are of stone and coloured glass, a technique probably introduced in the third century. In the capital of Alexander's successors in Macedon, at Pella, the mosaics are done

232

234 Gravestone of Metrodorus from Chios. The first frieze shows sirens with musical instruments, the next a fight with centaurs. By a prize-vase on a pillar hang an athlete's strigil, sponge and flask. The incised figures stand out on the dark, polished stone, against the roughened background. Third century B C

in the older style, with coloured pebbles, and the linear quality of the *233* figures is enhanced by the leaden strips outlining some of them. But the limitations of this technique and the few colours used do not conceal the promise these works hold of the later achievements in Hellenistic painting and mosaic.

235 Painting from the Tomba dei Tori at Tarquinia in Etruria. The ambush of the Trojan Prince Troilos is shown. He approaches a fountain on horseback. Achilles is springing out of hiding from behind it. *c.* 530 B C

236 Head of Velia, wife of Arnth Velcha, from the Tomba del Orco at Tarquinia.
She was shown reclining on a couch with her husband. Third century B C

237 Detail from an Etruscan black-figure vase. The extensive use of colour is characteristic of this class and in marked contrast with contemporary Athenian work. Notice the odd vegetation through which Herakles fights a centaur in the top frieze, *c.* 530 B C

Epilogue

Greek art did not come to a full stop with the Roman sack of Corinth
in 156 BC or Attalus III's bequest of the kingdom of Pergamum to
Rome in 133 BC. The Hellenistic art of the countries bordering the
eastern Mediterranean flourished as before, although with less
originality and with a more conscious nostalgia for the Golden Age
of Classical Greece. We are more concerned here with the way in
which this transition to the era of Rome's empire affected the course
of Greek art, but we should pause too to consider how far the common
idiom of Greek art had already been spread. The least receptive areas
had been in central Europe, where only the penetration of Greek
colonies into France and on the shores of the Black Sea had introduced
the Greek styles. Only Roman arms could complete the conquest. In
Africa, Egypt and Cyrenaica were Greek, and by now the arts of
Carthage were more Greek than Phoenician. In the East the arts of
the Persian Empire which Alexander overthrew were already
Hellenized, but the new Empire pushed farther east and eventually
in Gandhara (modern Pakistan) an important school of Greco-
Buddhist sculpture arose which influenced the arts of India and, to
some degree, those of Buddhist China.

The Romans were no strangers to Greek art, indeed their own arts
were wholly cast in the Hellenic mould. This was only in part due to
the presence of Greek colonies in Italy and Sicily and the examples
they offered of the most developed Greek styles or provincial variants.
For the Romans themselves shared, and perhaps even contributed to,
the development of Etruscan art, which is itself the result of the impact
of Greek and Orientalizing arts upon an artless people. The Eastern
elements in Etruscan art we may ignore. They were as soon assimilated
and discarded as they were by the Greeks. The Etruscans learned
their arts from the Greeks, they admitted Greek artists to work in
Etruria and copied their techniques and patterns. It is in the deviations
from their models that their character is revealed, such as in painted
pottery, where they show a predilection for colour, and for the more
monstrous elements of the Greek animal frieze style which they some-
times elaborated in an original manner. They were good copyists of *237*

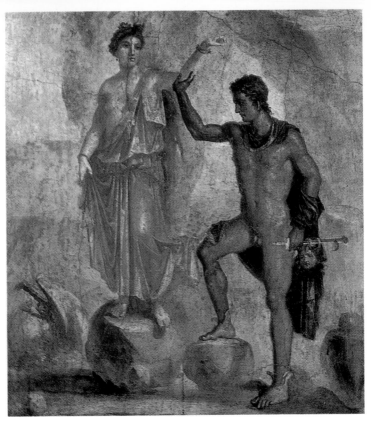

238 Perseus frees Andromeda from her fetters. The slain dragon is seen to the left. Painting from the House of Dioscurides at Pompeii, after a Greek original of the fourth century B C, perhaps by Nikias

technique – their jewellery rivals the best of Greece or the East in finesse, overreaching in flamboyance and showy effect. The figure style, though, is subjected to a coarsening of execution and subject, such as can be seen in Etruscan copies of Athenian black-figure and *240* red-figure vases. Greek mythological scenes are copied by Etruscans, but their context and story are not always wholly understood. This is well illustrated in the tomb-painting, where, for instance, we see the common Greek scene of Troilos' ambush by Achilles depicted with *235* all the emphasis on the wrong subjects – the horse rather than Achilles.

Etruscan built tombs invited painted decoration of a type not seen in Greece, where this sort of tomb architecture was not at that time known. The painting, at first on clay plaques, then on plaster, was at

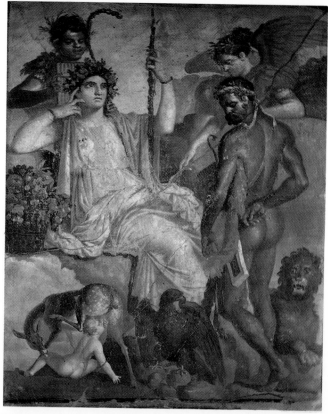

239 Herakles, led by Iris, finds his son Telephos being suckled by a hind, before the goddess Arcadia and a young satyr. Wall-painting from Herculaneum after a Greek original of the second century B C

the start done by Greek artists, then by Etruscans taught by Greeks – as were the vases. They give us an idea, at second hand, of the Greek major paintings which have not survived in the homeland. The native element in Etruscan art never overwhelmed its Hellenic form, and in the rich series of tomb-paintings, which continue into the *236* Roman period, we can catch repeated echoes of the new techniques and achievements of the lost Greek works. Rome shared this Hellenized Etruscan tradition, and when her armies gave her control of the Greek world, her generals, businessmen and connoisseurs knew what to look for in Greek art. They profited from and copied the practice of the Hellenistic kings in creating their own art galleries and collections. Indeed, by this time many Greek temples may have had

more to offer as museums than as places of worship. Many Greek
sanctuaries and towns were plundered for works of art which were to
adorn villas or temples in Italy. The group of Niobids was no doubt
loot of this sort, and the statues from shipwrecks were probably cargo
intended for a similar destination. But besides these simple acts of
theft there grew a demand for accurate copies of the better known
masterpieces of the Classical period, and Greek artists were long
engaged in producing these copies or pastiches of original works
which have not survived to the present day. We have already seen
how much we rely on these copies for knowledge of the style of some
of the masters of Classical Greece. Sometimes the copies are exactly
the size of the original, almost mechanically reproduced by the point-
ing system. These may be of single figures, or be taken from standing
monuments, like the reliefs from the Altar of the Twelve Gods at
5 Athens. More often a Classical type is adapted to suit the new taste.
There was always a market for Venuses, and later some were pro-
duced with portrait heads of Roman matrons, flattered by the divine
physique attributed to them. Other copies are reduced in size, to
statuettes of marble or bronze, or the figures are recalled in cameos
or engraved gems. Whole compositions may be broken up into
component groups, as in the famous series of reliefs from a wreck in

240 Etruscan cup imitating the Athenian red-figure style. A man takes leave of his
wife, with an Etruscan death-demon in the background. Fourth century B C. Height
38·5 cm

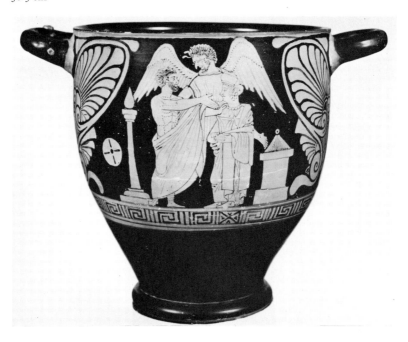

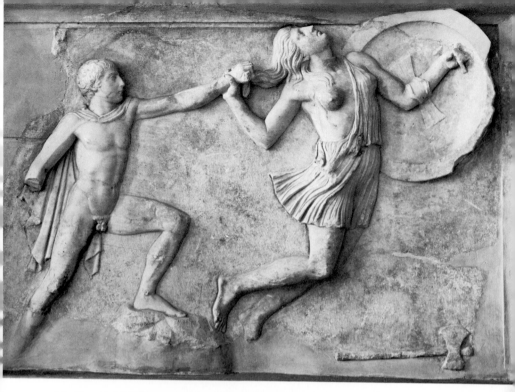

241 Marble relief slab from a wreck off Piraeus. A Greek seizes an Amazon by her hair. The group is adapted from part of the composition on the shield of Phidias' Athena Parthenos. Height 97 cm

Piraeus Harbour showing scenes from the battle of Greeks and Amazons which decorated the shield of Phidias' gold and ivory Athena in the Parthenon.

241

There are a few original works which were probably the result of the new patronage. A vogue for the Archaic style produced a series of Archaistic statues and reliefs which copy the massed folds and zigzag hemlines of the later sixth century, and even the Archaic smile. Some are possibly even copies of original Archaic reliefs. On the freer Archaizing works the drapery flies in splaying swallowtails and the mannered prettiness is a travesty of Archaic precision and vigour.

The so-called 'Neo-Attic' reliefs offered stylish versions of Classical figures – often Dionysiac scenes carved on to massive marble vases in imitation of contemporary relief metalwork. Keats's Grecian Urn was probably an elaboration of this type. Other essays more wholly in the Classical manner offer groups like the Naples Orestes and

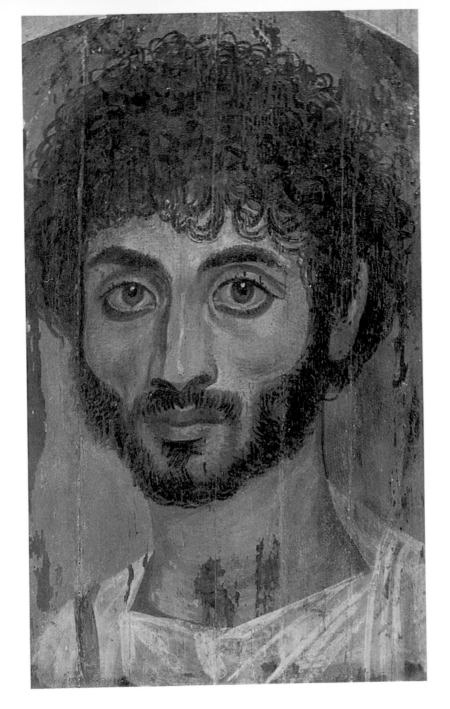

Electra, where the figures of the brother and sister are interpreted in the spirit of the fifth-century Attic tragedians who told their story, and in a version of the sculptural idiom of the same period. Works of this type are attributed to the school of Pasiteles.

The stricter realism of Roman portraiture has its origins in the death-masks and effigies which Etruscans and Romans alike revered. The actual carving, to judge from preserved signatures, remains largely in Greek hands. If there is anything at all to mark off por-traiture in the Greek world from that of Rome it is the continued interest in conveying character, and in the form and structure of the features rather than a plaster-cast likeness.

244

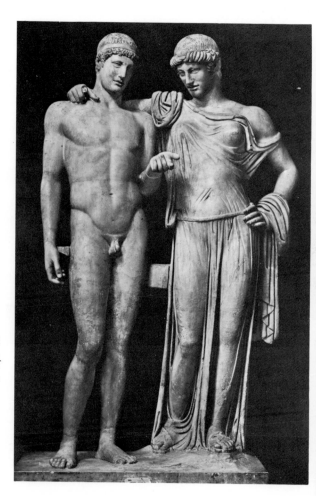

242 (*left*) Portrait of a man, painted on wood in the encaustic technique. These panels fitted at the head end of mummy-cases in Roman Egypt. Second century A D. Height 38 cm

243 (*right*) Group of a youth and a woman, possibly meant for Orestes and Electra. The youth recalls work of *c.* 460 B C but the group is a Classicizing creation of the first century B C

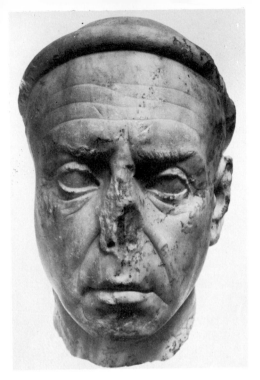

244 Portrait head of a priest from Athens. 'Roman realism in a Greek translation', where we should also certainly read the influence of Egypt. This must be a shaven priest of Isis, whose cult had been brought to Attica in the fourth century B C. *c.* 50 B C

Painted portraits offer a different problem. Back in the fourth century Xenophon recorded or invented a conversation between Socrates and the painter Parrhasios about whether it was possible to depict character in painting. For painted portraits comparable with the statuary we have to look far ahead into the Roman period, but still to the Greek East, to the mummy-portraits of Egypt. These were enclosed at the head end of the mummy-wrapping, in the position which was usually occupied by a relief mask. The techniques of the painting, the highlights and shading, show no appreciable advance on Hellenistic and Roman wall-painting.

242

As with the statuary so with paintings, Roman patrons stimulated a demand for copies of the Classical and Hellenistic masterpieces. We know these copies largely from the wall-paintings in houses at Pompeii and Herculaneum, preserved in the sudden deposit of ash from the eruption of Vesuvius in A D 79. Where the same theme appears in more than one version, and with but slight variations, we may reasonably suspect that a Greek original is copied. Rarely, too, the subject corresponds with a title of a masterpiece attributed to a famous artist, like Nikias' 'Perseus and Andromeda'. Nikias had

238

painted for the sculptor Praxiteles and is one of the great painters of his age, but it is more difficult to judge the quality of his work from the copies of the Roman period, than it is that of his sculptor colleague.

The landscape features of Pompeian wall-paintings probably derive from Hellenistic models – we have already seen their effect in contemporary reliefs. The painted architectural styles, much elaborated by the Romans, may owe something too to painters of Hellenistic stage sets. Hellenistic sculptural styles are reflected in works like the 'Heracles and Telephos'. The subject offers a scene in the life of Telephos, founder of Pergamum, whose story was also told in the inner frieze of the Great Altar of Zeus in that city. The poses, drapery, features and musculature of the figures invite immediate comparison with Hellenistic Pergamene statuary. And a yet more direct copy of a very famous statuary group appears in 'The Three Graces', from Pompeii. 239 246

These are some of the means by which Greek statuary and painted subjects remained in the artist's stock in trade in the Roman period. Gems, cameos and coins repeated the same themes. The low-relief decoration of Hellenistic clay and metal bowls leads directly to the Roman red bowls of Arretine and Samian ware. The finest 245

245 A mould for a Roman Arretine vase showing dancing girls wearing a basket head-dress (*kalathiskos*), altars, bucrania and swags. Late first century B C. Height 11 cm

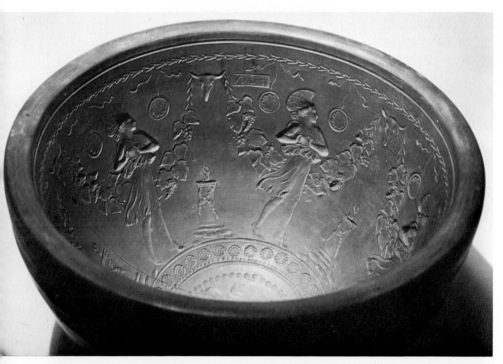

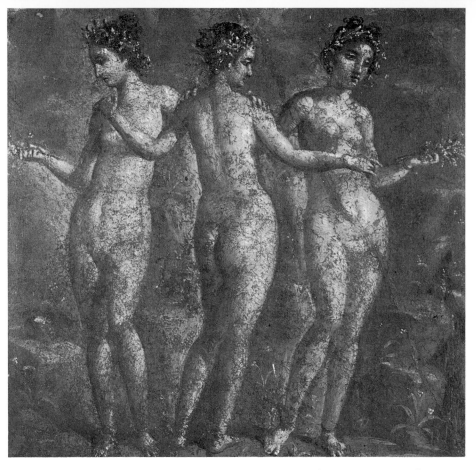

246 'The Three Graces'. Copy of a Hellenistic sculpture group in a wall-painting from Pompeii

compositions on these recall and perpetuate Greek motifs. Similar relief decoration, in stucco, appeared on Roman walls and ceilings and this encrusted decoration was to be an important medium for the transmission of Greek motifs – both figure and decorative floral – to Renaissance artists. Fragments of the red relief bowls were being collected and admired already in the thirteenth century, but treated as supernatural relics. It is easy to see how the survival of such works, as well as actual finds of statuary, introduced Italian artists to the great range of Greek figure studies and compositions which they either copied or adapted in their paintings, medallions and sculpture.

247 'The Three Graces', by Raphael, AD 1500, adapted from the Hellenistic marble group of which a copy had been found in Rome in the fifteenth century (now in Siena). In 1515 Raphael was appointed Inspector of Ancient Monuments and Excavations around Rome by Pope Leo X. 'The Three Graces' type is said to have served as a brothel sign in Renaissance Italy. Canvas, 17 × 17 cm

For the architect Doric and Ionic orders for columns, the details of Greek entablature and pediments remained the canon for mouldings and decoration, together with the variant orders, Greek or Italian – Corinthian, Composite, Tuscan. Only in their structural methods – which lie as close to the heart of good architecture as does proportion and decoration – did the Romans add something, in their special skills with brick, concrete and vaulting.

233

For Renaissance Italy there was of course a mass of Roman architecture available for study, but in Greece too there was much original architecture left above ground to instruct both the Romans and their successors. Italian scholars were visiting Greece in the fourteenth and fifteenth centuries. Many of the buildings had been converted to the needs of a new religion – the Parthenon in Athens; the Temple of Athena (now Cathedral) in Syracuse; part of the Erechtheion ended its career as a harem. Marble is ready fare for the lime-kiln and it is a tribute to the durability of Greek construction and material that so much remained standing for so long – indeed still remains standing.

It is the mystery and miracle of Western art that Renaissance artists were able to take up the tradition of Classical art more or less where the Greeks had left it in the Hellenistic period, with a spirit and understanding which seem the logical succession to the Greek achievement; and that the main intermediary was the technically brilliant, but monumentally dead art of the Roman Empire. A hall-mark of the

248 Dürer's engraving of the Fall of Man (dated AD 1504). Both 'ideal' figures derive ultimately from Classical models, the Adam from the Apollo Belvedere, a Roman copy of a fourth-century Greek statue

249 The drawing on a gold-anodized aluminium plaque attached to the antenna of Pioneer 10, launched in February AD 1972. The planetary system (*below*), pulsar pattern (*left*) and human figures (*right*) are intended to indicate the source of the spacecraft, its time of launching and the type of creatures which created it. Pioneer 10 is expected to travel a distance of 3,000 light years (30 million million km) in the next 100 million years, the time it might take for an alien civilization to discover it

tradition is the treatment of the Classical nude (see pp. 129–30). A measure of its potency is the fact that the figures chosen in the sixteenth century after Christ to represent the Fall of Man and in the twentieth century to represent his attempted Apotheosis, both derive in pose and detail from that idealized and basically unrealistic view of man and his mate – nakedly modest in either covering or removing the body hair that draws attention to their shame – devised by the artists of Classical Greece.

248
249

Chronological Chart

B.C.	Events and People	Sculpture
1200		
1100	Collapse of Mycenaean Empire Dorian Invasion	
1000	Migrations to East Greece	
900		
800	Greeks in North Syria	Minor bronzes
700	Greek colonies in Italy and Sicily	'Dedalic' style Monumental marble statuary begins 640
600	Greeks in Egypt Greek colonies on Black Sea Sappho, Alcaeus Solon Persians control Lydia and part of East Greece	Archaic *kouroi* 630–480 Athenian Archaic gravestones (600–500) Ionian-type *korai* 560– Limestone pediments Athens
	Pisistratus, Polycrates	'*Peplos kore*' 530
500	Persian invasion and defeat 490–79 Defeat of Carthage 479 Athenian Empire founded 478 Aeschylus Herodotus Pericles Peloponnesian War and defeat of Athens by Sparta 431–04 Thucydides, Aristophanes	Aegina sculptures Island gravestones 'Ludovisi·throne' 460 Olympia sculptures 460 Myron 450 Phidias and the Parthenon Athenian Classical gravestones (430–310) Polyclitus 440 Relief sarcophagi begin
400	Socrates, Plato	
	Demosthenes Aristotle Defeat of Greeks by Macedonians 338 End of Greek city-states Alexander King of Macedon 336–23	Kephisodotus 370 Scopas 360 Hermes of Olympia, Praxiteles 340 Portrait sculpture begins Lysippus 320 Athenian gravestones cease
300	Gauls invade Asia Minor	Tyche of Antioch 290
200	Defeat of Macedonians by Romans 197	Pergamene statues of Gauls Great Altar of Zeus at Pergamum Victory of Samothrace 190
100	Sack of Corinth by Romans 146 Greece a Roman province Sack of Athens by Romans 86 Foundation of Roman Empire 27	Venus de Milo Laocoön Copies of earlier statues made Archaistic and Neo-Attic

	Architecture	Vase Painting and other Arts	B.C.
			1200
			1100
Geometric		Protogeometric pottery	1000
			900
		Geometric pottery (9th–8th c.)	800
Orientalizing	First peripteral temple (Samos)	Protocorinthian (725–625)	700
		Protoattic (700–625)	
		Relief vases	
		Island Gems (675–550)	
	Doric order evolved by 600	Corinthian vases (625–550)	
		Coinage begins (600)	600
	Ionic order evolved by 560	Athenian black-figure (625–475)	
	Apollo Temple Corinth 550	'François vase' 570 Spartan cups	
Archaic	Hera temples Samos 560, 530–	Amasis Painter 550	
	Artemis Temple Ephesus 550–	Exekias 540	
	Siphnian Treasury Delphi 525	Spartan bronze vases	
		Red-figure invented 530	
		Chalcidian, Caeretan vases	
		Euphronios, Euthymides 510	500
		Berlin Painter 490	
		Pan Painter 470	
	Zeus Temple Olympia 470–56	Niobid Painter 460	
		White-ground lekythoi	
	Parthenon 447–33	South Italian red-figure begins	
	Hephaisteion 449–	Achilles Painter 440	
	Apollo Temple Bassae 425		
Classical	(first Corinthian capital)	Dexamenos	
	Propylaea Athens 437–32	Pebble mosaics begin	
	Erechtheion 421–05	Meidias Painter 410	400
	Asklepios Temple Epidaurus 380		
	Apollo Temple Delphi 366–26		
	Artemis Temple Ephesus rebuilt 356–	Boeotian Cabirion vases (4th–3rd c.)	
	Mausoleum Halicarnassus 350		
	Apollo Temple Didyma 313–	Original of 'Alexander mosaic'	
		End of red-figure vases	300
		Tanagra figurines	
		Gnathia vases (4th–3rd c.)	
Hellenistic		Hadra vases	
		Megarian relief bowls (3rd–2nd c.)	200
	Stoa of Attalus Athens 150		
			100

The floruits of artists and approximate dates for works of art are given.

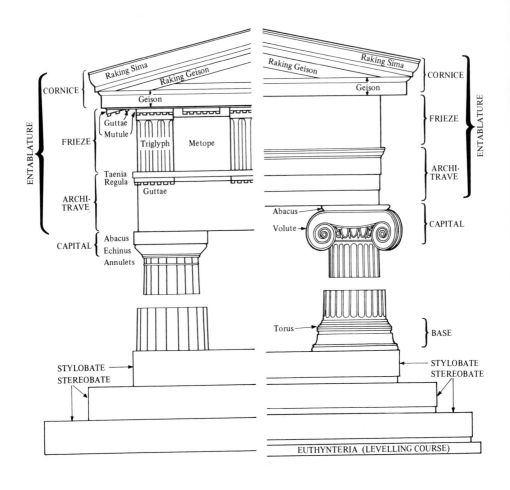

ENTABLATURE

CORNICE {
 Raking Sima
 Raking Geison
 Geison
}

FRIEZE {
 Guttae
 Mutule
 Triglyph Metope
 Taenia
 Regula
 Guttae
}

ARCHI-
TRAVE

CAPITAL {
 Abacus
 Echinus
 Annulets
}

STYLOBATE
STEREOBATE

Raking Geison
Raking Sima
Geison

CORNICE }

FRIEZE }

ARCHI-
TRAVE }

Abacus
Volute
CAPITAL }

Torus
BASE }

STYLOBATE
STEREOBATE

ENTABLATURE

EUTHYNTERIA (LEVELLING COURSE)

250 The Doric (*left*) and Ionic Orders

238

Selected Bibliography

*indicates an inexpensive book; †indicates a good source of illustrations; ‡indicates a standard handbook on a major subject

GENERAL BACKGROUND

Cultural history

ANDREWES, A. *The Greeks* London and New York, 1967 = *Greek Society* Harmondsworth, 1971

Cambridge Ancient History new editions of vols 3 (Cambridge, 1982) and 4–7 (forthcoming), and Plates to vols 3 and 7 (1984)

*COOK, R. M. *The Greeks till Alexander* London, 1961; New York, 1962

‡HAMMOND, N. G. L. *A History of Greece to 322 B.C.* Oxford, 1959; New York, 1967 *Oxford History of the Classical World* (eds J. Boardman, J. Griffin and O. Murray) Oxford, 1985

Mythology

*†PINSENT, J. *Greek Mythology* London, 1982

‡ROSE, H. J. *Handbook of Greek Mythology* London, 1960

†SCHEFOLD, K. *Myth and Legend in Early Greek Art* London and New York, 1966

GENERAL ART AND ARCHAEOLOGY

All periods

†BOARDMAN, J., DÖRIG, J., FUCHS, W. and HIRMER, M. *The Art and Architecture of Ancient Greece* London and New York, 1967

†LANGLOTZ, E. and HIRMER, M. *The Art of Magna Graecia* London, 1965

*POLLITT, J. *Art and Experience in Classical Greece* Cambridge, 1972

POLLITT, J. *The Ancient View of Greek Art* New Haven, 1974

POLLITT, J. *The Art of Greece: Sources and Documents* Cambridge, forthcoming

*†RICHTER, G. M. A. *Handbook of Greek Art* London, 1969

ROBERTSON, M. *History of Greek Art* Cambridge, 1975; and *Shorter History of Greek Art* Cambridge, 1981

Geometric and Archaic

*BOARDMAN, J. *Pre-Classical Style and Civilisation* Harmondsworth and Baltimore, 1967

BOARDMAN, J. *The Greeks Overseas* London and New York, 1980

†CHARBONNEAUX, J., MARTIN, R. and VILLARD, F. *Archaic Greek Art* London and New York, 1971

COLDSTREAM, N. *Geometric Greece* London, 1977

*†HOMANN-WEDEKING, E. *Archaic Greece* London, 1968

SNODGRASS, A. M. *The Dark Age of Greece* Edinburgh, 1972

Classical

†CHARBONNEAUX, J., MARTIN, R. and VILLARD, F. *Classical Greek Art* London, 1973

HOPPER, R. J. *The Acropolis* London and New York, 1971

*†SCHEFOLD, K. *Classical Greece* London, 1967

Hellenistic

†CHARBONNEAUX, J., MARTIN, R. and VILLARD, F. *Hellenistic Art* London, 1973

*†WEBSTER, T. B. L. *Hellenistic Art* London, 1967

SCULPTURE

General

ADAM, S. *The Technique of Greek Sculpture* London, 1966

†ASHMOLE, B. *Architect and Sculptor in Ancient Greece* London and New York, 1972

*†BARRON, J. *Greek Sculpture* London, 1982

239

BLÜMEL, C. *Greek Sculptors at Work* London, 1969

CARPENTER, R. *Greek Sculpture* Chicago, 1960

†LULLIES, R. and HIRMER, M. *Greek Sculpture* New York, 1957; London, 1960

‡RICHTER, G. M. A. *The Sculpture and Sculptors of the Greeks* New Haven, Conn., 1970; Oxford, 1971

†‡RICHTER, G. M. A. *Portraits of the Greeks* Oxford, 1984

Archaic

*†‡BOARDMAN, J. *Greek Sculpture, the Archaic Period* London and New York, 1978

†PAYNE, H. and YOUNG, G. M. *Archaic Marble Sculpture from the Acropolis* London and Chester Springs, Pa., 1950

†RICHTER, G. M. A. *The Archaic Gravestones of Attica* London, 1961

†RICHTER, G. M. A. *Korai, Archaic Greek Maidens* London, 1968

†RICHTER, G. M. A. *Kouroi, Archaic Greek Youths* London, 1970

Classical

*ASHMOLE, B. *Some Nameless Sculptors of the fifth century B.C.* British Academy, 1962

*ASHMOLE, B. *The Classical Ideal in Greek Sculpture* Cincinnati, 1964

*†ASHMOLE, B. and YALOURIS, N. *Olympia* London, 1967

BIEBER, M. *Ancient Copies* New York, 1977

*†‡BOARDMAN, J. *Greek Sculpture, the Classical Period* London and New York, 1984

†‡BROMMER, F. *The Sculptures of the Parthenon* London and New York, 1979

JOHANSEN, F. *The Attic Grave Reliefs* Copenhagen, 1951

RIDGWAY, B. S. *The Severe Style in Greek Sculpture* Princeton, 1970

RIDGWAY, B. S. *Fifth Century Styles in Greek Sculpture* Princeton, 1981

Hellenistic

‡†BIEBER, M. *The Sculpture of the Hellenistic Age* New York, 1954

LAWRENCE, A. W. *Later Greek Sculpture* London, 1927; New York, 1969

ARCHITECTURE

†BERVE, H., GRUBEN, G. and HIRMER, M. *Greek Temples, Theatres and Shrines* London, 1963

COULTON, J. J. *Greek Architects at Work* London, 1977

‡DINSMOOR, W. B. *The Architecture of Ancient Greece* London and Chicago, 1952

HILL, I. T. *The Ancient City of Athens* London, 1953

‡LAWRENCE, A. W. *Greek Architecture* Harmondsworth, 1957; Baltimore, 1967

†‡WINTER, F. *Greek Fortifications* London and Toronto, 1971

WYCHERLEY, R. E. *How the Greeks built cities* London, 1962; New York, 1969

WYCHERLEY, R. E. *The Stones of Athens* Princeton, 1978

PAINTING

General

†‡ARIAS, P., HIRMER, M. and SHEFTON, B. B. *A History of Greek Vase Painting* London, 1961

BEAZLEY, J. D. *Potter and Painter in Ancient Athens* London, 1944

‡COOK, R. M. *Greek Painted Pottery* London, 1972

NOBLE, J. V. *The Techniques of Painted Athenian Pottery* New York, 1965

RICHTER, G. M. A. and MILNE, M. J. *Shapes and Names of Athenian Vases* New York, 1935; College Park, Md., 1971

†ROBERTSON, C. M. *Greek Painting* Geneva, 1959

Geometric and Archaic

†‡BEAZLEY, J. D. *The Development of Attic Black Figure* Berkeley, 1951

240

★†‡BOARDMAN, J. *Athenian Black Figure Vases* London and New York, 1974

★†‡BOARDMAN, J. *Athenian Red Figure Vases, The Archaic Period* London and New York, 1975

†COLDSTREAM, N. *Greek Geometric Pottery* London and New York, 1968

DESBOROUGH, V. R. d'A. *Protogeometric Pottery* Oxford, 1952

†HASPELS, E. *Attic Black Figured Lekythoi* Paris, 1936

PAYNE, H. *Necrocorinthia* Oxford, 1931; College Park, Md., 1971

Classical

★BEAZLEY, J. D. *Attic White Lekythoi* London, 1938

†BEAZLEY, J. D. *The Berlin Painter; The Kleophrades Painter; The Pan Painter* Mainz, 1974

†KURTZ, D. C. *The Berlin Painter* Oxford, 1982

‡RICHTER, G. M. A. *Attic Red Figure Vases, A Survey* New Haven, 1958

★TRENDALL, A. D. *South Italian Vase Painting* British Museum, 1966

TRENDALL, A. D. *Early South Italian Vase Painting* Mainz, 1974

OTHER ARTS

†BOARDMAN, J. *Island Gems* London, 1963

†BOARDMAN, J. *Archaic Greek Gems* London and Evanston, Ill., 1968

†‡BOARDMAN, J. *Greek Gems and Finger Rings* London, 1970; New York, 1971

★CHARBONNEAUX, J. *Greek Bronzes* London, 1961

†*A Guide to the Principal Coins of the Greeks* British Museum, 1959

‡HIGGINS, R. A. *Greek and Roman Jewellery* London, 1961; New York, 1962

‡HIGGINS, R. A. *Greek Terracottas* London, 1963; New York, 1967

†HOFFMANN, H. and DAVIDSON, P. F. *Greek Gold* Mainz, 1965

JACOBSTHAL, P. *Greek Pins* Oxford and New York, 1956

†KRAAY, C. M. and HIRMER, M. *Greek Coins* London and New York, 1966

‡KRAAY, C. M. *Archaic and Classical Greek Coins* London, 1976

†MITTEN, D. G. and DOERINGER, S. F. *Master Bronzes from the Classical World* Mainz, 1967; Greenwich, Conn., 1968

‡†RICHTER, G. M. A. *The Engraved Gems of the Greeks and Etruscans* London, 1968

‡STRONG, D. *Greek and Roman Gold and Silver Plate* London and Ithaca, N.Y., 1966

PERIPHERAL

†ARTAMONOV, M. I. *Treasures from Scythian Tombs* London and New York, 1969

From the Lands of the Scythians New York, 1975

★HARDEN, D. B. *The Phoenicians* Harmondsworth, 1972

‡MINNS, E. *Scythians and Greeks* Cambridge and New York, 1913

†PALLOTTINO, M. *Etruscan Painting* Geneva, 1952

†★PORADA, E. *The Art of Ancient Iran* London and New York, 1965

★RICE, T. T. *The Scythians* London, 1957

†RICHTER, G. M. A. *Ancient Italy* Ann Arbor, 1955

‡RIIS, P. J. *An Introduction to Etruscan Art* Copenhagen, 1953

RELATED SUBJECTS

†BIEBER, M. *A History of Greek and Roman Theater* Princeton, 1961

★CLARK, K. *The Nude* Harmondsworth, 1960

GOMBRICH, E. H. *Art and Illusion* New York, 1960

†JOHNS, C. *Sex or Symbol* London, 1982

KURTZ, D. C. and BOARDMAN, J. *Greek Burial Customs* London and Ithaca, N.Y., 1971

†RICHTER, G. M. A. *The Furniture of the Greeks, Etruscans and Romans* London, 1966

†RICHTER, G. M. A. *Perspective in Greek and Roman Art* London, 1970

*SIMON, E. *The Ancient Theatre* London, 1982

SNODGRASS, A. M. *Arms and Armour of the Greeks* London and Ithaca, N.Y., 1967

†WEBSTER, T. B. L. *Everyday Life in Ancient Athens* London and New York, 1969

†WEBSTER, T. B. L. and TRENDALL, A. D. *Illustrations of Greek Drama* London, 1971

List of Illustrations

243

crater ('François vase') from Chiusi. Florence, Museo Archeologico, 4209. Photo: Max Hirmer

80 Chian chalice from Tocra. Tocra Museum, 785. Photo: the author

81 Athenian black-figure plate. Munich, Staatliche Antikensammlungen, 8760. Photo: G. Wehrheim

82 Detail of Athenian black-figure *amphora* from Vulci. London, British Museum, B 210. Photo: Max Hirmer

83 Detail of Athenian black-figure band-cup. Oxford, Ashmolean Museum. Photo: courtesy the Ashmolean Museum

84 Detail of Athenian black-figure *amphora*. Paris, Bibliothèque Nationale, 222. Photo: Max Hirmer

85 Chalcidian black-figure column *crater* from Vulci. Würzburg, Martin von Wagner Museum, 147. Photo: Martin von Wagner Museum

86 Spartan black-figure cup from Italy. Paris, Louvre, E 668. Photo: Max Hirmer

87 East Greek cup from Etruria. Paris, Louvre, F 68. Photo: Max Hirmer

88 Detail of Athenian black-figure *amphora* from Vulci. Brescia, Museo Civico. Photo: Max Hirmer

89 Interior and one side of Athenian red-figure cup. Karlsruhe, Badisches Landesmuseum, 63.104. Photo: Badisches Landesmuseum

90 Detail of Athenian red-figure *amphora* from Vulci. Berlin, Staatliche Museen, F 2159. Photo: Max Hirmer

91 Athenian red-figure cup from the Agora, Athens. Athens, Agora Museum, P 24102. Photo: Agora Excavations, American School of Classical Studies, Athens

92 Athenian red-figure *amphora* from Vulci. Munich, Staatliche Antikensammlungen, 2307. Photo: Max Hirmer

93 Detail of Athenian red-figure vase. Basle, Antikenmuseum (Depositum CIBA A.G.). Photo: Antikenmuseum

94 Clay plaque from the Acropolis, Athens. Athens, Acropolis Museum, 1037. Photo: German Archaeological Institute, Athens

95 Athenian red-figure cup from Orvieto. Boston, Museum of Fine Arts, 10.179. Photo: courtesy Museum of Fine Arts

96 Detail of Athenian red-figure *amphora* from Vulci. Munich, Staatliche Antikensammlungen, 2344. Photo: Max Hirmer

97 Athenian red-figure *psykter* from Cervetri. London, British Museum, E 768. Photo: courtesy the Trustees of the British Museum

98 Painted slab from tomb near Paestum. Paestum Museum.

99 Detail of Athenian red-figure cup. Paris, Louvre, G 156. Photo: Max Hirmer

100 Clay head of a silen from Gela. Gela Antiquario. Photo: Max Hirmer

101 Bronze figurine of a symposiast from Dodona. London, British Museum, 1954.10–18.1. Photo: Max Hirmer

102 Clay figure vase from the Agora, Athens. Athens, Agora Museum, P 1231. Photo: Agora Excavations, American School of Classical Studies, Athens

103 Bronze crater from Vix. Chatillon-sur-Seine Museum. Photo: Chambon

104 Bronze mirror support. New York, Metropolitan Museum of Art, Fletcher Fund, 1938.11.3. Photo: Metropolitan Museum of Art

105 Agate scarab. London, British Museum, Walters 465. Photo: R.L. Wilkins

106 Silver coin of Naxos. Private Collection. Electrum coin of Cyzikus. Paris, Bibliothèque Nationale, de Luynes 2430. Photos: Max Hirmer

107 Marble youth from the Acropolis, Athens. Athens, Acropolis Museum, 698. Photo: Max Hirmer

108 Restored drawing of the east end of the Temple of Zeus at Olympia. Cf. Berve, Gruben, Hirmer, *Greek Temples, Theatres and Shrines* 320, fig. 9

109 Clay group of Zeus and Ganymede from Olympia. Olympia Museum. Photo: Max Hirmer

110 Detail of Apollo from the west pediment of the Temple of Zeus at Olympia. Olympia Museum. Photo: Max Hirmer

111 Metope from the Temple of Zeus at Olympia. Olympia Museum. Photo: Max Hirmer

112 Head of a centaur from the west pediment of the Temple of Zeus at Olympia. Olympia Museum. Photo: the author

113 Detail of bronze statue from the Artemisium wreck. Athens, National Museum, 15161. Photo: Max Hirmer

114 Bronze charioteer from Delphi. Delphi Museum. Photo: Max Hirmer

115 Marble relief. Berlin, Staatliche Museen, Antikenabteilung, 1871. Photo: Staatliche Museen

116 Marble gravestone, probably from Paros. Berlin, Staatliche Museen, Antikenabteilung, 1482. Photo: Staatliche Museen

117 Model of the Acropolis, Athens. Royal Ontario Museum, University of Toronto. Photo: Royal Ontario Museum

245

247

196 The Victory from Samothrace. Paris, Louvre. Photo: Max Hirmer
197 Marble statue of a boy from Tralles. Istanbul Museum. Photo: Max Hirmer
198 Copy of a crouching Aphrodite. Paris, Louvre. Photo: Alinari
199 Copy of sleeping hermaphrodite. Rome, Terme Museum. Photo: Anderson
200 Statue of Aphrodite from Melos. Paris, Louvre, Photo: Max Hirmer
201 Bronze boxer. Rome, Terme Museum, 1055. Photo: Max Hirmer
202 Marble sleeping satyr. Munich, Staatliche Antikensammlungen, 218. Photo: Max Hirmer
203 Copy of a portrait of Epicurus. New York, Metropolitan Museum of Art, Rogers Fund, 1911.90. Photo: Metropolitan Museum of Art
204 Bronze statue of a prince. Rome, Terme Museum, 1049. Photo: Max Hirmer
205 Copy of a statue of Demosthenes. Rome, Vatican Museums. Photo: German Archaeological Institute, Rome
206 Bronze head from Delos. Athens, National Museum, 14612. Photo: Max Hirmer
207 Marble relief. London, British Museum, 2191. Photo: courtesy the Trustees of the British Museum
208 Marble relief from near Corinth. Munich, Staatliche Antikensammlungen, 206. Photo: Kaufmann
209 Detail from the 'Alexander sarcophagus' from Sidon. Istanbul. Photo: Max Hirmer
210 Clay group from Capua. London, British Museum, D 161. Photo: Max Hirmer
211 Clay head from Tarentum. Taranto, National Museum, 20068. Photo: Max Hirmer
212 Clay figure from Tarentum. Taranto, National Museum, 52074. Photo: Max Hirmer
213 Clay figure from Tanagra. Berlin, Staatliche Museen, Antikenabteilung, TC 7674. Photo: Staatliche Museen
214 Gold and silver pyxis lid from near Tarentum. Taranto, National Museum, 22429. Photo: Max Hirmer
215 Bronze figure of a Negro boy. Paris, Bibliothèque Nationale, 1009. Photo: Giraudon
216 Clay figure vase. Würzburg, Martin von Wagner Museum, 4958. Photo: Martin von Wagner Museum
217 Bronze statuette of a philosopher. New York, Metropolitan Museum of Art, Rogers Fund, 1910.231.1. Photo: Metropolitan Museum of Art
218 Bronze statuette of a god. Paris, Louvre, MND 2014. Photo: Archives Photographiques
219 Gold diadem from Thessaly. Athens, Benaki Museum. Photo: Benaki Museum
220 Gold ears of wheat from near Syracuse. Collection: Mr and Mrs J. W. Hambuechen, USA
221 Gold amphora from Panagurishte. Archaeological Museum, Plowdiw, Bulgaria. Photo: Dr Helga Reusch
222 Plate from Capena. Rome, Villa Giulia Museum, 23949. Photo: Alinari
223 Clay hydria from Arsinoe. Brussels, A 13. Photo: A. C. L., Brussels
224 Gnathia crater. Leiden, Rijksmuseum van Oudheden, B 677. Photo: Rijksmuseum van Oudheden
225 Crater from Centuripe. Catania University. Photo: Max Hirmer
226 Kantharos from Vulci. Collection: Prinz Philipp von Hessen. Photo: R. and R. Büttner, Fulda
227 Clay hydria from Naples. Copenhagen, Danish National Museum, Antiksamlingen, 3240. Photo: Danish National Museum, Antiksamlingen
228 Clay relief bowl. London, British Museum, 1902.12–18.4. Photo: courtesy the Trustees of the British Museum
229 The Gonzaga Cameo. Leningrad, Hermitage Museum. Photo: M. L. Vollenweider
230 Silver coin of Mithradates III. London, British Museum. Photo: Max Hirmer. Silver coin of Arsinoe III. Paris, Bibliothèque Nationale. Photo: Bibliothèque Nationale
231 Painting from tomb at Lefkadia Naoussa. Photo: courtesy Photios M. Petsas
232 Detail of the 'Alexander mosaic' from Pompeii. Naples, National Museum. Photo: André Held
233 Stag-hunt mosaic at Pella
234 Blue marble tombstone of Metrodorus from Chios. Berlin, Staatliche Museen, Antikenabteilung, 766A. Photo: Staatliche Museen
235 Painting from the Tomba dei Tori, Tarquinia
236 Painting from the Tomba del Orco, Tarquinia
237 Detail of an Etruscan black-figure vase. Munich, Staatliche Antikensammlungen, 838. Photo: Martin Hürlimann
238 'Perseus and Andromeda', painting from Pompeii. Naples, National Museum.

248

Photo: André Held

239 'Heracles and Telephos', painting from Herculaneum. Naples, National Museum. Photo: André Held

240 Etruscan red-figure *skyphos*. Boston, Museum of Fine Arts, 97.372. Photo: courtesy Museum of Fine Arts

241 Marble relief from the Piraeus. Piraeus Museum. Photo: Max Hirmer

242 Wooden portrait panel, from the Fayum, Egypt. New York, Metropolitan Museum of Art, Rogers Fund, 09.181.1. Photo: Metropolitan Museum of Art

243 Marble group of a youth and a woman. Naples, National Museum. Photo: Anderson

244 Marble head of a priest from the Agora, Athens. Athens, Agora Museum, S 333. Photo: Agora Excavations, American School of Classical Studies, Athens

245 Arretine mould for a vase. New York, Metropolitan Museum of Art, Rogers Fund, 1919.192.24. Photo: Metropolitan Museum of Art

246 'The Three Graces', painting from Pompeii. Naples, National Museum. Photo: André Held

247 'The Three Graces', by Raphael. Musée Condé, Chantilly. Photo: Archives Photographiques

248 A. Dürer, 'The Fall of Man'. Engraving, AD 1504. London, British Museum. Photo: courtesy the Trustees of the British Museum

249 Plaque on spacecraft Pioneer 10. Photo: U.S. Information Service

250 Doric and Ionic Orders. Drawn by Garth Denning

The author and publishers are grateful to the many official bodies, institutions and individuals mentioned above for their assistance in supplying original illustration material

Index

Italic figures are illustration numbers